Photoshop CS3 Photographer's Handbook

Brad Hinkel • Stephen Laskevitch

Photoshop cs3 Photographer's Handbook

An Easy Workflow

rockynook

Brad Hinkel Stephen Laskevitch
bradhinkel@msn.com steve@luminousworks.com

Editor: Jimi DeRouen
Copyeditor: Don Lafler, Joan Dixon
Layout and Type: Stephen Laskevitch
Cover Design: Helmut Kraus, www.exclam.de
Printer: Friesens Corporation, Altona, MB, Canada
Printed in Canada

ISBN 13 978-1-933952-11-6

1st Edition
© 2007 by Rocky Nook Inc.
26 West Mission Street Ste 3
Santa Barbara, CA 93101-24320

www.rockynook.com

Library of Congress catalog application submitted

Distributed by O'Reilly Media
1005 Gravenstein Highway North
Sebastopol, CA 95472-2811

Acknowledgements

From Brad

I especially want to thank those who gave me the opportunity to start teaching photography: Neil and Jeanne Chaput de Saintonge, who hired me straight out of the Rocky Mountain School of Photography Summer Conservatory to start teaching their first digital photography courses, mostly due to Neil's instincts rather than my personal portfolio. Also I want to thank Tim Cooper & Jim Hanson, with whom I taught so many workshops and from whom I learned more about photography and enjoying it, and Jennifer Schramm and Claire Garoutte who hired me at the Photographic Center Northwest when the digital lab consisted of two computers in the back of a classroom.

I would also like to thank my wife, Sangita, for creating a last ditch effort to edit this book properly, and for her patience when I spent too many late nights in front of the computer, as well as too many weeks away from home teaching or photographing; and my aunt Jeannine who worked so intensely on wordsmithing my original text, and who we can all thank for adding the word 'opine' to the text.

Finally, I need to acknowledge Raja and Pablo for their late night support during this project, and Mira Nisa and Anjali for teaching me some perspective on what is really important.

Thanks to all—Brad Hinkel
www.bradhinkel.com

From Steve

Thanks must go first to Brad for involving me in this project.

Its beginning, however, goes back nearly a decade, and for that I thank Liz Atteberry.

I have greatly benefitted from the support and encouragement of the Adobe Partners program and the many very fine folks there, especially Bill McCulloch. Lou Cuevas, photographer and friend, thanks for your generous time and input.

To all my students for these many years who have kept me on my toes, I am deeply indebted as well.

I am grateful, as well, for the thorough and thoughtful editors at Rocky Nook.

Without the inspiration and knowledge I was blessed to receive from the words of Bruce Fraser, I may not be doing this work at all.

Of course I must thank other great teachers in my life:

Hugo Steccati, teacher of art and the art of life: though you're gone, I still hear your advice in any good thing I do;

Colin Fleming, software maestro and tremendously fine human—my heart's brother;

and most dearly, Carla Fraga, who *is* inspiration and life. I still can't believe she married me.

Thanks to you, too, for reading this book,
Steve Laskevitch
www.luminousworks.com

Table of Contents

Introduction

Digital technology is fundamentally changing the realm of photography and printing. Photographers now have almost unlimited options to achieve the precise image that they intend. Printing has become infinitely more flexible and pushed closer to the control of the image creator. We can now use images in almost any form of visual communication. This added flexibility brings more and more attention to the process of editing images. Adobe® Photoshop® is the essential tool for visual imaging.

Photoshop is a very comprehensive program—one of the most complex programs we have ever used. There is a reason "Photoshop" has become a verb! Our goal is to present Photoshop in an accessible way. Even though it provides thousands of complex techniques for editing images, most users (and most images) don't need all of this complexity. In fact, only a few basic steps in Photoshop are needed to get the vast majority of images to shine. In this book, we introduce you to the basic step-by-step processes we use on most of our images. This includes steps for editing density, contrast, and color, plus basic techniques for image processing like converting images from color to black & white and sharpening images. The workflow discussed is complete, but we do not include many of the more complex and esoteric techniques common to the Photoshop marketplace.

Take a quick look at the chapters of this book. They include the basic workflow for editing images—opening digital camera images, cleaning up images, basic adjustments, local adjustments, photographic processes, printing, and output to the web. They also include some Photoshop lessons—layers and masks, elements of the interface, and some special features—and lots of image editing techniques. Let's get working!

Using This Book

Who Should Use this Book

This book is for those who want to learn the basic tools and image editing steps within Photoshop to create professional looking images. This, of course, includes photographers and graphics designers, but also a wide range of technicians and office workers who just want to do more effective image editing. This book provides insight into the creation of good images, but doesn't showcase "cool" but useless Photoshop techniques. We also don't pull any punches. We include all the key techniques necessary for good image editing: using layers and layer blending, Curves, color correction, printer profiles, and more.

Most of our students have a good grasp of working with computers, so users of this book will have no problem navigating the computer, menus, dialogs, or dragging a mouse. We do not demand that the reader have any experience with Photoshop, although many readers may have a good, basic understanding by having played with Photoshop.

Steps for Using this Book

This book includes three key chapters: Essentials of Photoshop CS3, the Editing Workflow, and Advanced Options. The Essentials chapter includes basic information on Photoshop and digital imaging. The Workflow chapter describes the specific tasks we recommend for a digital imaging workflow, including all the basic tasks necessary for image editing. The Advanced Options chapter includes a series of more complex step-by-step tasks for image editing that are used by imaging professionals. We have also included chapters on printing and producing images for the Web.

The book ends with a chapter on the newest member of the Photoshop family: Adobe Photoshop Lightroom, a kind of workflow in a window.

This book is of greatest benefit when read cover to cover. However, those looking for a handbook on Photoshop can flip through the pages to find the specific tasks of interest.

Conventions

Some helpful conventions are used throughout the book. Important terms are in bold type, making it easier to skim through for specific information.

Most tasks are numbered step-by-step.

The conventional notation for choosing a command from a menu is used throughout: e.g., File > Browse is used for selecting the Browse command from the File menu.

The icons and terms used in the application are used in this book for identifying different types of information.

Note: The red "Note" text identifies text in a chapter that summarizes or emphasizes a key point. Make sure you understand the key points of each chapter.

Photoshop Versions

This book is designed specifically for use with Adobe® Photoshop® CS3 released in April of 2007 and Lightroom 1.0 released earlier that Spring.

For the most part, the workflows and techniques described in this book still work well with Photoshop CS2.

Mac OS X vs. Microsoft Windows XP Operating Systems

Although most of the screen shots in the book are taken from a computer running Mac OS 10.4.8, we are completely platform indifferent. The Photoshop interface is almost identical on both Windows and Mac. In fact, Photoshop happens to be one of the best cross-platform programs ever developed. With very few exceptions, every step on the Mac is identical to the same command on Windows. The differences that exist are identified in the text.

Keys Two differences throughout are in regard to keyboard modifiers and mouse clicks. The two keyboards have essentially the same function keys, but with different names. The Mac Command key (⌘) functions the same as the Windows <Ctrl> key. This keyboard modifier is identified as ⌘+[other key(s)]/<Ctrl>+[other key(s)] (for example ⌘+N/<Ctrl>+N means you would hold the modifier key while pressing the N key).

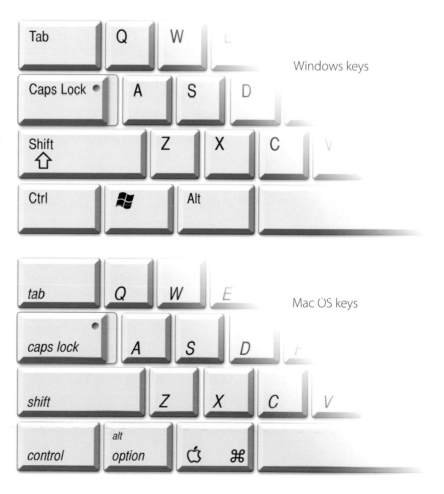

Windows keys

Mac OS keys

Similarly, the Mac **‹option›** key, identified in menus by the cryptic symbol ⌥, functions the same as the Windows **‹Alt›** key. This keyboard modifier is identified as **‹option›**+[*other key(s)*]/**‹Alt›**+[*other key(s)*].

Colors We'll be using **‹blue for Windows›**, **‹dark gray›** when the platform doesn't matter (e.g. **‹Shift›** or **‹Space›**), and **‹red for Mac›** or as part of a Mac-specific shortcut

Finally, the older Mac mouse included only one mouse button, whereas the newer "Mighty Mouse" can have two-button functionality within its single shell. The Windows mouse includes a second mouse button for additional functionality—often a Context menu. Mac users can achieve this same functionality on a single-button mouse by holding down the **‹control›** key when clicking the mouse. This mouse modifier is identified by **‹control›**+**click**/**Right-click**. Mac users should update older mice and turn on the right click functionality. Ironically, a Microsoft mouse works great when plugged into a Mac.

Photoshop CS3 works on both PowerPC and Intel Macs running OS 10.3 and newer (including 10.5 "Leopard"), although other applications in some editions of the Creative Suite (programs new to the Mac platform) may run only on Intel machines. Windows computers running Windows XP Service Pack 2 or higher and Windows Vista are compatible as well.

Configuring Your System

Computer Requirements

What is the best computer for running Photoshop? The cheapest you can get! Very high-end, expensive computers are definitely faster, but require careful configuration to achieve the best performance.

If you are purchasing a Windows-based computer, buy the more advanced processors. They provide features that allow Photoshop increased performance over the lower priced processors. Apple has a simpler product line with the latest dual core processor technologies.

We both use modestly configured computers to run Photoshop. The greatest aid to smooth and responsive performance was adding additional RAM (at least 2GB). Since Photoshop performs much better with 1GB of RAM or more, use the money you save on a less expensive computer to buy the extra RAM. In Steve's training lab, he's using early vintage Intel Mac Minis with great results!

Buy a good monitor. The monitor is the interface between you and the image inside the computer. Inferior monitors make it very difficult to edit images: you simply can't see the details. Today's flat panel LCD monitors are excellent. The flicker free LCD display makes working in front of a computer much less tiring. You don't need to buy the best monitor on the market (they

can cost much more than the rest of the system!), but avoid the cheapest LCD monitors. We suggest buying the second tier of any product line. Lastly, if you want to do color correction, you need to calibrate and profile your monitor. This can be done with a hardware device made for that purpose. Calibrate your monitor as soon as practical.

Work Environment

Light Work with subdued and consistent lighting. Overly bright lights make the monitor appear dim and reflect light off the monitor. Dim lights can make the monitor appear overly bright and lead to eye fatigue as they move from the monitor to adjacent objects. Variations in room lighting will also change the appearance of images on your monitor. You can keep reflected light off of your monitor by buying or making a monitor hood. You will need a good, bright light for viewing your prints near your monitor. It is worthwhile to consider "daylight balanced" lights for that purpose, as monitors often are aglow with that same color of light.

Colors Use boring, gray colors for your computer desktop. You should set the colors of the computer screen to be mostly neutral (grays, black & white); vibrant colors on the monitor make it difficult for you to accurately perceive colors.

On Windows, open the **Display Properties** from the control panel; set the Appearance to Windows XP style and the Silver color style.

On Mac OSX, open your **System Preferences** and select **Appearance**. Choose the **Graphite** appearance. In the Desktop and Screen Saver Preferences, choose a Solid Color background, preferably a gray.

Finally, keep overly vibrant and distracting colors away from your direct field of view. Your walls don't need to be flat gray, but avoid hot pink. (Many professionals do use medium to light gray walls.)

Color Settings

We will discuss color managed workflows (those involving profiles) later in this book. However, as you process the image files from your camera, their color data has to be in sync with where they are in the workflow. That is, your camera captures a very wide range of color; this must be translated into Photoshop's range of color (its Working Space profile, most likely Adobe RGB); then later, that range of color must get squeezed and finessed into your printer's range of color, its profile. To help ensure that this happens as expected, you should configure your Color Settings (Edit > Color Settings) as illustrated here:

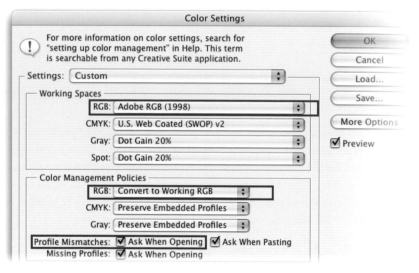

An Honest Window to Your Image: Monitor Profiling

There are five basic elements of monitor calibration:

Calibration: You need to configure your monitor to the best settings for brightness and color. A well calibrated monitor does a good job of displaying colors; the monitor profile will only need to make a few small adjustments. To calibrate your monitor, you will need to use the controls on the monitor itself to adjust brightness and color. Refer to the monitor manual if you don't already know how to do this.

Set the Target Color and Contrast: The monitor can mimic the color and contrast of a variety of light sources. You should set your monitor to mimic daylight. These values are referred to as the White Point and the Gamma. All monitor profiling tools require that you set these.

Set the White Point to: 6500K, D65, or Daylight, which are synonyms for the same value.

Set the Gamma to: 2.2, Windows or TV Standard (even on a Mac).

Profiling: Profiling requires a software utility to display colors on the monitor and provide a way to correct these colors. The best solutions also

use a hardware sensor to measure the colors displayed by your monitor and to create a profile that corrects inaccuracies.

If you use one of these solutions, turn on your monitor and let it warm up for 20 minutes before profiling it. Be sure you've set it up to not go dark in that time.

Options for Profiling and Calibration

Software Profiling—Windows Adobe® Gamma is a utility for profiling your monitor visually. It is installed with Photoshop. If you use it, run it from the Windows control panel. Adobe Gamma can be run in a 'Step by Step' mode that eases the process. Adobe Gamma will help you calibrate your monitor, as long as you can adjust the monitor brightness.

As you proceed through Adobe Gamma, you will be asked to set the White Point and the Gamma; use 6500°K and 2.2 as described above.

Adobe Gamma will also ask for the phosphors of your monitor. This confuses most users. Your monitor is likely to use Trinitron or P22-EBU (typical CRT monitors). There are *no options listed* for LCD monitors. Adobe Gamma does not work well on LCD displays; use the Trinitron option for LCD displays, but realize that the results may not be great.

After you have run through Adobe Gamma once, you should see a difference in the color of your monitor. Run through it again to see if the color changes with a second try. It can be difficult to calibrate with this type of utility.

Software Profiling—Mac Apple provides the Display Calibrator Assistant for profiling the monitor. Select the Display preferences from the System Preferences. Select the Color tab and press Calibrate to access the Calibrator Assistant. This tool is very similar to Adobe Gamma; but as an integrated system, the Calibrator Assistant can calibrate the monitor color and brightness for you. The basic mode merely requires that you supply target values for the White Point and Gamma; use 6500°K and 2.2 as described above. The expert mode provides a five step wizard to help profile the monitor.

After you have run through the Calibrator Assistant once, you should see a difference in the color of your monitor. Run through it again to see if the color changes with a second try. It can be difficult to calibrate with this type of utility.

Hardware Profiling Preferred! It is possible to buy a hardware sensor (known by some as a puck or spider or, properly, a colorimeter) that can be attached to your monitor to measure the displayed colors. These sensors work with software that is similar to the software utilities described above, but measure the output color values much more precisely than the 'eyeball' technique. **The result is a very accurate monitor profile.**

The software for the sensor is also fairly easy to use, requiring only one or two steps after the initial installation, so it can be easily run once a month.

If you have an LCD (or flat panel) monitor, you will need to use a sensor for accurate calibration.

Some options for monitor sensors are:

Eye-One Display 2 from GretagMacbeth, a subsidiary of X-Rite (www. i1color.com)

MonacoOPTIXXR from Monaco, also a subsidiary of X-Rite (www. xritephoto.com)

Color Vision Spyder2Pro (www.colorvision.com)

All of these products work well. They all provide a software utility that uses a step-by-step wizard to guide you through the process of profiling your monitor. These also have an easy or automatic mode; this mode will automatically set the White Point and Gamma values for you (to 6500K and 2.2 respectively) if the monitor supports it. The more advanced modes also include steps for precisely calibrating your monitor using the sensor device.

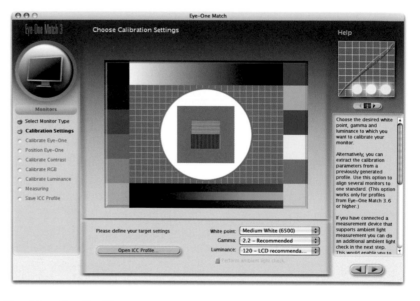

Checking the Profile

Once you have profiled your monitor, it is best to check the profile using a good visual target. **Getty Images** provides an excellent test image for evaluating the color of your monitor. Google "*site:gettyimages.com color resources*" to find it. A good test image contains a variety of common objects in color and gray, a color test target, and most importantly, some examples of skin tones. Open the image on your computer screen and evaluate it.

Essentials of Photoshop CS3

*In this chapter we discuss the main elements of Photoshop,
in order to set the stage for the production steps that follow
in the following chapters. Interspersed throughout are short
exercises to reinforce the tour of the application.*

*If you are familiar with previous versions of Photoshop, you may
be surprised by some implications of the new features of Photoshop
CS3, especially the extended version which is what we use.*

*Especially well developed are Smart Objects. In Photoshop CS2, it was
easy to overlook these novel entities. In CS3, Smart Objects are your entrée
into the realm of re-editable Filters, filter masking and blending, combining
numerous exposures for grain reduction, and the creation of special effects.*

*So read this chapter, and enjoy what's new. We strongly
encourage you to experiment and explore.*

A Look at Photoshop

This chapter introduces the basic interface of Photoshop: its Tools, Palettes, Options Bar, and image window. If you're comfortable with these topics, skip ahead to the next chapter. The main goal of this chapter is to identify the basic vocabulary of Photoshop used throughout this book.

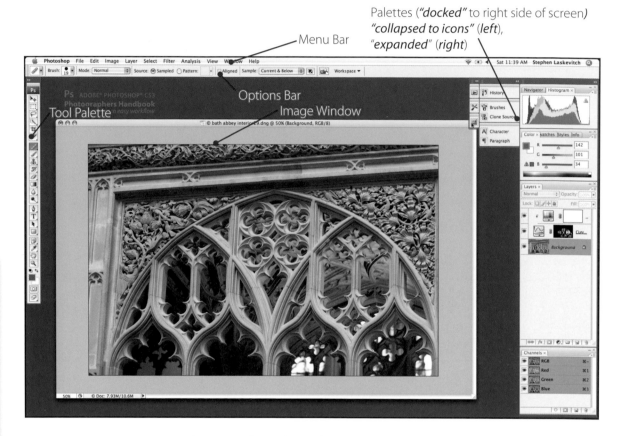

The image above shows the main elements of Photoshop. Be sure you have an image open if you want to experiment with the interface, as many Photoshop options are not available if no image is open.

The Tool Palette

The tools in this palette allow you to work directly on the image: selecting, painting, adding text, etc. Generally, you'll select a tool, move your mouse pointer over the image, and use the tool directly on the image by clicking on the image. Most of the tools change the cursor when the mouse moves over the Image Window to reflect the selected tool.

The Tool Palette includes a number of hidden tools. A tiny black triangle identifies the tools having hidden tools beneath. Access them by clicking and holding the mouse on a single tool icon.

Each tool has a set of options for customizing its function. When you select any tool, the Options Bar (just below the menu) changes to display the options for that tool.

You apply a tool with its current settings by clicking or dragging on the image. For example, clicking on the image with the paint tool makes Photoshop paint the Foreground Color onto the image.

The Palettes

Photoshop has many different palettes for evaluating and editing your image. Palettes are very useful for monitoring the various elements of your image, especially as your image becomes more complex.

Palettes can be visible, grouped, docked, collapsed to their icons (and names if you like), or hidden. *See right.*

By default, visible palettes are docked to the right edge of your screen, with a few groups fully expanded in a column at the far right, and a second, inner column (or *"dock"*) collapsed. Each palette may be dragged by its icon or name. If you drag one away from its dock, you may let it float freely on screen, put it elsewhere in a dock, or even group it with other palettes. Try it! It's actually quite easy to customize your workspace this way.

Docks and free floating palettes in the workspace can be resized. You can resize column widths by dragging the textured bit at the top of the column. The double arrows collapse or expand the column.

Drag to resize column width

Click to collapse or expand column

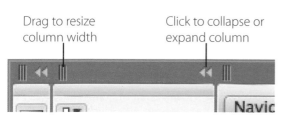

Visible palettes can have other palettes grouped with them. These appear as named tabs behind the visible palette's name. To make these palettes visible, just click on their tabs. If you look carefully, you'll see that even the icons are in groups.

Palettes that are collapsed to icons allow one-click access without cluttering up your Photoshop workspace. Collapse the palettes you often use, but do not usually need to see.

Palettes are hidden when you close the palette window. A palette can be made visible again by selecting it from the Window menu.

Each palette has its own menu with options for customization. It can be accessed by clicking on the tiny menu icon in the upper right of the palette.

To close an individual palette

To close a palette group

Cleaning up the Palettes

When you first run Photoshop, there are 3 palettes expanded, and another 14 that are one click away. For image editing, some of these are seldom used. So let's rearrange the palettes:

1. If you don't have the default palettes displayed, go ahead and make them visible by selecting Window > Workspace > Default Workspace.

2. Close the group with the **Color** Palette. The **Swatches** and **Styles** palettes will also close. Notice how the Layers palette grew to take the available space.

3. Move the **Navigator** palette tab to the bottom of the icons to its left. You'll see a blue line appear to show you where the **Navigator** icon will appear when you release the mouse.

4. Experiment! Click the double arrows at the top of each palette dock to expand and collapse them. Move tabs and icons around in their docks— you'll quickly see how they accommodate one another.

Be sure as you finish your palette moving experiments that your **Layers** palette has a prominent place. You can do so by repeating steps 1 & 2 above. You'll use the **Layers** palette more than any other and it will fill up quickly as you create new layers.

You can now access any of the visible and docked palettes by clicking on the tab or icon for that palette. Take a look at the palettes that are left. You will use the Navigator, Info, Histogram, History, and Layers palettes (and occasionally others) throughout this book. As you can see, Adobe software applications are palette heavy.

The Navigator palette allows you to quickly zoom and pan across your image in the main image window. The slider and buttons at the bottom let you zoom either arbitrarily or in set increments, respectively. The red box, if present, surrounds the part of the image to which you're zoomed. Zoom in, then drag the red box to quickly pan around your image.

The Info palette displays color information for the pixels under the cursor as it is passed over the image window. It also gives you hints for the tool that is currently in use, the position of the cursor, and the file size of the image. Some Photoshop users never take this palette off the screen.

The Histogram palette displays a histogram for your image's tones: it maps the number of pixels at each tonal level. There will be more on histograms in the section on Basic Adjustments.

The History palette lists the past states of the image. Each time you edit the image in some way, that state is recorded. You can use the History palette to quickly jump to former states, much like multiple levels of undo, but better, as you can traverse many states at once.

The Layers palette is where you create and examine the structure of your image. We'll be looking at layers more later, but you should start to think of them as stacked transparencies or sheets of clear plastic with images on them. Some layers act as color adjustments for the layers below them, much like colored gels might. Others can have effects and filters put on them, such as sharpening and and other corrections.

Once you have created a favorite arrangement for your palettes, save it. Select Window > Workspace > Save Workspace... and enter a name for your workspace. By default, Photoshop leaves your palettes where they are, and remembers their locations each time you close and reopen Photoshop. You can always return to a particular *saved* workspace by selecting the name of your workspace from the Workspace menu in the Options Bar at the top of the screen.

You can hide all of the palettes (including the Tool Palette and Options Bar) by pressing the <tab> key; pressing <tab> again makes them reappear. If you hold the <Shift> key when you hit <tab>, the tools and the Options Bar will remain while the others' visibility is toggled.

Menu Customization Photoshop CS3 has the ability to customize the items that appear on the menus. This is a terrific feature since it allows you to clean up your menus by hiding many of the less frequently used features. We don't use any custom menus in this book, but you may wish to consider this feature as you grow comfortable determining which features you can do without.

Viewing the Image

As you edit your image, you will need to change the view of the image — zoom in and out, pan around the image, and change the gray background Photoshop displays around the image. Two important views are 'Fit on Screen' and 'Actual pixels'. The keyboard shortcuts for changing the view of the image are very useful, since they allow you to change the view at any time, even if you are in the midst of an operation (e.g., defining a crop area with the Crop tool or correcting color with Levels). It can be important to change the view of the image as you are making edits.

Fit on Screen Often, you will want to view the entire image as large as possible within the Photoshop window. This viewing mode is called 'Fit on Screen'; access it by selecting View > Fit on Screen.

In most cases, when the image is sized to 'Fit on Screen', there are many more pixels in the actual image than can be displayed on the screen. Photoshop compresses the images pixels into screen pixels. This can cause some artifacts in the view of the image. However, 'Fit on Screen' works great for getting an overall view of the image.

You can also select Fit on Screen by double-clicking on the **Hand** tool (which will, of course, change the active tool), or, *best*, by pressing ⌘+0/Ctrl+0 **(zero)**.

Note: Fit On Screen may cause edges to look rough, as Photoshop will be trying to display a large number of image pixels with a completely different number of monitor pixels. The magnification value you see in the image's

title bar will usually be something arbitrary (like above), unlike when you zoom by increments (*right*).

Actual Pixels Sometimes you need to see each individual pixel for editing without any of the viewing artifacts mentioned above. For this, use the 'Actual Pixels' mode, select View > Actual Pixels. In this case, **each image pixel is mapped to exactly one screen pixel**. In most cases, you will only be able to see a portion of the image on the screen.

You can select View Actual Pixels by double clicking on the zoom tool, or by hitting ⌘+option+0/Ctrl+Alt+0 **(zero)**.

Zooming In and Out: It's easy to zoom in and out of the image in Photoshop. You can hit ⌘+**[Plus sign]**/Ctrl+**[Plus sign]** to zoom in or ⌘+**[Minus sign]**/Ctrl+**[Minus sign]** to zoom out.

The Hand Tool: The Hand tool is always available. Just hold down the **Spacebar** to get the Hand tool; click with the hand tool to drag the view of

the image around to see other parts of the image. The hand tool used in combination with the zoom in and zoom out key commands allows you to see all of the details of the image.

This image at 25% magnification has 16 of its pixels mapped to each monitor pixel. (Only 1 in 4 across as well as up and down.)

This image at 100% magnification or Actual Pixels has each of its pixels mapped to a monitor pixel. This is the best magnification at which to view an image, or at least the part that fits on the screen.

You can also create a second window of the current image easily (one for each of two magnifications, perhaps): select Window > Arrange > New Window for [document name]. These views all work on the same image, and all your edits simultaneously.

Navigator Palette (take two) The Navigator Palette displays a small thumbnail of the whole image, with a small, red box displaying the area visible in the image window. Moving your pointer into the Navigator window displays a hand tool that can be used to move the view of the image.

Hand Tool If your cursor is over the image window, with any tool active, you can hold down <Space> to access the **Hand** tool. While <Space> is down, you'll be able to press and drag with your mouse to pan around your image. The cool part? When you release the <Space>, you'll be right back to the last tool you had been using!

The <tab> and F Keys can be used to quickly change the Photoshop workspace around your image window. The <tab> key hides and displays all of the Photoshop palettes. The F key switches Photoshop between Standard Mode, Full Screen Mode with Menus (your image will be placed center screen on the Photoshop workspace), and Full Screen Mode (your image will be placed center screen on a field of black). These allow you to quickly view your image without much clutter. Try pressing <tab> (to remove the palettes), F twice (to go to Full Screen Mode), and ⌘+0/<Ctrl>+0 (zero) to 'Fit on Screen'. Press <tab> and F to return to the standard viewing mode.

Accelerators: Keyboard Shortcuts and Mouse Clicks

Although we've shown you several keyboard shortcuts already, we're not going to provide a long list of keyboard and mouse-click accelerators. A list is just not a practical way to learn them. But, to learn some of them makes it easier to focus on editing rather than navigating through menus each time you need to find a particular command.

Many accelerators are easy to find right in the Photoshop interface. For example, if you repeatedly use a menu item, note the keyboard accelerator listed just to the right of the command's name, then use the accelerator instead. You'll quickly get the hang of it. (This may sound trivial, but few people use this easy technique for learning accelerators).

Tool Tips The Tool Palette shows **tool tips** for each tool. Point your cursor at a tool, wait a second and a tool tip will appear. The tool tip displays the tool name plus the keyboard accelerator used to select it. As seen in the illustration, the brush tool can be selected by pressing the 'B' key.

There are many additional accelerators hidden within Photoshop. We use a number of them, and, as necessary, identify them throughout the book. Photoshop also has a number of popup menus that accelerate access to various functions—they are typically identified by a small triangle (as in the case of the hidden tools) or tiny menu icon (in the corner of palettes). Click on some of them to see various popup options.

Note: Finally, you probably already know about Undo—⟨⌘⟩+Z/⟨Ctrl⟩+Z. This is likely the most important accelerator in Photoshop making editing safer: knowing you can always undo a change that doesn't work out. Note, though, that the Undo command toggles between Undo and Redo—if you select ⟨⌘⟩+Z/⟨Ctrl⟩+Z once it will undo, but a second time will Redo the previous command. This is great for evaluating the most recent edit.

Layers

Understanding layers is the most essential step to understanding Photoshop. The classic way to envision layers is as a stack of acetate sheets with images on each one. This stack combines to create the final image: the top layer obscuring the next down, all the way to the background.

There are three main classes of layers:

▸ Image Layers
▸ Adjustment Layers
▸ Smart Objects

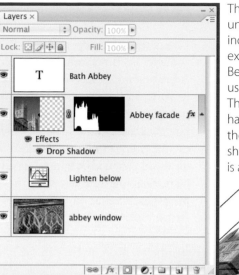

The layers at left should be understood as a stack of independent images. In this example, the layer called "Lighten Below" is an **Adjustment Layer** used to lighten the layer below it. The façade **Image Layer** has been masked to hide the sky. It also has a drop shadow applied. Finally, there is a text layer at the top.

Image Layers are independent images that can be stacked on top of one another to form the final image. (Photoshop refers to these simply as 'Layers', but in this book, we'll often use the term 'Image Layers' to distinguish them from other layers.) The **Background** layer, at the bottom of the stack, is the Image Layer containing your original image. Other Layers, are often used in conjunction with the **Background** to create a final image.

Adjustment Layers don't contain an image, but "hold" a specific adjustment to the layer(s) beneath it. You can apply many Adjustment Layers to your image to change its brightness, contrast, and/or color.

The whole image is a blend of the stacked Image Layers and Adjustment

Layers from the bottom up— applied adjustments and added images form the final desired image.

Smart Objects are special layers that can be made in many ways. For photographers, their primary use is as layers that "remember" their original condition no matter how much editing (color correction, resizing, filters such as sharpening, etc.) is done to them! The use of Smart Objects usually adds to file size, but diminishes worry and hard work when edits need to be reconsidered.

◂ *The result of the layer stack above*

Layer Masks

Layers often have an associated black and white mask that defines where
the layer is visible or hidden. You can use a mask to localize the effect of an
Adjustment Layer, or limit where an Image Layer is visible. **Where the mask
is white, the layer (either image or adjustment) is visible; where it is black,
it is hidden.** By default, new masks are entirely white: that is, the layer is
completely visible.

Masks are often created from selections. Selections define a region
of an image and these can be converted into masks. You will learn to use
Selections to create masks in the section on Localized Adjustments in the
Workflow chapter. Masks can also be painted with black or white using the
Brush tool.

Masks are a vital part of Photoshop, though you'll often find yourself
painting a mask actively in the Image Window, but you won't see the black
or white paint: just the image appearing or disappearing! A glance at the
Layers palette will reveal that the mask has indeed been changed.

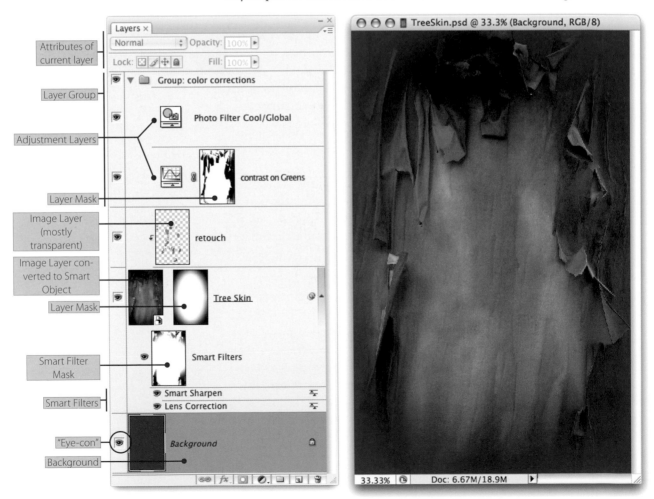

A Look at the Layers Palette

Look at the layers used to create this image.

1. The main image, the picture of the tree bark, was originally the **Background**. However, it was converted to a **Smart Object** (so filters could be applied nondestructively) and renamed "Tree Skin."

2. Two filters, Smart Sharpen and Lens Correction (to add a dark vignette), were applied to the Tree Skin Smart Object.

3. To limit the extent of those filters, the **Smart Filter Mask** was painted with black in areas.

4. A new Image Layer was added and brought below the Tree Skin layer. It was filled with a dark green and made into a new Background for the document.

5. A blurry, oval mask was added to the Tree Skin layer so the new background could be seen around its edges. The Tree Skin layer appears to fade away near the edges, especially at the corners

6. Finally, two Adjustment Layers were added: one to increase contrast, but masked to affect only the greenish areas, and the other to "cool" the whole image a bit, as it was just a little too reddish overall.

The Layers palette shows the status for all the layers in your image.

As illustrated, the Background layer is always labeled Background. It is a special type of Image Layer. There can be only one, it must be at the bottom of the Layer Stack, and it can have no mask. Its presence is actually optional for the PSD and TIFF formats, but for other file formats (e.g., JPEG) it is the only layer that can be present. More on these formats and their limitations later.

Each Image Layer has its own thumbnail displayed to the left and any associated mask, if there is one, to the right.

The active layer (the one currently selected) is highlighted. Any edits you make apply only to the active layer. You can select more than one layer at a time, but only some edits, like movement and scaling, can be applied to more than one layer simultaneously.

Each Adjustment Layer has a thumbnail icon representing the type of adjustment it is to the left, and its associated mask to the right— by default all Adjustment Layers have a mask filled with white (and therefore are active everywhere).

The eyeball to the left of each layer is sometimes called the "eye-con." Click it to make its layer visible or invisible. **<option>**+click/**<Alt>**+ click on the eye-con for any layer and all *other* layers toggle their visibility.

Many readers of this book may already be comfortable working with layers. But, there is always something new to be learned, even for very experienced users.

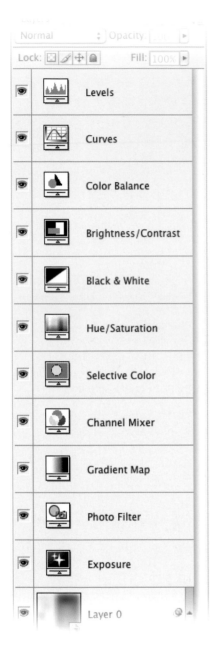

Adjustments

You can apply the basic adjustments to your background image directly by using the individual adjustment tools; these are found under the Image > Adjustments submenu. These tools apply their adjustments to the image's pixels. Once the adjustment is applied, the image is changed; these changes are irrevocable once the image is saved and closed.

Adjustment Layers

You can also apply many of the same adjustments using Adjustment Layers. These act as filters over your image to apply the adjustments as the image is viewed (or printed), but do not actually alter the underlying image. The Adjustment Layers can be created under the New Adjustment Layer submenu. Many of the adjustment options available under Image > Adjustments have a corresponding Adjustment Layer available under Layer > New Adjustment Layer.

Note: Whenever possible, it is best to apply Adjustment Layers rather than applying the adjustments directly to the image—select the Layer > New Adjustment Layer menu, not the Image Adjustments menu.

When you first create an Adjustment Layer, Photoshop displays the **New Layer** dialog so you can provide a name for the Adjustment Layer. Name your layers based on the Adjustment task that it will perform on your image—something like "Brighten" or "add Contrast"—this makes it much easier to find the appropriate Adjustment Layer when you are editing the image at a later time. Once you have named the new layer, the appropriate adjustment dialog will appear and allow you to apply that adjustment. Selecting OK creates the Adjustment Layer and applies the adjustment.

The new Adjustment Layer will appear on the Layers palette. Each type of Adjustment Layer has an associated icon to identify it. You can turn the adjustment on or off for each layer by clicking on the 'eye-con'. Each Adjustment Layer also has an associated mask. These are completely white (the adjustment evident everywhere) by default, but can be mixed black and white to localize where the adjustment should be applied.

One significant advantage of Adjustment Layers is the ability to return to the adjustment dialog and fine tune your adjustments. This is often referred to as 'non-destructive' editing; since the underlying background image is not actually changed by the Adjustment Layer, just the combined displayed or printed image. To change the adjustments in an Adjustment Layer, double-click on the layer icon for the Adjustment Layer that you wish to edit. The adjustment dialog will appear, showing the previously applied adjustment. You can then fine tune your adjustment. Using multiple Adjustment Layers, it becomes easy to apply each adjustment, and then go back and edit each one until the cumulative effect creates the desired results.

You will use Adjustment Layers significantly in the Basic Adjustments and Localized Adjustments sections of the Workflow chapter.

Some Notes on Layers

Selecting the Image or the Mask One of the biggest confusions many new users have with Photoshop is determining if a layer or its associated mask is selected. It isn't very obvious in the Photoshop interface.

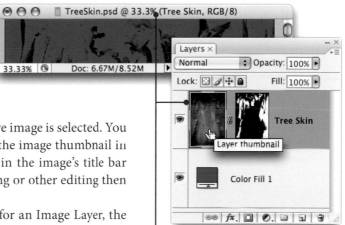

If you click on an image thumbnail, its respective image is selected. You can tell by the addition of a thin black line around the image thumbnail in the Layers palette and by a 'color-mode' reference in the image's title bar —typically "RGB," "CMYK," or "Gray." Any painting or other editing then directly changes the image part of the Image Layer.

If you click on the associated mask thumbnail for an Image Layer, the mask is selected. You can tell by the addition of a thin black line around the mask thumbnail in the Layers palette and by a "Layer Mask" reference in the image's title bar. Any painting or other editing then directly changes the associated mask of the Image Layer.

Since Adjustment Layers have no image, if you click on an Adjustment Layer thumbnail, its mask will be selected. Any painting or other editing then directly changes the the Adjustment Layer's mask.

Note the subtle border around the Layer thumbnail (above) and the Layer Mask thumbnail (below). Less subtle is the identifier in the title bar of the image.

Inadvertently editing the wrong "selected" element (image vs. mask vs. adjustment) is probably the number one problem many people encounter when editing images in Photoshop. Don't worry, though, if you

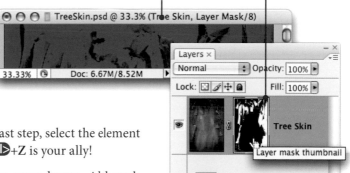

happen to edit the wrong element. Just undo the last step, select the element you really want, and repeat the edit. ⌘+Z/Ctrl+Z is your ally!

Naming Layers It is very important to name your layers. Although Photoshop assigns default names to all layers like "Background copy" or "Curves 1," these provide little useful information. Assigning your own useful names makes it easier to find and edit the appropriate layers later. If you create or duplicate a layer using the menu (or the keyboard accelerators listed on the menu), Photoshop provides you with a dialog to name the layer before creating it. Even if you end up with a default name for your layer, double-click it and Photoshop will let you rename it.

Copying Layers Drag and Drop! It is possible to copy a layer from one image onto another image merely by dragging the layer from the source image's Layers palette and dropping it onto the destination Image Window. You can also copy a layer from one image to another by selecting the layer in the source image and using the Layer > Duplicate Layer command. In the

Duplicate Layer dialog, change "Destination Document" to the destination image.

Layers Palette Buttons Along the bottom of the Layers palette are several button icons you can use to quickly edit your layers.

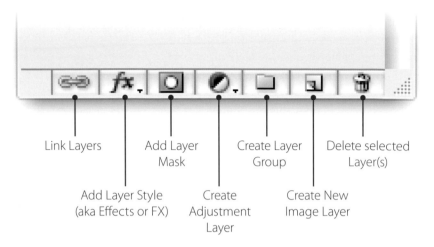

Click on the **Trash button** to delete the currently selected layer(s). Or you can drag a layer to the trash button to delete it.

Click on the **New Layer button** to create a new Image Layer. Or you can drag any layer to the New Layer button to make a copy of it. Hold down the <option>/<Alt> key when dragging a layer to this button and Photoshop will give you a dialog to name the new copy.

Click on the **Adjustment Layer button** to get a pop-up menu for the Adjustment Layers available in Photoshop. Select one to create it. Hold down the <option>/<Alt> key when selecting an Adjustment Layer and Photoshop will give you a dialog to name the new Adjustment Layer.

Click on the **Mask button** to create a new mask. Photoshop creates a mask that is either white everywhere or a mask that mimics a selection if you have a selection on the image. You only need to create a mask for Image Layers, since Adjustment Layers automatically have an associated mask. If your Image Layer already has a mask, it is possible to create another mask (a vector mask), but don't do it! Usually, one mask is enough.

Layer Styles and **Linked Layers** are advanced topics not covered in this book.

Smart Objects

Adjustment Layers are great: they can be applied, revisited, and removed if you change your mind. The same can not be said of Filters and a few other features (such as the correction tool called Shadow/Highlight) unless you convert Image Layers into a Smart Object.

However, if you convert one or more layers to a Smart Object, then you can enjoy the same non-destructive editing with these traditionally pixel-destructive tools.

To see what we mean try the following experiment:

1. Open an image in Photoshop. Duplicate the image by choosing Image > Duplicate (give the file a name with the word "smart" in it). Return to the original image.

2. Go to the menu command Filter > Blur > Gaussian Blur. Choose a blur "Radius" of 20 pixels then click OK.

3. Go to the duplicate file. The image will likely be on a **Background**.

4. Convert that **Background** to a Smart Object: <control>+click/ Right-click on the Background layer's name in the Layers palette and choose Convert to Smart Object.

5. Now for this Smart Object, Go to Filter > Blur > Gaussian Blur. Choose a blur "Radius" of 20 pixels then click OK.

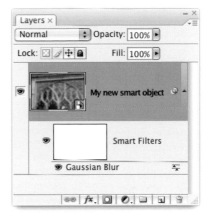

What you should see is the Gaussian Blur listed below the Smart Object's name. That makes it a **Smart Filter**! If you change your mind about the strength of the blur, just double click on the name of the filter, and you can change it. Click on the "eye-con" to turn the filter on and off.

Remember, you can select several layers then convert them all to a single Smart Object. If you later wish to edit any one of those layers, you can double-click on the Smart Object's thumbnail. After a startling dialog box, you will see a new, temporary document containing those original layers. When you've finished editing them, simply chose File > Save and File > Close. Your Smart Object will update, and any Smart Filters you applied will automatically update, too.

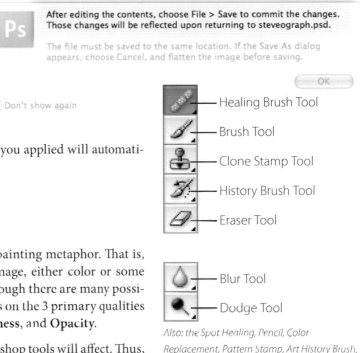

Photoshop "Painting" Tools

There are several tools in Photoshop that use a painting metaphor. That is, as you click or drag your cursor across your image, either color or some other effect builds up where you've done so. Although there are many possible configurations of brush settings, we will focus on the 3 primary qualities that brushes for all these tools share: **Size**, **Hardness**, and **Opacity**.

A brush defines the image area that certain Photoshop tools will affect. Thus, a brush appears as a circle as you move the cursor over the image. The ability

Adobe Photoshop

After editing the contents, choose File > Save to commit the changes. Those changes will be reflected upon returning to steveograph.psd.

The file must be saved to the same location. If the Save As dialog appears, choose Cancel, and flatten the image before saving.

Don't show again

OK

— Healing Brush Tool

— Brush Tool

— Clone Stamp Tool

— History Brush Tool

— Eraser Tool

— Blur Tool

— Dodge Tool

Also: the Spot Healing, Pencil, Color Replacement, Pattern Stamp, Art History Brush, Background Eraser, Magic Eraser, Sharpen, Smudge, Burn, and Sponge Tools.

to edit the brush quickly and easily makes overall editing much easier. The basic techniques for manipulating brushes are so important that we have listed the steps here and refer back to them whenever we introduce a new tool that uses brushes.

Brush Size

When you move a brush over your image, Photoshop displays a circle that represents the size of the brush. If the brush is very small, Photoshop displays a small crosshair. You can change the brush size most easily by either a <control>+**click**/ <Right-click> and dialing in a size in the dialog box that appears, or by using the square bracket keys, "[" (for smaller) *or* "]" (for larger).

Once you get accustomed to the keys, it becomes much easier to select an appropriate brush size.

Brush Hardness

Sometimes you will want the "paint" to blend into what's already there, and sometimes you'll want to produce a nice hard edge. To control this, you will have to set an appropriate Hardness for the brush, from 0% for very soft to 100% for a sharper edge. You can also give your brush a harder or softer edge by pressing <Shift>+ [*or*], or using a <control>+**click**/ <Right-click> then dialing in a hardness value in the dialog box that appears.

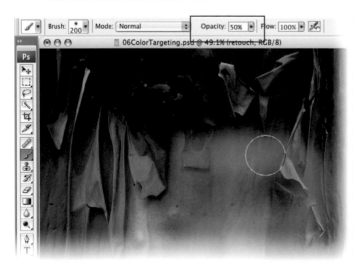

Brush Opacity

There are times you'll want to apply a brushstroke lightly or heavily. In general, do not change brush color to change density—rather, change brush opacity. When using the Brush tool, opacity represents the amount of color a brush puts down as you drag the cursor across your image. By changing opacity, you change how thickly you apply the color with the brush: 10% opacity for very thin coverage, 50% for heavier coverage, etc.

The opacity level is changed via the Opacity slider in the Options Bar, or by pressing the number keys: 1 for 10% opacity, 2 for 20%…up to 9 for 90% and 0 for 100%. When you press these keys, note how the brush opacity changes in the Options Bar. For the Brush Tool, this is literally the opacity of the stroke, for tools like the Blur Tool, Opacity is a measure of the intensity of effect.

The Brush Tool: Color

The Brush Tool uses the Foreground color as its paint color; interestingly, the Eraser Tool uses the Background color as its color. We'll see later how the best colors for painting are sometimes the default colors of humble black and white. Use the **D** key to set the default colors. With these colors, you will commonly paint on layer masks.

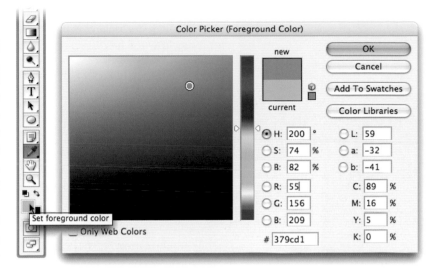

If you need to switch the Foreground and Background colors, use the **X** key, or the small, two-headed arrow between them.

If you click on the foreground or background color squares, Photoshop will display the Color Picker. Use this to select colors. When the Color Picker is open, click on a Hue from the bar of color near the center, then choose from the large square on the left how light (top to bottom) and how saturated (left to right) a color you want. Remember: the Color Picker almost always requires these two clicks. On the right are fields where you might enter numerical values for colors.

A Simple Exercise with the Paint Brush:

1. Select the Brush tool—simply press **B**.

2. Move the cursor over your image and you'll see a circle, i.e., the brush. Resize the brush using the [or] keys.

3. Click on the Foreground color and choose a color from the Color Picker. Click OK, then paint with the brush on your image. Change the hardness of the brush edge using **‹Shift›**+[or].

4. Change the Opacity using the number keys. Paint some more. Click on the Background color and choose a color. Click OK. Switch between the Foreground and Background colors by using the **X** key. Reset your colors back to the defaults by clicking the **D** key. Even with a low opacity value, you should be able to paint a part of the image to pure black or pure white by repeatedly painting over the same spot.

5. Next create a new Adjustment Layer; Color Balance is easy to try. Select Layer > New Adjustment Layer > Color Balance. Name this new layer 'Lots of Red'. In the Color Balance dialog, make a strong adjustment by adding lots of red. Hit OK to close the dialog.

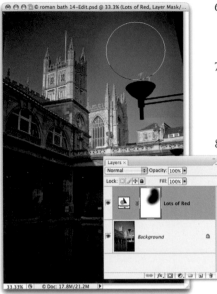

6. The image will now appear very red. The 'Lots of Red' layer will also appear in the Layers palette, and the Title for the Image window will include the text (Lots of Red, Layer Mask).

7. Use the paint brush tool to paint on this layer mask. If your brush color is white, you'll merely be painting white onto a white mask, so start with a black brush. Remember, pressing X switches the fore and background colors. You should be able to mask the red adjustment.

8. Experiment with changing the brush size, the brush edge hardness, the brush color and the brush opacity. Notice how using a soft edged brush and a moderate opacity can make the painted edges appear softer.

Make a habit of using the keyboard shortcuts mentioned in this section as you work with the brushes so you won't need to move your mouse away from the image with every change. This will make editing a breeze.

Basic Adjustments

Histograms

The Histogram is one of the key tools in digital imaging. It provides a graph of the density values of an image. The histogram shows the number of pixels at each particular density value. The left-most point of the Histogram is pure black (very dense), the midpoint gray, and the right-most point pure white (no density). A big peak in any of these regions means the image has lots of pix-

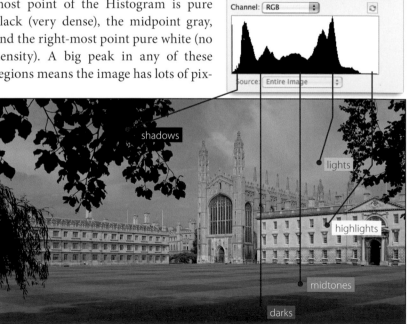

els at this density; an open gap in the histogram means there are no pixels at this density.

Use the distribution of the histogram to determine the overall exposure of an image. The rule of thumb is that most images look best if they contain values at both the dark and light ends. Without some dark and light values, the image may lack contrast and appear flat. If you have a strong peak at the bright or dark end of the histogram, it's possible your image is over or underexposed. Much depends on the individual image and personal aesthetic.

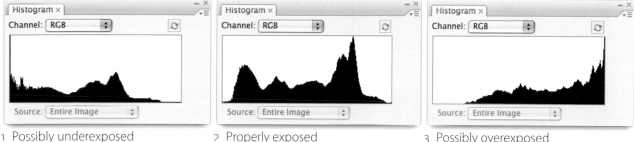

1 Possibly underexposed image, or a darker subject

2 Properly exposed

3 Possibly overexposed image, or a lighter subject

The Histogram is also used to depict the smoothness of tones in an image. The illustrations above show from left to right:

1. A Histogram representing an image that is likely underexposed, and therefore dark.

2. A smooth Histogram representing an image with a full range of tones. You can edit this image extensively without concern.

3. A Histogram for an overexposed image, and therefore light.

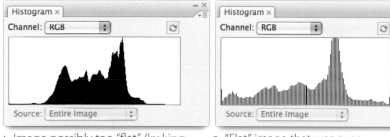

4 Image possibly too "flat" (lacking contrast), or just a foggy day

5 "Flat" image that was over-corrected; now posterized

4. A Histogram representing an image that is likely too "flat", and therefore possessing neither highlights nor shadows

5. A Histogram with a comb-like appearance representing an image with sparse tones. This image may appear blotchy or posterized especially when printed.

The histogram palette provides a real time histogram of the active image as it is being edited. Typically it docks behind the Navigator palette—click on the histogram tab to bring it forward. Here are a couple of tips to keep in mind when using this tool: First, make the histogram display as large as possible. Do this by opening the histogram palette menu and selecting Expanded View. Second, the histogram palette uses cached data to update the histogram in real-time, but this cache quickly gets out of date and inaccurate. When this happens, Photoshop displays a cached data warning icon. Click on this icon to update the palette and get an accurate histogram.

Finally, the Histogram immediately shows the effects of an adjustment on the image. New adjustments made to the image appear in black overlaying the old ones which appear in gray. This real-time feedback allows for quick decisions on how much to edit your image.

Levels

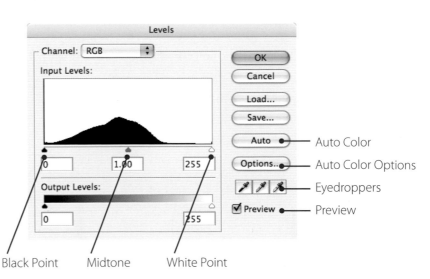

Black Point Midtone White Point

To refine an image to full contrast, and to adjust the image brightness, use the Levels Adjustment tool. It's the best tool for defining black and white points, making the overall image lighter or darker, and doing color correction. To access the Levels dialog, select Layer > New Adjustment Layer > Levels.

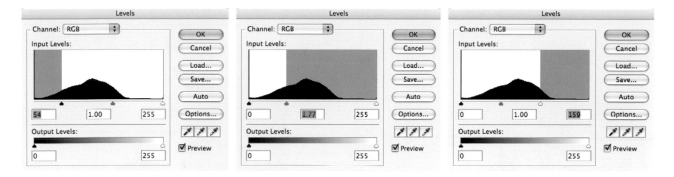

As illustrated, the Levels dialog contains a histogram with slider controls. You'll learn more about the use of the sliders with individual-channel histograms, color, and eyedroppers in the Advanced Options chapter. For now we'll only address the operational function of:

▸ The Black-point slider

▸ The Midpoint slider

▸ The White-point slider

The black-point slider can be moved to set dark pixels to pure black. All the pixels represented in the histogram directly above the black-point slider (and those to its left) will be changed to pure black, and all the other pixels in the image will be shifted darker towards the black point, making the image darker.

The white-point slider similarly sets the pure-white pixels and makes the image brighter.

Adjusting both the black & white point sliders stretches the image towards both the black and white ends, resulting in an increase in image contrast.

The midpoint slider sets the middle-gray pixels. At the same time, it sets all the pixels to the left darker than middle gray, and those to the right brighter than middle gray. This may seem counter intuitive since you slide the midpoint slider towards the white slider to make the image darker, but the image preview displays the change to the image as you adjust it.

The preview checkbox is key to all the dialogs in Photoshop. Turn it on to see the effect of the current dialog in the image window, and off to see the image before this effect. (Windows toggles this action via alt+p.) This is great for checking out subtle changes to your image before you save them.

The Levels dialog is commonly used with two basic adjustment types: setting black and white points and changing image brightness.

The Black & White Point adjustment is very simple: merely drag the black and white point sliders in far enough so the image has some black pixels and some white pixels. This is often the single best adjustment you can make to an image since it ensures good overall contrast.

A Brightness adjustment using Levels is also very simple: merely drag the midpoint slider to the left or right to alter overall image brightness.

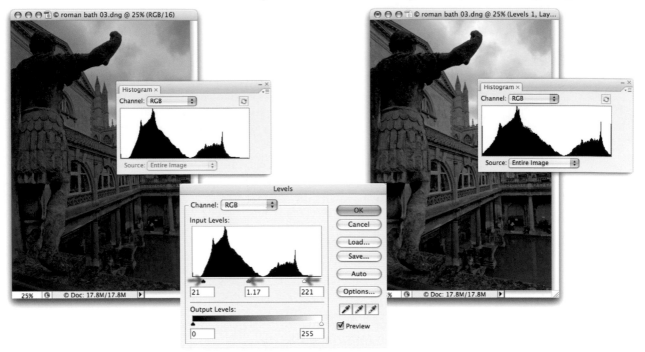

One of the advantages of the Levels adjustment is it allows changes to the brightness of midpoint pixels without major changes to shadow (black) or highlight (white) pixels.

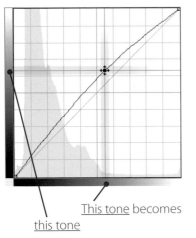

This tone becomes
this tone

Curves

To refine your image tones with more precision use the Curves Adjustment tool. The Curves tool is commonly used to add contrast to the image and to make precise adjustments to individual tones in the image.

To access the Curves dialog, select Layers > New Adjustment Layer > Curves.

When the Curves dialog is opened, the default curve is a straight line. The straight line maps the input values to the output values leaving the image unchanged. The horizontal axis is the input values for the tones; the vertical axis is the output values. The tones are displayed on the bottom and left of the curve as a black to white gradient. Use this gradient to visualize the various tones as you adjust your image.

To make a simple curve, click on the curve line to create an adjustment point, and drag the point upward. (Note: You can also use the keyboard arrow keys to move adjustment points.) This is a classic brightening curve.

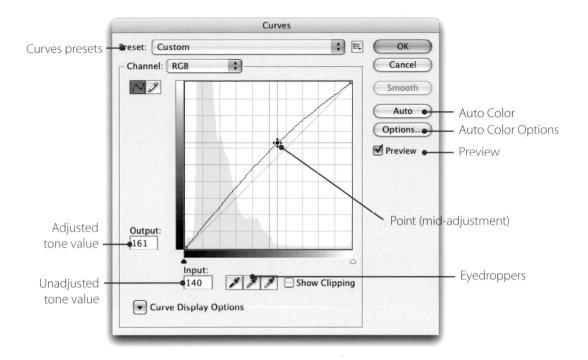

Curves presets →

Adjusted tone value → Output: 161

Unadjusted tone value → Input: 140

Auto Color

Auto Color Options

Preview

Point (mid-adjustment)

Eyedroppers

Click on another part of the curve to add a second point and drag it around to see the effect on the curve. Points can be removed simply by dragging them outside of the curve box.

In grayscale images, Photoshop reverses the direction of the input and output gradients (from light to dark rather than dark to light), so the metaphor for pushing the curve upward is that you're adding ink rather than light. Expand the Curve Display Options at the bottom of the dialog box, then check the button to Show Amount of Light (0 255) to switch the direction of the gradient. We most often prefer that metaphor.

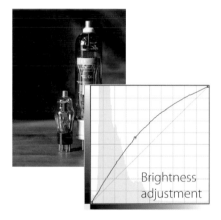

Brightness adjustment

Some Sample Curves: There are many different types of edits you can perform with the Curves tool. In fact, some Photoshop gurus claim they can do almost everything using Curves. Here are a couple of basic examples for changing image brightness and adding contrast.

To change image brightness, open the Curves dialog (create a Curves Adjustment Layer), click near the center of the Curve line to create a point, and drag the point up, just like in the illustration above. This makes the pixels in the image brighter.

To add contrast to the image, open the Curves dialog, click on the curve to create a point at the quarter tone of the image (about ¼ of the way from the white point) and another at the three-quarter tone of the image (about ¼ of the way from the black point). Move the quarter-tone point upward

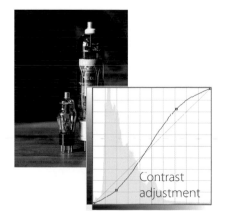

Contrast adjustment

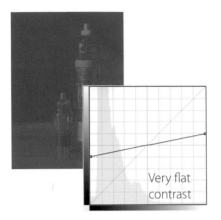

Very flat contrast

(brightening the brighter pixels of the image). Move the three-quarter point downward (darkening the darker pixels of the image). Now we have a classic "S-curve." Contrast is added by darkening the dark pixels and lightening the bright pixels. The result is a curve that is steeper through the midtones.

The S-curve preserves the values of the black and white points in the image—it doesn't push any pixels to pure black or pure white.

Very small adjustments made in the Curves dialog make very significant changes to the appearance of your image. The Curves tool is all about subtlety—often less is more when using Curves. Once again, the Preview option proves invaluable. Toggle it on and off to check out the effect of these subtle changes.

Finally, try moving the white point straight down almost halfway, and the black point up almost halfway. The "curve" is now almost a flat line. The image has almost no contrast. Could this be why a low contrast image is referred to as "flat"?

Color Balance

To refine the image's overall color balance and eliminate any color cast, use Color Balance. With this tool you can add or remove Red, Green, and Blue from the image pixels.

To access the Color Balance dialog, select Layers > New Adjustment Layer > Color Balance…

Color Balance actually makes a lot of sense once you understand the basic color wheel theory used in photography and digital imaging. In photography and in computers, color is created by mixing Red, Green, and Blue values from the RGB color wheel. (You may have heard of other color wheels used in painting.) Colors complementary to Red, Green, and Blue are Cyan, Magenta, and Yellow—so changes in R, G, & B also force changes in the values in C, M, & Y. It follows then that adding one color automatically implies removing its complement. Adding Red is the same as removing Cyan.

Color Balance is therefore very simple to use. If your image has too much Green overall, then add Magenta (and remove Green) by moving the

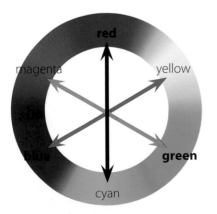

slider between Magenta and Green left towards Magenta. Be careful when using Color Balance to identify the various color cast in your image. Often what appears as a Blue cast (especially blue in shadows) is actually a Blue/Cyan cast, which requires adding Yellow and Red.

Color Balance also allows you to adjust the colors based on the overall image tone. By default, the tone balance is set to "Midtones," so that color changes appear strongest at the Midtones, and weaker in the Shadows and Highlights. This setting works best for applying overall changes to the image color balance. It is also possible to make color changes that are localized to the shadows or highlights in your image by switching to 'Shadows' or 'Highlights'.

Color Balance is useful in order to learn the basics of editing color in digital images.

Ironically, Color Balance isn't necessarily the best tool to use for performing color balance. In the Advanced Options chapter, you will learn to use the Levels tool for more precise color adjustments.

Hue/Saturation

To make changes to individual colors in the image, use the Hue/Saturation tool. With this tool you can make changes to individual ranges of colors in the image; e.g. you can change the cyan pixels to make them bluer, or you can change the red pixels to make them more saturated. This is a powerful tool to make subtle but effective changes to colors.

Digital colors are typically represented by values of red, green, and blue (RGB). Colors can also be represented by values of Hue, Saturation and Lightness (HSL). The Hue provides a value for the shade of the color (red, orange, yellow, etc.) and the Saturation a value for the intensity of the color.

As the Color Balance dialog allows changes to R, G, or B values, the Hue/Saturation dialog allows independent changes to Hue, Saturation, and Lightness values.

To access the Hue/Saturation tool, select Layers > New Adjustment Layer > Hue/Saturation…

When the Hue/Saturation dialog is opened, it defaults to editing all of the colors in the image. Adjusting the Saturation slider increases or decreases the saturation for every color in the image. Adjusting the Hue slider shifts the color of every color in the image; usually, this is not the desired result. Adjustments to Hue shifts the adjusted colors around the color wheel—in the example shown, blues are shifted to purple, reds to yellow, yellows to green, and so on. The color bars at the bottom of the dialog display these color shifts.

The Hue/Saturation tool becomes much more powerful when it is localized to affect only a narrow range of colors. Change the Edit option from 'Master' to one of the listed colors. Now a range is displayed between the color bars.

Increasing saturation

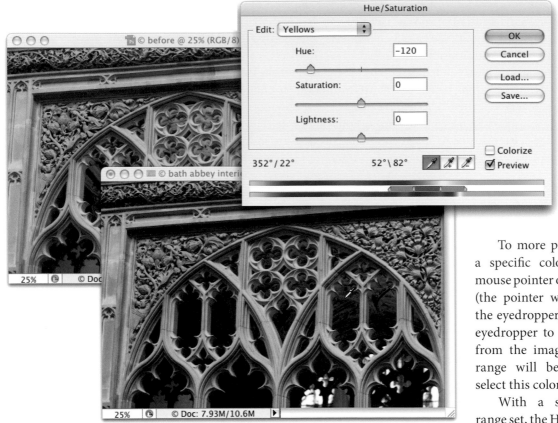

To more precisely select a specific color, move the mouse pointer over the image (the pointer will change to the eyedropper), and use the eyedropper to select a color from the image. The Color range will be adjusted to select this color.

With a specific color range set, the Hue/Saturation tool becomes a much more effective color editor. Adjustments to Hue, Saturation & Lightness will only affect the specified color range.

The Hue/Saturation tool is very powerful for making subtle (or not so subtle) changes to individual colors by changing the hue, saturation, or lightness of the color. For example, you can make the orange interior purple (as above), or make a cyan sky bluer, or make blue water more saturated, and so on. It is common to create many different Hue/Saturation Adjustment Layers on a single image that each make small color adjustments.

The Hue/Saturation tool can easily be overused. Small changes to hue, saturation, or lightness can be fairly dramatic. Be subtle.

Looking Deeper

(Everything you ever really wanted to know about bits but were afraid to ask). This section covers the technical details of how computers deal with digital images. Many people just want to skip the technical details because they are about the geeky inner workings of the computer. But it is useful to have a basic understanding of how Photoshop 'sees' your digital image. We'll break down these details into a fairly straight-forward glossary of terms: Digital Images, Pixels, Resolution, Bits, etc. As much as software engineers try to hide the technical details of image editing, these terms still popup over and over again in digital photography. You may already know many of the details of computers, but review the terms as we define them here anyway. They're often used incorrectly in regard to digital imaging.

A Digital Image

Computer software programs (including Photoshop) see digital images as a rectangular array of pixels. Each pixel (a shortening of "Picture Element") is merely a tiny square of color. This image of ornate stonework is composed of an array of 511 x 332 pixels—or 169,652 pixels. A typical digital camera image often has at least 2000x3000 pixels—or 6 Mega-pixels. Most digital images contain millions of pixels—thus the common term "Megapixels."

Summary: Digital images are merely a rectangular array of pixels that represents an image. Digital images typically contain millions of pixels.

Pixels

Pixels are, therefore, the most basic element of a digital image—a small square of color. If you've ever seen a mosaic, you get the idea. In the computer, however, pixels are no more than a simple set of numbers used to describe a color. For most images, each pixel contains a Red (R), Green (G), and Blue (B) value. The computer uses these RGB values to create the color for that particular pixel. Grayscale images don't use RGB values. They use only one number for each pixel to represent the density of black. It is useful to remember that computers only think in terms of number values—and an image is broken down into an array of simple numbers for each pixel.

Summary: Pixels are simple, square elements that make up a digital image. Pixels exist only within the computer and contain simple numbers that describe its color.

Image Size

The size of a digital image is referred to in several different ways. The most informative, and least common, method is to refer to its horizontal and vertical dimensions—a typical image might have a size of 2000 x 3000 pixels. This provides information about the shape of the image as well as its size. But the most common way to refer to image size is to refer to its overall number of pixels—multiplying the horizontal by the vertical dimensions; which in this example results in 6,000,000 pixels or 6 megapixels.

Finally, it is also common to refer to image size in terms of megabytes. Traditionally, computers used 3 bytes of information to store one pixel. By multiplying the number of pixels by 3, you get the size in megabytes (MB), or 18MB in this example.

Dots & Sensors

What about the resolution of pixels in scanners, digital cameras, monitors, and printers? Although the term "pixels" is often used in regard to these devices, it is best to use "sensors" for input devices or "dots" for printers. Usually, scanners and digital cameras produce one pixel for each sensor, but not always. And usually, printers print many dots for each pixel. The following examples illustrate these phenomena. Since a typical scanner might have 3000 sensors per inch, scanning a 1" x 1½" piece of film produces a digital image of 3000 x 4500 pixels. Similarly, a printer doesn't print with pixels, but rather converts pixels into ink dots that are sprayed onto the paper. There are almost always significantly more ink dots printed per digital image pixel. Thus, a printer with a resolution of 2880 *dots* per inch (DPI) prints an image with only 300 *pixels* per inch (PPI). In practice, the term "DPI" is commonly used for the resolution of a wide number of devices. We can't change the usage of this word completely, but remember there is a difference between the computer's "pixels", the scanner's and camera's "sensors", and the printer's "dots."

Summary: Pixels are not the same as Dots & Sensors: Even though "Pixel" and "Dot" are commonly used interchangeably, pixels actually exist only within a computer.

Resolution

A convenient way to understand resolution is as the density of pixels in an image. We might express this as 300 pixels per inch or 115 pixels per centimeter.

Remember, our objective is to transform a physical image into a digital image and, likely, back into a physical image (i.e., take a piece of slide film, scan it into the computer creating a digital image, edit the digital image,

and print it back out to paper). To generate an acceptable print, we need to send a sufficient number of pixels to the printer for each inch or centimeter of dots it will produce.

For example, our image of 2400 x 3600 pixels image "maps" to a size of 24" x 36" at 100 pixels per inch—or to a size of 8" x 12" at 300 pixels per inch. Resolution is further complicated by the difference between dots and pixels. Typically, scanners produce an image with one pixel for each scanner sensor. But, as noted previously, printers almost always print with many more dots than pixels; often 6, 8, or more dots print for each pixel in the digital image.

Here's a concrete example demonstrating the transformation of a piece of 35mm film to a larger printed image:

The 35mm film has an image area of about 1" x 1½". If your scanner scans at 2400dpi (dots per inch, sensors per inch) and produces a file with 2400ppi (pixels per inch)—that's one pixel for each dot/sensor.

1" x 1½" at 2400ppi produces a file of 2400 x 3600 pixels.

Once this file is in Photoshop, you can edit it without regard to the resolution—it is always a 2400 x 3600 pixel image.

To print an 8" x 12" image, change the image resolution to the printer resolution of 300ppi, a typical printer resolution. The image is still 2400 x 3600 pixels, even though the printer might print at 1200dpi (here four *dots* for each pixel).

1 inch

Scanned at 2400 ppi
2400 pixels x 3600 pixels

Digital Image

Resampling/Interpolation

But, what if you want to print an image that is 4" x 6" instead of 8" x 12"? By changing the digital image size to 1200 x 1800 pixels, the image prints at 4" x 6" at 300ppi. Changing the actual number of pixels of a digital image size causes Photoshop to resample (or interpolate) the image. In other words, Photoshop takes the existing pixel information and estimates the appropriate pixel colors for the same image with the new image size. Interpolation is a good thing; it makes it possible to change the size of the image from various source sizes (different film sizes, different scanners, or different digital cameras) to various output sizes (different print sizes, different printers, or the web). Photoshop is generally very good at interpolating digital images.

Native Resolution

Often, when we discuss interpolation, many people suggest that they can avoid interpolation merely by changing the scanning resolution and/or the printing resolution. For the 2400 x 3600 pixel example—couldn't you also change the print resolution to 750ppi if you wish to print a 4" x 6" image? The math is correct, but most digital imaging devices (like scanners and printers) only operate at a single fixed resolution—their native resolution.

8 inches

Printed at 300 **ppi**
or 1200 **dpi**

For scanners, the native resolution is based on the number of actual dots in the scanner. A typical film scanner has a 1" wide sensor with 3000 actual dots for measuring light across the sensor. The software for most scanners allows you to set the resolution to any value, but the scanner merely scans at its native resolution and then interpolates to the resolution you set. Similarly, most printers only print at a resolution of 300ppi. But, if you send the printer a digital image at a different resolution, the printer software will interpolate to 300ppi. In almost all cases, Photoshop does a better job of performing this interpolation. Don't interpolate in the scanner or printer software—do it in Photoshop.

Many professional scanner or printer operators disagree and recommend scanning at the specific resolution for the target print or sending a file with any resolution to the printer. In the case of very expensive scanners or printers (in the $100,000 range), this is true—the issues of native resolution don't apply rigidly. But the vast majority of desktop scanning and printing devices have a single native resolution.

Channels/Color Models

The red, green, and blue (RGB) parts of the color image are separated into three distinct images referred to as "channels." Typically these are displayed in grayscale. You can see the channels for your image by selecting the channels palette in Photoshop.

Understanding RGB is understanding color photography itself. Imagine three slide projectors shining light onto a screen. One has a red light bulb, the second a green light bulb, and the third a blue one. The three lights overlap partially (*see illustration*). Where the red and green lights overlap, the combine to form yellow. This is not like pigment! Notice the colors where any two lights overlap. You might think of these (cyan, magenta, and yellow) as the sum of two colors, or as the absence of the third.

If something were to block one of the lights, for example the blue one, the shadow would either be completely dark or filled in by one or both of the other lights. If the item casting the shadow was not completely opaque, then we'd be able to control the ratios of each light.

Imagine using black and white transparencies in each of these hypothetical projectors. Where each slide is dark, it blocks (or masks) the light. Now do the arithmetic: if the red-lit image is very light, and the other two dark, then the light that reaches the screen will be predominantly red. In Photoshop, each of these transparencies is represented by a channel.

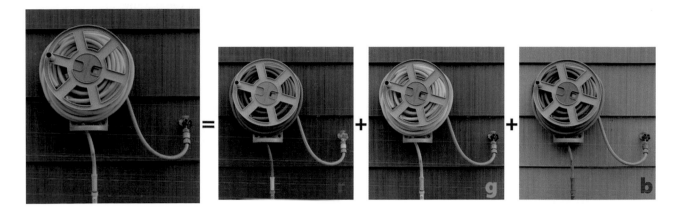

In the example above, each of the three channels is shown. The red handle is lightest on the red channel, the hose is lightest on the green channel, and the wall itself is lightest on the blue channel. Since this is the way color photographs have been made for nearly 150 years, it makes sense that Photoshop should use the same method, even if it's just a software simulation.

RGB is just one of several color modes available in Photoshop. For photography, color digital images should (almost) always be in RGB mode. Digital cameras and scanners capture information in components of red, green, and blue. And most desktop printers, as well as many large professional photo printers, also work in components of red, green, and blue.

But, don't printers work in CMYK? Yes, generally most printers create colors by mixing CMYK inks—Cyan, Magenta, Yellow, and blacK. Cyan, magenta, and yellow are the complementary colors of red, green, and blue. And CMY inks need to be used to create colors when mixing ink onto paper. But the conversion from RGB images to CMYK images is something best left to your print professional if sending images elsewhere for printing. In the case of desktop printers, the printer driver only accepts RGB values and performs the conversion from RGB to CMYK within that printer driver. Don't worry about CMYK color mode—the printer driver or professional print shops deal with these.

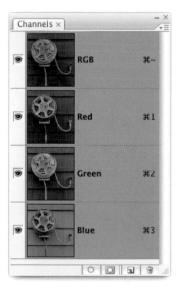

Note: For digital images, there are really only two important color modes: RGB and Gray. RGB has three color channels: Red, Green, and Blue. While the Grayscale only has one channel: Gray.

Bits and Bytes

Computers are binary devices. At the simplest level, all numbers within a computer are made up of bits. Bits can only have the values of 1 or 0; that is, yes or no. Bits are grouped together into bytes. There are 8 bits in a typical byte, providing a range of values from 0000 0000 to 1111 1111, or 0 to 255

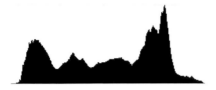

in decimals that we commonly understand. Traditionally, the color represented by a pixel is stored in three bytes—one each for red, green, and blue. This is the reason that Photoshop often represents the values of colors with the range from 0 to 255—the range of values for one byte. We'll see this range of 0 to 255 throughout Photoshop and digital imaging. A color pixel has three such numbers for each red, green, and blue; R100, G58, B195 is a rich purple. A grayscale pixel only has one number representing the density of the pixel from black to white.

The histogram in Photoshop becomes simply a graph of the number of pixels at each byte value from 0 to 255.

Today, it is very common for pixels to have more than one byte of information for each color in each pixel. We still refer to these colors as having the range of 0 to 255, but the second byte allows for more precision in each of these numbers. A one-byte color represents color from 0 to 255 in whole increments, but a two-byte color represents color from 0 to 255 with fine intermediate increments allowing such values as 58.55. Color can be described much more precisely with two bytes.

Bit Depth

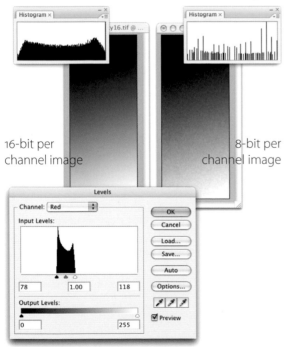

16-bit per channel image

8-bit per channel image

The number of bits used for each color channel in a pixel is referred to as the "bit depth." An image with pixels that uses one byte per channel (or 8-bits per channel) is referred to as an 8-bit image or as having a bit depth of 8 bits per channel. The vast majority of digital images have 8 bits per channel. This allows for 255 different values of each red, green, and blue or ideally 16 million possible colors. For the vast majority of printing or display options, this is more than sufficient for representing colors. But in the world of digital image editing, more bits are often desired. Scanners and digital cameras often create files with more than 8 bits per channel—each of these options provide the same range of values (0 to 255), but the extra 8 bits provide intermediate values for finer precision (i.e. values like 100.254 rather than 100). When editing images, it's possible that significant edits will result in operations that reveal the limited precision in 8-bit images. At left, a moderate field of blue has been expanded to cover densities from bright blue to dark blue. A version with 8 bits per channel doesn't have sufficient precision to display across this entire range of colors, resulting in an image with several discrete values of blue. This is often referred to as posterization. The version with 16 bits per channel has sufficient precision to edit across the full range of colors and display a smooth gradation of colors.

When scanning images or capturing digital camera images, it's best to try to create images with more than 8 bits per channel. Most scanners allow

for scanning at more than 8 bits. Digital cameras that support RAW files allow for more than 8 bits, as well. JPEG files only support 8 bits per channel. (This is the main limitation of using JPEG files for capture in digital cameras.) JPEG files still can be used for digital capture, but cannot be edited as well as RAW image files.

When devices with 12 bits, 14 bits, or 16 bits save files, they always save the files with two full bytes per color channel per pixel. These are all represented as 16 bits per channel when the files are opened in Photoshop. We refer to images as having 8 bits per channel (limited editing), or more than 8 bits per channel (edited freely).

Note: When editing in Photoshop, start with images that have a bit depth of 16 bits per channel.

Bit depth is also often referred to in terms of bits per pixel (bpp). If each pixel has three color channels, each with 8 bits, these images have 24 bits per pixel. Images with 16 bits per color channel have 48 bits per pixel. Bits per pixel (bpp) is often used incorrectly to mean bits per channel. Just remember that 8 bits per color/channel limits the type of image editing you can do, while more than 8 bits (i.e., 16 bits per channel) provides for very extensive editing.

File Formats for Digital Imaging

Photoshop supports a wide variety of file formats, but almost all image editing work will be completed with the formats described below. Most of the other formats are either outdated or of little interest to photographers. You can select the format for your image file by selecting File > Save As and selecting the file format from the Format option.

Photoshop (*.PSD)

Photoshop Document (PSD) is the standard file format for Photoshop. It stores all of the information for a Photoshop image, including Channels, Layers, Selections, and File Configuration. It's important to save a version of your image as a Photoshop file with all this extra information so you can retrieve it all when you open the file later. You should save all of your working files in PSD format. Only Photoshop (or other Adobe software) can read Photoshop files. Save your images in TIFF format if you wish to take them to another program or give them to someone else who may not have Photoshop.

Photoshop gives you the option to make the files smaller by eliminating a composite version of the image from the file. But some early versions of Photoshop (ver. 4.0 and earlier) and some non-Adobe applications that read PSD files cannot use these modified PSD files. When saving

Photoshop PSD files, Photoshop will provide you with a **Maximize Compatibility** option dialog. Note the text in the dialog. You can change the preferences (Edit > Preferences > File Handling on Windows or Photoshop > Preferences > File Handling on the Mac OS) so that you always generate the preview, and never see the dialog box again.

Photoshop PSD files can only support files up to 2GB in size. For the majority of images, this is sufficient. But in the real world of digital imaging, it is possible to have larger files. Photoshop supports larger files by using the Large Document Format (PSB). This format supports all of the features of PSD files, but also supports files of any size.

TIFF (*.TIFF, *.TIF)

Tagged Image File Format (TIFF) is the industry standard image file format. In many ways, a basic TIFF is just a big array of pixels stored in a large file. It doesn't usually contain much of the sophisticated information used in Photoshop (esp. Layers). TIFFs do contain color space information which is important for color management. Thus, TIFFs are a very safe way to save your image files since the image is saved in a lossless state, i.e., there's no data conversion caused by image file compression. Use TIFFs any time a file is used outside of Photoshop. TIFFs support images of both 8 bits and 16 bits per channel.

Adobe has added a new wrinkle to TIFF—saving layers. As far as we know, this extended version of TIFF is supported only by Adobe. We recommend saving TIFFs without layers.

One TIFF option allows compression of TIFF files. Check with your images' recipients before using these compression settings. Lempel-Ziv-Welch (LZW) compression can save much space on storage media, but isn't always supported. Don't use this option if you're worried about compatibility with other programs and systems. The other TIFF options aren't typically relevant.

JPEG (*.JPG, *.JPEG)

This is the format for compressed files. Most images on the Internet are saved in Joint Photographic Experts Group (JPEG) format, since they can be compressed to such small file sizes—at least 20:1—with little loss in *apparent* image quality. Compressions of 100:1 are possible, but result in significant loss of image quality.

All digital cameras have the option to save images as JPEG files which allows you to save many more images onto your camera's data card. But since this format only supports 8 bits per channel images, avoid using it for

capture. If your camera only supports the JPEG format, it's still workable.

Compression works best for smoothly toned images. Images of complex subjects do not compress well and lose detail if compressed. Keep this in mind when saving in this format.

JPEG files are essential for use on the Internet. Use JPEG for images on a website or email.

The JPEG Options dialog appears after you save you image. Set Image Quality to 9 - "High" for most files and to 6 - "Medium" for especially large files or relatively unimportant files.

JPEG Format Options should be set to Baseline for most images.

PDF Files

Photoshop has excellent support for Portable Document Format (PDF) files. These files can be viewed by anyone using the Adobe® Reader. Since the Adobe Reader is almost universally available, PDF files are an excellent way to send very high quality versions of your files to someone who may not have access to Photoshop or even a modest image viewing program. You can even add password protection for either opening the file or just for printing or editing.

DNG & RAW Files

Many digital cameras can also save their images as RAW files. These are unprocessed digital camera images. Photoshop can process them to a higher-quality image than JPEG files. One of the biggest advantages of RAW files is that they have more than 8 bits per channel of information and can therefore be edited more than JPEG files. Every camera manufacturer has its own proprietary RAW file format—the term RAW refers to a category of file formats. It encompasses a wide range of formats include NEF (Nikon RAW), CRW (Canon), as well as many other formats. Adobe Photoshop CS3 supports most RAW file formats. Unfortunately, that support does not extend to adding metadata or saving into these manufacturer-proprietary formats. For that, there is the Adobe Digital Negative (DNG) format. Unless you use DNG, metadata, for example, will have to be saved into an accompanying "sidecar" file—a risky situation at best.

Therefore we recommend converting manufacturer specific RAW files into Adobe's opensource DNG format. Adobe has pledged to be the "steward" of this format in much the same way they have for TIFF. Files you save in this format can be safely archived as they will be able to be opened by Adobe applications far into the future.

DNGs will contain all the important data of your camera's RAW file and will not require any support files as they are processed or have metadata applied.

The Image Editing Workflow

We strongly recommend starting out with a well-defined workflow for editing digital images. Since Photoshop offers so many different options for any task, it's almost impossible to describe them all. Thus, a carefully constructed workflow structure helps you tighten your focus on the larger tasks during each individual stage as you move through the editing process. Even after working with Photoshop for many years, an effective workflow helps us organize the editing process.

In this chapter, we outline all the stages of the workflow we use, and describe most of them in detail. Two stages, local image adjustments and printing, are detailed in the chapters that follow.

Of course, you may wish to develop your own steps, augmenting or paring down ours. Feel free to use our recommendations as a starting point.

The Workflow Outline & Summary

Any complete workflow has dozens of different tasks. To simplify, we've broken our overall workflow into a series of stages. Each major workflow stage has about three to six tasks within it, but most can be performed easily in a few minutes. Each major stage has its own section in this chapter. This chapter covers in detail the stages from "Image Import" through "Performing Local Adjustments." "Creative Edits" are covered in the Advanced Options chapter. "Printing" and "Web Output" are covered in the next two chapters.

Stage	Major Task(s)	Application Choices
1	Image Import	Bridge[1]
2	Sort & Organize the Images	Bridge[1]
3	Develop Images: Global Adjustments	Adobe Camera RAW, Photoshop[1]
4	Image Clean-Up	Adobe Camera RAW[2], Photoshop[1]
5	Perform Local Adjustments	Photoshop
6	Creative Edits	Photoshop
7a	Print Output	Photoshop[1]
7b	Web Output	Photoshop[1]

Let's begin with a brief summary of each stage…

1 *Adobe Photoshop Lightroom, in Chapter 6, can also handle this function.*

2 *Adobe Camera RAW (ACR) and Lightroom have a slightly limited set of retouching tools.*

Stage 1: Image Import

This is a book about Photoshop, not photography, so we won't cover the specifics of digital image capture with particular cameras. But there are a couple points to make about the importance of image capture. First, ensure good exposure in your images. There's a myth that Photoshop can fix any type of problem in digital images. There are definitely many options for fixing problem images in Photoshop, but it's always best to start with the best possible image. Second, capture a sharp, unfiltered image: use sharp lenses and limit the use of camera filters or other light modifying tricks. Many filter effects are easily mimicked by Photoshop and with much greater precision.

When it's time to actually move your images from your camera or card to your computer, both Adobe Bridge and Adobe Photoshop Lightroom have many options for this process (we'll discuss the Lightroom workflow in Chapter 6). Adobe Bridge can be set to automatically open Adobe Photo Downloader when your camera or card is attached to your computer. We'll carefully discuss the options presented there including file naming, destination folders and their naming, automatic backup, conversion to the DNG

format, and the use of metadata. Metadata is the magic hook to find and organize even the biggest image libraries.

Stage 2: Sort & Organize the Images

Create a strategy for keeping your images organized. Bridge and the Adobe Photo Downloader can send freshly downloaded images to any specified folder, and can automatically create subfolders based on various dating schemes or an arbitrary custom name of your choosing. We outline a strategy for keeping track of unedited images, images in progress, and finished images, as well as variants. We'll keep similar or related images together with Stacks in Bridge. Moving your images through this process will make it easier to find them later and see your progress at a glance.

Stage 3: Develop Images: Global Adjustments

If you're new to digital photography and image editing, your camera is probably set to capture JPEG files. If setting your camera to capture RAW files sounds like a new and complex idea, don't worry about doing that now. But once you're more comfortable working with your camera, you should try to set it to capture RAW files. Processing RAW files in Photoshop is covered in the "Processing RAW Images" section. If you continue to work with film, you'll need to scan your images into the computer to perform some basic processing steps on them.

Global adjustments are those made to tone, brightness, contrast, and color that affect the entire image (or close). If performed well, you can do 90% of the image editing work with a few simple, global adjustments. The section "Global Adjustments" uses the basic adjustment tools described in the "Foundations" chapter, or with similar controls found in Adobe Camera RAW (which, despite its name, can now be used with RAW, JPEG, or TIFF). The Advanced Options chapter includes advanced adjustment techniques that can be performed globally or on isolated areas of your images.

Stage 4: Image Clean-Up

Do basic image clean-up early in the editing process. Get this stage out of the way so you won't have to deal with it over and over again. The three basic clean-up elements are: straightening and cropping, "spotting" (removing dust spots), and noise reduction. Like the Global Adjustments of the Develop stage, clean-up can be done in Photoshop or Camera RAW.

Stage 5: Perform Local Adjustments

Sometimes you'll want to perform adjustments on only a portion of your image, say the sky or a person's face. In order to localize these adjustments to part of an image, you'll often need to create a selection for the part of the image you want to affect and then perform one of the basic adjustments. You merely need to get comfortable with making selections to perform local adjustments.

Stage 6: Creative Edits

This is a catchall step for all the various types of image effects you might want to employ, such as adding soft focus, burning in, defocusing the image corners, blurring the background, adding film grain, or adding borders. Most of these techniques are best left until after other image adjustments are done. Some example techniques are described in the "Advanced Options" chapter.

Stage 7a: Print Output

Some steps in the workflow are specific to the particular print size and the printer. They include final image cropping, final print resizing and resampling, and sharpening.

Most inkjet printers today can make very good photographic prints right out of the box. Photoshop also allows many desktop printers to print using profiles. Profiles improve printer color accuracy. You can also print using an Internet printing service. All these print techniques are covered in the chapter on printing (Chapter 3).

Stage 7b: Web Output

Whether you need to output a few images for your blog, or an entire web site of images for your family or clients to peruse, Photoshop CS3 (and Lightroom) have tools that make this stage far less painful than even a few years ago. See Chapter 4 for more.

Now, let's examine each of these stages in detail.

Stage 1 Image Import

Use Adobe Bridge to import your images from your camera or memory card. There are options for renaming the images, sorting them by folder based on date shot or imported, and even for automatically backing up the original files to another disk or folder in your system or over a network.

Configure Bridge

To be confident that Bridge does what you want, you should change a few of the preferences: Go to the Edit menu (Windows) or the Bridge menu (Mac OS) to Preferences.

The General Preferences page is where you configure the application's appearance (we're using an Amber accent color so you can see what's highlighted in our illustrations, but we recommend Obsidian as a good, neutral choice). More importantly, this is where you can inform Bridge that it is to automatically open the Adobe Photo Downloader. More on that shortly.

The second page of the Preferences has a few items we need as well. As we will often wish to use Adobe Camera RAW for doing Global Adjustments, we may want to check the box to "Prefer Adobe Camera RAW for JPEG and TIFF Files." It is always possible in Bridge to **‹control›+click/ Right-click** and choose to Open in Camera RAW... For now, make sure that this Preference page is set so that new thumbnails "Convert to High Quality When Previewed." In the bottom half, we get to choose which Metadata (data about the image data) is seen below each thumbnail. We need Label and Keywords, and we like to see the Color Profile and Date Created (although that will be in the folder name).

That's good enough for now. There are other Preferences that you'll want to customize later. Now let's get some images!

Adobe Photo Downloader

When you connect a camera or its memory card to your computer, Bridge should now launch its downloader program. The standard dialog is often good enough, but we'll use the Advanced dialog so we can pick and choose which images we want to download by their thumbnails. There are two other advantages to the Advanced dialog: we get to apply a metadata template (once we make one) and we can apply our copyright text to the metadata as we download the images—now we can't forget.

Both the Standard and Advanced dialogs have an option to convert camera-proprietary RAW files into DNGs (recommended) and you can specify a destination for copies made of the image files. If you click the Choose button, you can specify an awaiting DVD, backup hard drive, or network backup drive, so the files are backed up instantly. Some photographers prefer to backup images that have been globally corrected first, but others don't want their workflow interrupted to do backup.

There is a wonderful option to create subfolders in your download location, preferably named after the date shot. This means that there are already two places where that date is stored: the folder in which the image is located and in the image file's metadata. When choosing a file naming scheme, give each image a name that is meaningful to the shoot. Adobe Photo Downloader has a field for specifying a custom name, and it will add serial numbers to the end automatically. The last option to mention is to Open Adobe Bridge with the new downloads in the window (recommended).

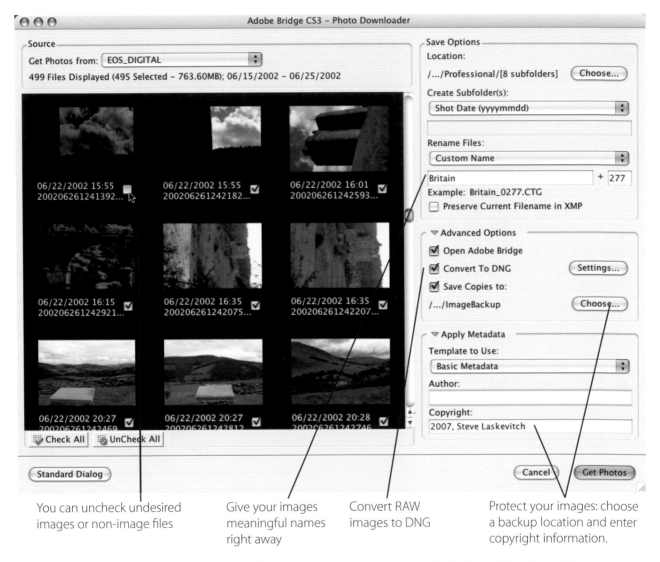

You can uncheck undesired images or non-image files

Give your images meaningful names right away

Convert RAW images to DNG

Protect your images: choose a backup location and enter copyright information.

To create a metadata template in Bridge CS3, choose Tools > Create Metadata Template…. Fill in fields that you feel are general enough to be applied to any image you make. If you need several variations, make more than one template.

Stage 2 Sort & Organize the Images

Bridge Interface Tour

The Bridge window has "panels" like Photoshop has "palettes." You can rearrange, resize, and close these panels. You can access Bridge Workspaces from the buttons in the lower right (e.g., "Lightbox" with only the Content panel, "Metadata Focus" with a details view in the Content panel and more space given to the Keywords and Metadata panels, and the "Default" with a good balance of those panels and a Preview panel). Let's use the Default.

1. Use the Favorites panel to navigate to images on your computer. If you loaded images to your operating system's Pictures folder: click on it.

2. If the images are elsewhere, use the Folders panel to navigate as you would in Explorer (Windows) or the Macintosh list view.

3. When you find a folder with images, click (just one click!) on an image thumbnail. (Double-clicking opens the image—that comes later).

4. Notice that the Preview panel is showing a larger version of the image.

5. Find another image not adjacent to the first. Hold down ⌘/ Ctrl and click on it. Both are now selected. Hold down Shift and click on another. This selects a range of images.

6. Click on one of the images in the Preview panel. You've discovered the Loupe! Drag it around to get a closeup view of the image's pixels. You can use your "+" or "-" key to zoom the Loupe. ⌘+Shift+A/ Ctrl+Shift+A deselects all images.

7. Select just one image in the Content panel. Look at the Metadata panel for technical data about that image. Turn down the disclosure triangles to see more data (IPTC Core holds the data you may have made in a Metadata template).

8. If there are subfolders within the folder you are viewing, and you wish to see their content, click on the folder icon at the top of the Filter panel. Click it again to see only the images in the current folder.

9. On the right side of the Filter panel you can set the criteria for sorting the images. "Manually" allows you to drag the images around in the Content panel much as you would on a real lightbox.

10. Select several related images. Choose Stacks > Group as Stack or use the shortcut ⌘+G/ Ctrl+G. This is a great space-saver! The number tells you how many are in the stack; click on the number to expand or collapse the stack. Clicking the second (shadow) border selects just the front image or all images in the stack.

◀ *If there are more than 10 images in a Stack, you'll see a "Scrubber" button at the top of the thumbnail. Slide it back and forth to see previews of the images in the Stack.*

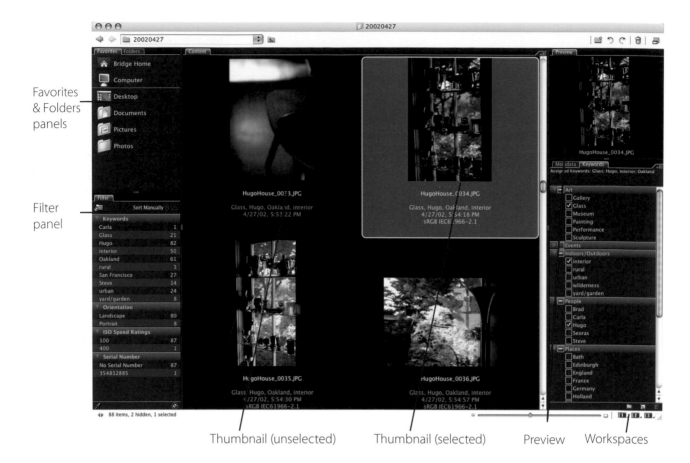

Favorites & Folders panels

Filter panel

Thumbnail (unselected) Thumbnail (selected) Preview Workspaces

Sorting

After the images have been imported, Bridge should now be showing the images. It's now time to pick the keepers, choosing the images that deserve further attention. For this, we'll use Bridge's star rating system.

To apply star ratings, select an image (or many or all in a shoot), then:

1. Choose Label > *[the star rating you want, 1 through 5]*

2. Use the command ⌘+[1–5]/ Ctrl+[1–5]. If using the modifier key gets tedious, you can just type the number if you change the preference under "Labels" in Edit > Preferences (Windows)/Bridge > Preferences (Mac OS): uncheck the box that says you need to use that modifier to apply Labels and Ratings.

3. Choose View > Slideshow Options. Set the options as illustrated here, for now. You can change them later. When you click Play, you'll see one image at a time. If you have a full keyboard, you can place your right thumb over the right arrow key (to advance to the next image), and a few fingers over the number pad, to apply ratings. No modifier is needed in Slideshow mode! Rate, advance...rate, advance...and so on.

When the images have been star-rated, you can filter the view in Bridge. To show only those images that have been rated, for example ★★, you merely have to click on the ★★ row in the Filter Panel in Bridge.

We should say star rating "systems", because we've heard and seen many ways of using those five little stars! So we'll give you a few rating methods from which to choose—we'll use the first one in this book.

Rating Method	Procedure
"Build-up"	**Review 1:** rate with ★ or ★★ *filter:* ★★ & above *(shift-click on 2 star filter)* *then…* **Review 2** *(optional):* ★★ or ★★★ *filter:* ★★★ & above *(shift-click on 3 star filter)* *then…* **Review 3** *(optional):* ★★★ or ★★★★★ *Stop reviewing the images when you have enough of them. Then filter for the highest rating you gave.*
"Brutally Binary"	**Review 1:** ★ or ★★ *filter:* ★★ *then…* **Review 2** *(optional):* demote ★★ to ★ if they no longer please you *Repeat as necessary. Then filter for* ★★
"Yes, No, or Maybe"	**Review 1:** ★ or ★★ or ★★★ (no, maybe, yes) *filter:* ★★ & above *(shift-click on 2 star filter)* *then…* **Review 2** *(optional):* change ★★ to ★ or ★★★ until there are no more ★★ *Finally, filter for* ★★★
"The Decider"	**Review once** ★ or ★★ or ★★★ or ★★★★★ that's it

Reserve 5 stars for only those images you think should win a Pulitzer.

We prefer the method we call "Build-up", as it gives us a range of quality from which to choose, and which could be revisited later.

By rating first, you know if downloaded images have been looked over or not. If an image has at least ★, then you know it's ready for development.

Clears all applied filters

Keeps filters applied as you browse other folders

Labelling: Workflow Landmarks

As you progress through the workflow, you will need to know how far along a particular image has proceeded, or what else it needs. You may just want to label an image as "Ready to go." In the past, we depended on elaborate hierarchies of folders to govern our original files, copies we made for different purposes, other copies in file formats that allow edits that our original files would not, and possibly more for images prepared for specific output. The location of those files was the indicator of "where" they were in the workflow.

Now, Photoshop and Bridge (through Adobe Camera RAW or ACR for short) give us ways of nondestructively correcting and adjusting our images. That is, we can make many changes to color, tone, sharpness, and even the removal of dust or other artifacts, all without really affecting the original data. So if we make a mistake, or wish to make a different creative decision, we simply make the new corrections. Much of this can be done in ACR, even more of course in Photoshop proper. In ACR 4.0 (which comes with CS3) and newer, we can apply "Camera RAW" corrections to JPEGs and TIFFs, as well as proprietary raw files and DNGs (Digital Negative format).

One image file can therefore be moved through the workflow, and even moved backward in it, without risking the original data captured by the camera. The trick is remembering where in the workflow a particular file is. So it is important to establish a labelling system that clearly identifies a file's status. The default labels in Bridge attempt to do this, but somewhat generically. We propose some label names to match our workflow, but you should use phrasing that is meaningful to you.

In Bridge's Preferences, you can change the label text, but not the label color or order.

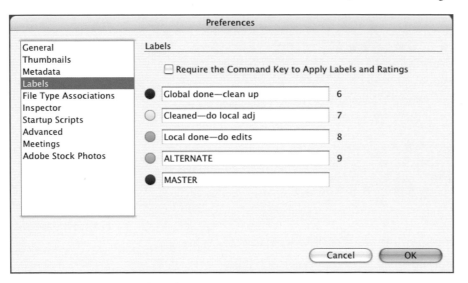

There are excellent arguments in favor of exchanging the ALTERNATE and MASTER labels. Keep in mind that we are outlining our suggestions. Your workflow may benefit from other settings.

As mentioned earlier, you can also simplify the key command (modifier key plus a number) you use to apply a particular label by unchecking the box at the top of that Preference page.

When you have imported the images for a particular project, Adobe Photo Downloader creates a folder within your designated images folder, with the date in the folder name.

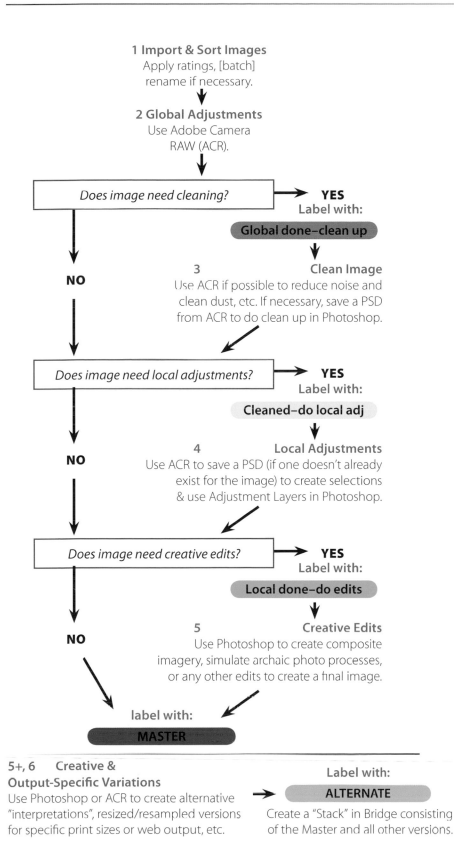

1 Import & Sort Images
Apply ratings, [batch]
rename if necessary.

2 Global Adjustments
Use Adobe Camera
RAW (ACR).

Does image need cleaning? → **YES**
Label with:

Global done–clean up

3 **Clean Image**
Use ACR if possible to reduce noise and
clean dust, etc. If necessary, save a PSD
from ACR to do clean up in Photoshop.

NO

Does image need local adjustments? → **YES**
Label with:

Cleaned–do local adj

4 **Local Adjustments**
Use ACR to save a PSD (if one doesn't already
exist for the image) to create selections
& use Adjustment Layers in Photoshop.

NO

Does image need creative edits? → **YES**
Label with:

Local done–do edits

5 **Creative Edits**
Use Photoshop to create composite
imagery, simulate archaic photo processes,
or any other edits to create a final image.

NO

label with:

MASTER

5+, 6 **Creative &
Output-Specific Variations**
Use Photoshop or ACR to create alternative
"interpretations", resized/resampled versions
for specific print sizes or web output, etc.

Label with:

→ **ALTERNATE**

Create a "Stack" in Bridge consisting
of the Master and all other versions.

Archiving Files

When you first downloaded the images, hopefully you created copies using Adobe Photo Downloader's "Save Copies to:" option. After you've done all the work of sorting, organizing, and the steps to follow, you'll likely want to back up your final images, too.

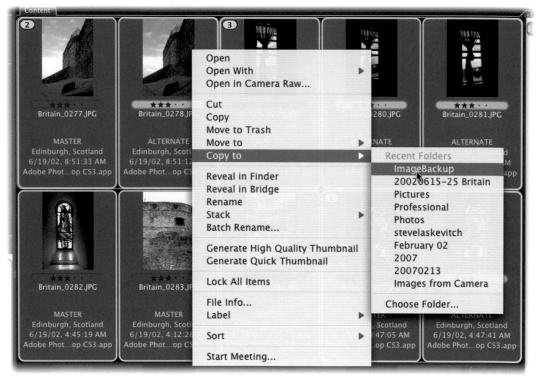

Select the images/Stacks you want to back up, then <control>+click/ Right-click. In the menu that appears, choose Copy to > *[choose your backup volume]*. This could be a waiting DVD or external hard drive that you store in a bank vault. It really should be a medium **not** inside your computer. Insurance may cover a stolen or flooded computer, but it won't cover lost files!

Take care to select only archival CDs or DVDs and to store them in a protected environment, e.g., away from light. Also, be advised that archiving with CDs or DVDs consumes lots of time and disks. The other mode of archiving, onto removable hard drives, is not archival: if left unused for many years, the data can be corrupted. Someday, perhaps, there will be a perfect solution. For now, we usually store redundant files—just in case.

Stage 3 Develop Images: Global Adjustments

Your image files will likely be in one of three common formats: TIFF, JPEG, or RAW.

Opening an image file by double-clicking on it in Bridge opens the file in Photoshop. If it's a RAW file, Adobe Camera RAW (ACR) will open, "hosted" by Photoshop, so you'll still have to wait for Photoshop to launch if it's not open already. However, there's a sure way to have ACR open, hosted by Bridge (no waiting for Photoshop), for JPEGs, TIFFs, and RAW files. <control>+click/ <Right-click> on the file (or a range of them), then choose Open in Camera RAW. Now you'll be able to make the majority of your global adjustments using tools that are very similar to those found in Photoshop itself. But in ACR, these adjustments are nondestructive: they exist only in the file's metadata, and thus can be revisited many times, removed, copied, pasted to other images, saved as Develop Settings, and more.

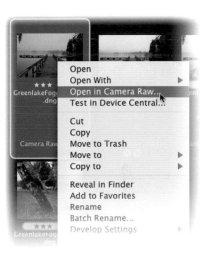

Of course, you may also choose to apply your adjustments with Adjustment Layers in Photoshop. Again, just double-clicking most image file formats will open them in Photoshop. RAW images *must* pass through ACR, and benefit from the settings there. Often, images will need the attention of both applications.

If you tire of the <control>+click/ <Right-click> way of opening RAW files through Bridge, you can set Bridge's General preferences to have Bridge "host" ACR:

┌─ Behavior ──────────────────────────────────────┐
│ ☑ When a Camera is Connected, Launch Adobe Photo Downloader │
│ │
│ ☑ Double-Click Edits Camera Raw Settings in Bridge │
└──┘

Adobe Camera RAW (ACR)

RAW Images: Why?

Many higher end digital cameras create RAW files. Each digital camera has its own RAW file format and file extension— Canon RAW files are called CRW or CR2 files, Nikon files NEF, etc. RAW file images contain all the original data captured by the digital camera sensor. The RAW file can produce a higher quality image than a JPEG image. The main advantage of RAW files is their inclusion of data for 16-bit per channel images and less susceptibility to image degradation under significant edits. One disadvantage is that RAW files are much larger than JPEG files, so you can store far fewer RAW images in your camera. And only a few applications, Adobe Photoshop and Adobe Bridge among them, can view them.

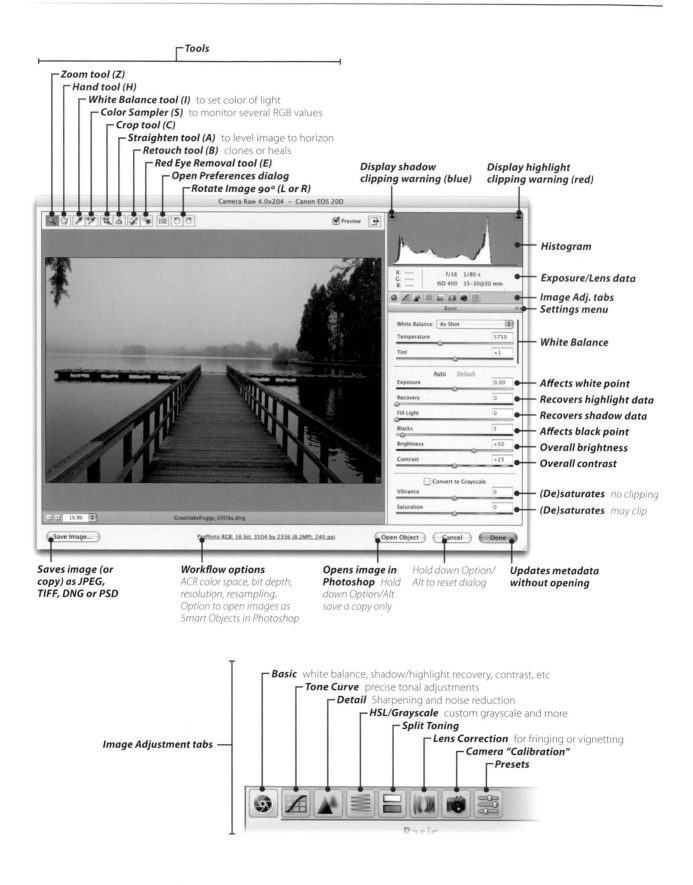

Tools

Zoom tool (Z)
Hand tool (H)
White Balance tool (I) to set color of light
Color Sampler (S) to monitor several RGB values
Crop tool (C)
Straighten tool (A) to level image to horizon
Retouch tool (B) clones or heals
Red Eye Removal tool (E)
Open Preferences dialog
Rotate Image 90° (L or R)

Display shadow clipping warning (blue)

Display highlight clipping warning (red)

Camera Raw 4.0x204 – Canon EOS 20D

Histogram

R: ---
G: --- f/16 1/80 s
B: --- ISO 400 15–30@30 mm **Exposure/Lens data**

Image Adj. tabs
Settings menu

Basic

White Balance: As Shot
Temperature 5750 **White Balance**
Tint +1

Auto Default
Exposure 0.00 **Affects white point**
Recovery 0 **Recovers highlight data**
Fill Light 0 **Recovers shadow data**
Blacks 5 **Affects black point**
Brightness +50 **Overall brightness**
Contrast +25 **Overall contrast**

Convert to Grayscale
Vibrance 0 **(De)saturates** no clipping
Saturation 0 **(De)saturates** may clip

19.9%

GreenlakeFoggy_0009a.dng

Save Image... ProPhoto RGB: 16 bit; 3504 by 2336 (8.2MP); 240 ppi Open Object Cancel Done

Saves image (or copy) as JPEG, TIFF, DNG or PSD

Workflow options
ACR color space, bit depth, resolution, resampling. Option to open images as Smart Objects in Photoshop

Opens image in Photoshop Hold down Option/Alt save a copy only

Hold down Option/ Alt to reset dialog

Updates metadata without opening

Basic white balance, shadow/highlight recovery, contrast, etc
Tone Curve precise tonal adjustments
Detail Sharpening and noise reduction
HSL/Grayscale custom grayscale and more
Split Toning
Lens Correction for fringing or vignetting
Camera "Calibration"
Presets

Image Adjustment tabs

Basic

That said, it's best to capture digital camera images using RAW files. If you are new to digital imaging, capture your images as JPEG files until you feel comfortable with the overall process. When you're ready, configure your digital camera to capture images as RAW files.

Adobe Camera RAW integrates RAW files with Photoshop easily and provides a simple integrated interface for global adjustments before opening them in Photoshop (sometimes instead of opening in Photoshop). These features make Adobe Camera RAW one of the best RAW utilities available. Camera RAW supports most digital camera RAW file formats. Check Adobe's web site to confirm support for any particular camera. (A search on the site for "Camera RAW" yields the appropriate page.) Adobe has done a good job of keeping Camera RAW up to date as new cameras (and RAW formats) are released. Newer cameras may require that you download a newer version of the Camera RAW utility from the Adobe website. And, if you convert to DNG format as you download your images from the camera, you won't have to worry about ACR "forgetting" about your camera.

Camera RAW provides some very rich options for editing that quickly generate very good looking images. Use Camera RAW for many global corrections and leave local adjustments to Photoshop. Photoshop allows for precise area fine-tuning using layers. The default settings for Camera RAW are a good place to start.

It's important to set the appropriate Workflow Options (along bottom of dialog, see illustration of interface). If you have configured your Photoshop Color Settings to convert RGB data to the Working Space (see "Color Settings" in Introduction), set the Space option to ProPhoto RGB. When you open this image in Photoshop, it will automatically convert to AdobeRGB by default.

Set the Depth option to 16 bits/channel. 8 bits can be fine if you know you won't do any moderate to major adjustments in Photoshop. Many photographers leave this option set to 16 bits just to be safe. The only cost is to file size and to the number of Filters available to 16 bit/channel images.

Resolution should be set to the default resolution for your typical output: 300 pixels/inch for most print devices, 240 or 360 pixels/inch for Epson inkjet printers, 72 pixels/inch for web images.

Camera RAW sets the Size option to match the default resolution for the digital camera. Other size options are available. An asterisk (*) option in the size menu identifies a high quality option for upsampling images for some cameras.

Upon opening, Photoshop displays the name of the opened RAW file in the title bar of the image window, but Photoshop is actually editing a copy of the file as processed by Camera RAW. If you try to save this image, Photoshop displays the Save As dialog and forces you to save a new file different from the original RAW file. You cannot open and save RAW files.

Basic Adjustments

Basic, the first Adjustment Tab, has the most important controls for global adjustments. The White Balance control sets the overall color balance of the image.

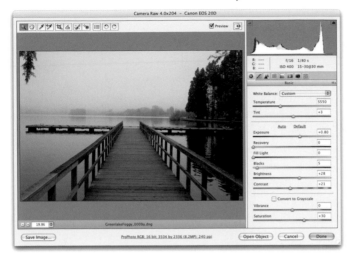

The default As Shot setting uses the control values set in the camera when the image was shot. As Shot values often work well, but if the image color seems off, try adjusting the Temperature. The Temperature control makes the image appear warmer (more yellow) or cooler (more blue). The Tint control makes the image appear more green or more magenta and is more difficult to use. If there is a light gray in the image, or an area that should be light gray, you may try clicking on it with the White Balance tool. This one click will set both the Temperature and Tint sliders to make the area on which you clicked a neutral gray. As this is based on the light in the image, we chose a light area (not too light, however: there needs to be some tone where you click).

When your cursor is just near (not even on) a slider's label, you'll see the Scrubber. Use this instead of the slider itself—it's so much easier!

The default settings for the Exposure, Shadows, Brightness, and Contrast controls are determined at Adobe for each model of camera. There are no default values for Recovery or Fill Light. Above the Exposure slider, you'll see the words Default and Auto. Auto attempts to adjust the image overall. Always try this to see if it does the bulk of your work for you! For many images the Auto values work very well. Change these controls to adjust over-all image density. Change the Brightness control for small overall brightness adjustments to the image. Exposure and Shadows act similarly to the black and white point sliders in the Levels tool. Contrast will add contrast by spreading out the image's histogram.

Vibrance and Saturation are very similar to one another. Either can be used to enhance or subdue the color "intensity" in an image. The difference is that Saturation can lose details in one or more of the color channels (red, green, or blue) if the Saturation level is too high.

Use the Histogram while you work to see if any data is "clipping" (losing detail at the light or dark ends). There are buttons at the top of the Histogram to turn on an overlay to see shadow (blue) or highlight (red) clipping.

Summary: Basic Adjustments are the most important ones in ACR. Use the White Balance Tool on a light gray, then adjust the Exposure through Contrast sliders to achieve a mostly balanced image. Watch the Histogram to be sure you're not losing data (unless you want to do so). You can "pump up" colors or make them pastel with the Vibrance and Saturation sliders.

Tone Curve

ACR's **Tone Curve** offers a novel way to make curve adjustments more intuitive: the "Parametric" interface. It deals with each of four parts of the tonal range by name from lightest to darkest with sliders. As you drag each slider, the curve updates, as does the image. Click the "**P**" key to get a before and after (this is the case with each tab). Again, we encourage you to watch the **Histogram** to be sure you're not losing important detail.

The three sliders along the bottom of the curve grid are for changing where, e.g., **Highlights** give way to **Lights**, or **Darks** to **Shadows**.

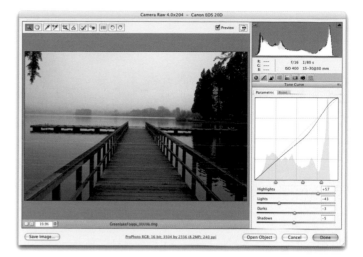

Detail

This is the tab where sharpening *may* be done. If you want to start an argument among Photoshop users, the most debated topic may well be sharpening. Photoshop has Smart Sharpen, which offers fantastic control for curing slightly soft images. There are also many third-party plugins. The same is true for noise reduction, especially important in dark or underexposed images. Well, some of the control we get from Photoshop's Reduce Noise and Smart Sharpen filters is here in the Detail tab. One of us (Steve) likes to use a little sharpen here (10 to 30, depending on needs), as it is derived from the excellent Photoshop filter. As noise reduction is just fancy blurring, that part gets less use, but not always zero (just almost always!).

As the dialog box says, zoom in to 100% (from the menu in the lower left of the image window) before using these controls.

HSL/Grayscale

This tab controls 8 different hues from red through magenta. You can shift one hue toward another (e.g., make oranges more red or more yellow), make it more or less saturated (take some of the red out of someone's face), or make it lighter or darker (make the sky's blue darker and more rich). This is a marvelous way to emphasize some colors and not others, unlike the saturation controls under the **Basic** tab.

If you check the **Convert to Grayscale** box, the 8 sliders control the tone of those hues in the underlying color image (remember, no data is lost in ACR—all that color is really still there).

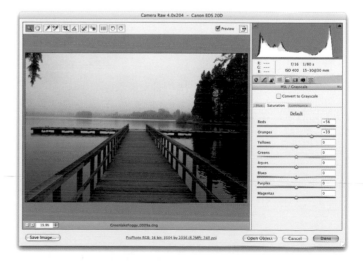

▦ Split Toning

Especially useful for grayscale images, but not exclusively so, Split Toning is the process of colorizing the darker areas of an image with one hue and the highlights with another.

▥ Lens Corrections

Even the best glass can have its flaws. When we use wide-angle lenses, especially zooms, and especially on SLRs, there will often be fringing of color at the edges of the frame. This is because the lens can't focus all the colors onto the same, exact sensor (or film grain, in the old days). Thus, if you zoom in *very* close (e.g., 400%) on one edge of your image, and you see fringes of red or cyan, or blue or yellow, then this tab can be your friend. Move the sliders (or scrubbers!) only a little at a time. **Red/Cyan** fringing is more common than **Blue/Yellow**, but if what you see is *Magenta/Green*, then you have both.

 If you use a filter on your lens, or used the wrong lens hood, then you might have darker corners, or vignetting, in your final image. Use the **Lens Vignetting** slider. Once that has been engaged, the **Midpoint** slider awakens, so you can adjust how far into the image the vignetting correction extends.

▣ Camera Calibration

If you shoot products or art in a studio with controlled lighting, you may find the gentle tweaks of this tab helpful to fine tune your camera's particular color sensitivities. This process is beyond the scope of this book.

▤ Presets

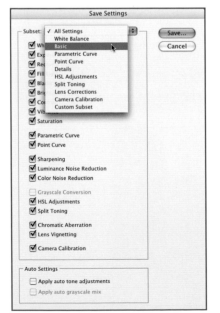

If a combination of the many foregoing settings need to be applied to other images, especially from other shoots in the future, then you may wish to save them as a preset.

 When you click the tiny menu icon on the right of the tab, choose Save Settings…

 In the dialog that appears, you can choose which settings you want to save: individually or by tab (via the menu at the top). This can make it easy to choose a particular group of settings that can be applied at once or in sequence (e.g., one White Balance for *Brand X* lights, another for *Brand Y* lights).

Clean-up in ACR

In the next section, **Stage 4: Image Clean-Up**, we'll look at those tools that aid in fixing other flaws: the **Retouch** tool, the **Straighten** tool, and the **Crop** tool.

Still, it might be useful to see a "before and after" image in its entirety:

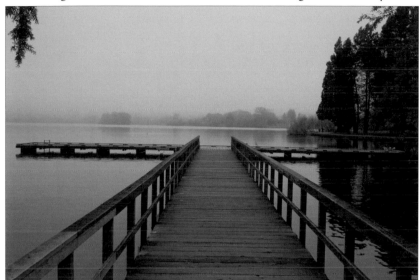

Greenlake Dock **Before** Adobe Camera RAW photo by Steve Laskevitch

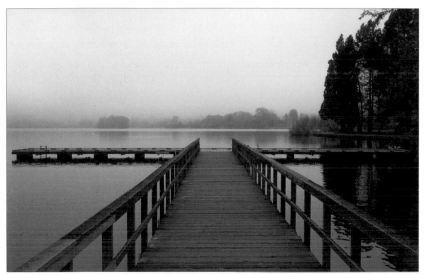

Greenlake Dock **After** Adobe Camera RAW photo by Steve Laskevitch

Using ACR with Multiple Images

Adobe Camera RAW can apply the same settings to multiple images. This is especially useful for images shot under similar lighting conditions and intended to be displayed together. Images processed together may show some variation in lighting, depending on exposure, but appear to come from the same scene thanks to consistent white balance. Obviously, processing multiple images together can speed up the work.

To open multiple images in Camera RAW:

1. In Bridge, select multiple RAW image files and **control**+**click**/**Right-click** on one of the images. Choose Open in Camera RAW… You should probably select images shot under the same or similar lighting conditions. From Photoshop, select multiple RAW images using the File > Open dialog. Photoshop displays the Camera RAW dialog with a filmstrip along the left side of all the selected files.

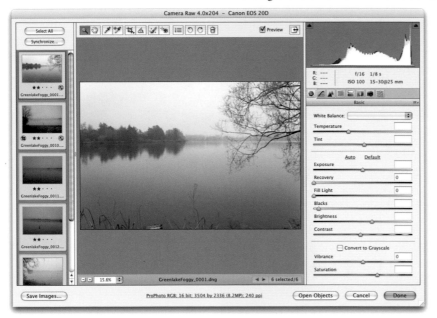

2. Click in the **Select All** button at the top of the filmstrip to select all the images. You may also click on one image in the filmstrip, then use the **Shift** key to select a range, or the **⌘**/ **Ctrl** key to select discontiguous images.

3. Make adjustments to the **Exposure**, **White Balance**, etc., as you would for one image. Evaluate the top image as you make these adjustments. Look through the other images (without deselecting) by using the small arrows at the lower right of the image window.

4. Once the top image appears accurate, select the individual images in the filmstrip (click on each) to inspect the effect of these settings on each image. Make small adjustments to each image as necessary.

5. Click Done if you're finished adjusting the images (for now).

Saving Copies from ACR

▶ Select the images that you'll want to open in Photoshop, then Click on **Open Images** to process and open those images in Photoshop. It can take some time to open many images.

▸ Or, click on **Save Images** to process each selected image and save them. Since you cannot save a processed RAW file, save them in another file format; Photoshop (.psd) is a good choice. If there are many images to process, the image files will save in the background. You'll see a process report near the **Save Images** button. Open the first processed image and begin working as soon as it's saved back to the folder.

Global Adjustments in Photoshop

Many users may want to open an image and quickly perform some basic edits on the image to improve its contrast and color in Photoshop rather than Adobe Camera RAW. The basic adjustment tools covered in the **Essentials of Photoshop** (Chapter 1—*Levels, Curves, Color Balance, Hue/Saturation*) suffice for these edits on most images. This is the heart of editing images in Photoshop. If you learn to perform these adjustment tasks well, you can do 90% of the work necessary to edit images. Perform these basic adjustment tasks first, then few if any "fancy" edits may be required.

Remember: adjustments are just simple operations on image pixels, e.g., making each pixel 10% darker, or adding 5 points of blue to each pixel. Some adjustments get significantly more complicated, but in general, adjustments are just pixel-by-pixel operations. Yet, most of the important work on your image results from these basic adjustments.

Compare global adjustments to creating a good straight print in the traditional darkroom. A good straight print should have good density, good contrast, and good overall color. It may not have *perfect* density, contrast, and color *everywhere*!

Adjustments Tasks and Adjustment Tools

Determine the adjustment task you want, then pick the appropriate tool. Often there's more than one tool for each adjustment. Here are the common adjustment tasks and some tools used to perform each:

Adjustment Tasks	Adjustment Tool
Black & White Points	Levels
Brightness	Levels
	Curves
Contrast	Curves
	Contrast Mask
Highlight/Shadow Enhancement	Curves
	Shadow/Highlight

Adjustment Tasks	Adjustment Tool
Color Balance	Color Balance
	Auto Color
	Curves
	Levels
Edit Colors	Hue/Saturation

There are more options for these basic adjustments, but these are the main ones covered in this book. Associating the tools listed in Photoshop with the task you want may be confusing at first. Notice that Curves can be used for just about every adjustment. Curves is *the* power tool in Photoshop. However, you'll want to do an adjustment that may be better served by a different tool. Let's look at a few of these.

Order of Adjustments

Some imaging professionals perform adjustment tasks in a specific order— perhaps density first, then color balance, then individual colors. However, some adjustment tools do more than one of these tasks at once. For example, if one uses Levels to adjust *per channel contrast* (essentially correcting the density on each color channel, one at a time or using Auto Color), one will have corrected color balance and overall density *and* contrast at the same time.

So, we'll take a different approach: do adjustments from global to specific. That is, use the tools that give overall improvements first, then incrementally refine until the image is perfected.

Adjustment Layers

Apply all the basic adjustments described in this section using Adjustment Layers. Apply Adjustment Layers rather than adjustments directly to the image. Use Layer > New Adjustment Layer, not Image > Adjustments.

When you first create an Adjustment Layer, Photoshop displays the New Layer dialog so you can name it. Name layers based on the adjustment task to be performed, e.g., "Black & White Point", "decrease Brightness", or "remove green cast." This makes it much easier to find the appropriate Adjustment Layer when editing the image at a later time. Once named, the appropriate adjustment dialog appears. Perform the adjustment task using the dialog. Clicking on OK applies the adjustment.

Review Adjustment Layers in the Essentials chapter (page 23).

Black & White Point Adjustment (Levels)

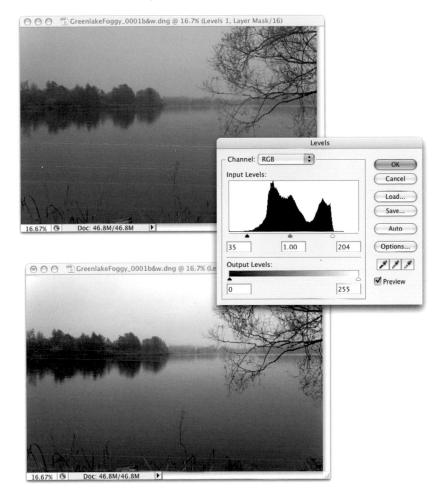

Most images look best printed to maximum contrast: full black to full white (or, perhaps, nearly black to nearly white to preserve detail). The first step for adjusting global image density is to ensure that the image is adjusted to this maximum contrast.

Move the black point slider to the right until it is under the first few darkest pixels in the image. This makes these pixels pure black. Move the white point slider to the left until it is under the first few brightest pixels. This makes these pixels pure white. Many images need only a small amount of black and white point adjustment. This can be the most effective adjustment you perform.

More on the Levels tool in the Essentials chapter (pages 31–33), and more on black and white point adjustment in the Advanced Options chapter.

Adjusting Image Brightness (Levels)

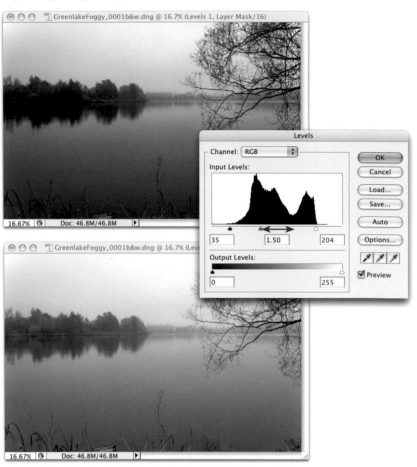

The Levels Adjustment tool provides an easy way to adjust the overall brightness without necessarily adjusting white or black point values. To make a brightness adjustment, open the Levels Adjustment dialog, and slide the center gray slider under the histogram.

Adjusting Image Brightness (Curves)

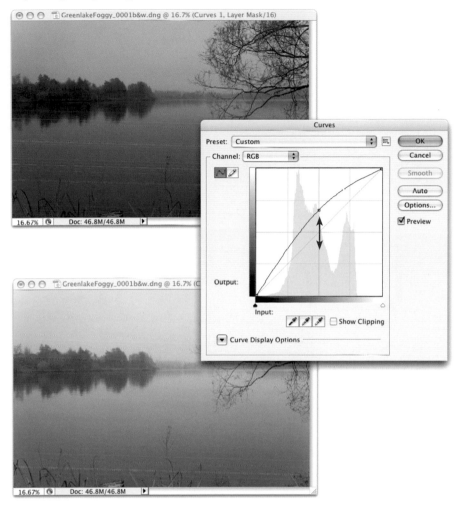

Curves may also be used for brightness adjustments. Since the starting point may be any point between shadow and highlight (black and white), the effect may be more customized and finessed.

Adjusting Image Contrast (Curves)

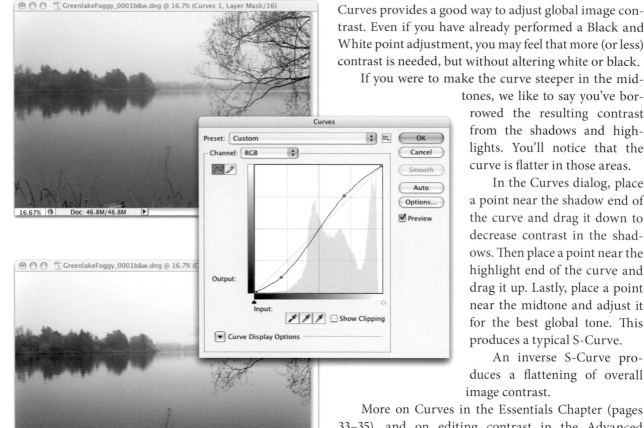

Curves provides a good way to adjust global image contrast. Even if you have already performed a Black and White point adjustment, you may feel that more (or less) contrast is needed, but without altering white or black.

If you were to make the curve steeper in the midtones, we like to say you've borrowed the resulting contrast from the shadows and highlights. You'll notice that the curve is flatter in those areas.

In the Curves dialog, place a point near the shadow end of the curve and drag it down to decrease contrast in the shadows. Then place a point near the highlight end of the curve and drag it up. Lastly, place a point near the midtone and adjust it for the best global tone. This produces a typical S-Curve.

An inverse S-Curve produces a flattening of overall image contrast.

More on Curves in the Essentials Chapter (pages 33–35), and on editing contrast in the Advanced Options chapter.

Adjusting Shadows/Highlights (Curves)

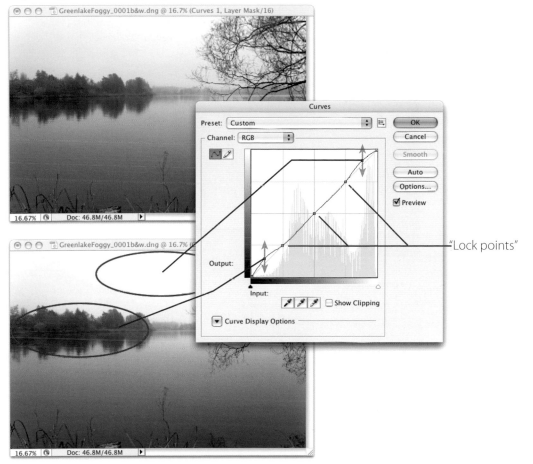

The Curves tool is also great for increasing the detail in highlights and shadows. It's best to perform this adjustment separate from using Curves to increase contrast, i.e., perform the separate adjustment tasks by creating two Adjustment Layers.

In the Curves dialog, first place a point at quarter tone, midtone, and three-quarter tone. This fixes the curve for most of the tonal image range and allows localized adjustment to the shadows only. Now place an additional point in the shadows and/or highlights and pull up or down to bring out more detail.

There is a separate Adjustment called Shadow/Highlight that can be applied as a Smart Filter. Options for using the Shadow/Highlight tool are found in the Advanced Options chapter.

Color Balance (Color Balance)

The Color Balance tool is adequate, if not optimal, for making large global image adjustments. We mention it because many photographers come across it and notice the how the sliders remind them of those on a color photographic enlarger. However, Color Balance provides for only basic control of global color balance, despite the separate controls for Highlights, Midtones, and Shadows.

Although most photographers use Levels or Curves for color balancing images, Color Balance is good for understanding the basic color model used in digital images (Red/Green/Blue and their opposites). Note the checkbox option to Preserve Luminosity: without this, dragging toward Red, for example, would add more red *light*, making the image lighter, too. More

options for performing a color balance adjustment are in the Advanced Options chapter.

Edit Colors (Hue/Saturation)

Hue/Saturation is a tool for both global and somewhat selective adjustments. With "Master" chosen at the top of the dialog, you are affecting all the colors, or rather Hues, in the image. You may, however, choose a particular hue to affect instead. For example, you might choose to make all blues in the image become greens.

The Hue slider shifts each hue towards an adjacent one on the color wheel, e.g., blue colors shift towards cyan or magenta. This is especially useful for color shifts localized in specific colors.

You can also change the saturation globally or of specific colors. You may make an image appear grayscale or vividly intense.

Change the Lightness option with care, as it affects global brightness and can turn pixels completely white or black.

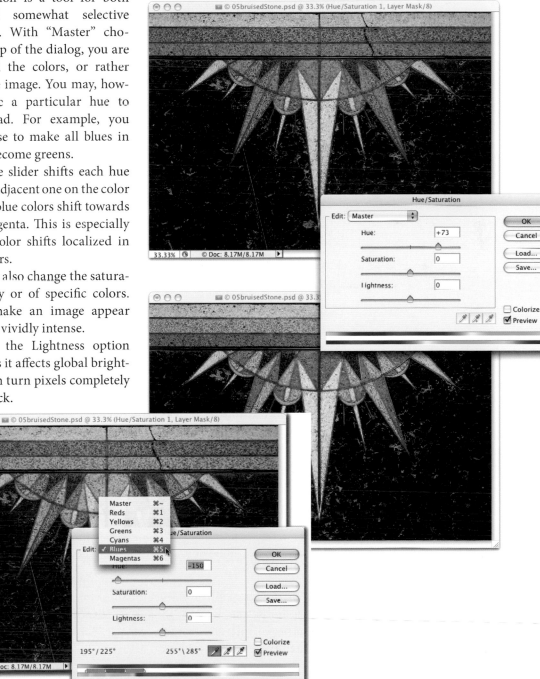

Stage 4 Image Clean-Up

Clean-up involves any obvious straightening, cropping, dust removal and noise reduction. Note that much of this can also be done while processing RAW images.

Brad often does image clean-up as soon as he opens his images—before he does his global corrections. This way he has a clean image even before he makes any decisions about how the rest of the process is conducted.

Steve finds that spots and noise may be more easily found—and eliminated—after global corrections. This approach may be your default if you're doing your global corrections during RAW processing.

Outline of Image Clean-Up Tasks

Some image clean-up tasks aren't necessary for every image. Evaluate the need in regard to each particular image.

▸ Straighten—Rotate the image to straighten it.

▸ Crop—Crop out what is unnecessary (like the edge of scanned film, or a distracting object). You can crop again before you print.

▸ Spot—Remove any dust spots or other blemishes from the image.

▸ Reduce Noise—Reduce the digital camera noise or film grain in the image.

Straighten

If an image needs straightening, do it before you crop since you'll need to eliminate the unsightly border created by the image rotation.

Use the Ruler tool to straighten an image. It lets you draw a line along something in the image you want horizontal or vertical (like the horizon line or a building), and then rotates the canvas so the drawn line becomes horizontal or vertical.

1. Select the Ruler tool. It's the little ruler hidden under the Eyedropper tool in the Tool Palette.

2. Draw a line using the Ruler Tool along something in the image that should be horizontal or vertical. (Here, a line along the horizon.)

3. Select Image > Rotate Canvas > Arbitrary. The value in the dialog reflects the correction required to level the line you drew with the Ruler Tool! Click on OK to straighten the image. Remove the resulting wedges of color (usually white) when you crop.

Alternate approach:

Filter > Distort > Lens Correction

Within the filter's interface, you'll find a set of tools for straightening, removing "barrel" or "pincushion" distortions, correcting for perspective (straightening converging lines), and even removing the fringing caused by chromatic aberration. We don't recommend using this filter to scale the image to crop it, however. For that, we prefer the control of the Crop Tool.

Crop

Use the Crop tool for very precise cropping. You should zoom in for careful adjustments. The Crop Tool creates a good preview to help you judge the final crop.

| ↴ ▾ | Width: 12 cm | ⇄ | Height: 18 cm | Resolution: | | pixels/inch ⬍ | (Front Image) | (Clear) |

Select the Crop tool. If you know the exact size for the final image, enter a specific Width and Height in the appropriate fields in the Options Bar. **Remember to clear the options by clicking the Clear button**. Leaving the Width and Height clear allows for an image of any size or shape.

Use the Crop tool to select a portion of your image, but don't be too precise here, just get the crop onto the image. Once selected, adjust the crop size by grabbing a handle on the corner or edges of the selection. The dark area outside the crop box shows those pixels that will be eliminated.

Zoom in and out of the image while cropping to ensure that the crop is exact. (Use the View Menu or Zoom accelerators found in the Essentials chapter.)

After you've drawn a selection with Crop, the Options Bar changes. Before accepting the final crop, you can change the Opacity of the Shield from 75% to 100%. This completely blocks the pixels to be removed by the crop and provides a precise preview. Return Opacity to 75%.

When you drag the crop edges near the image's original edges, you may experience the annoying "Snap to Document Bounds" feature. This feature is often handy, except when it isn't. To temporarily disable it, hold down the **‹control›**/ **‹Ctrl›** while you drag near the edge, and the crop won't snap!

Press the Enter/Return key to crop.

Retouching

There are three tools for spot removal that we employ: the Healing Brush, the Spot Healing Brush, and the Clone Stamp. These work by sampling "clean" pixels, and using them to repair or replace defective pixels. As you may be unsure that some spots actually are defects, we recommend creating a separate layer just above the original image to hold your retouching, in case it needs to be revisited.

Note: *For each retouching tool, use the menu in the Options Bar called "Sample" to choose* Current & Below *to sample pixels from the original image while working on a retouching layer.*

The only complication in doing so is that you must inform each of the retouching tools that they are to pull the "clean" pixels from the layer below. **So for each tool, note the menu in the Options Bar called "Sample." Choose** Current & Below. The Spot Healing Brush has only a checkbox labelled "Sample All Layers." Use that instead, but you will have to turn off (make invisible) any adjustment layers you made above the retouching layer.

The Clone Stamp Tool

In Photoshop, it is rare to use the traditional Copy and Paste functions used in so many other programs. One reason is that when one copies something, it is usually many megabytes of material, and Photoshop users don't like that much stuff clogging their computer's memory. The other reason is that there are much more useful and elegant ways of copying material.

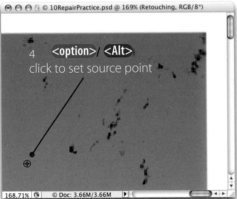

For example, we use the Clone Stamp tool to copy pieces of an image and "stamp" it onto another area of the image. This tool cleverly uses a paintbrush metaphor: larger brushes copy more pixels, softer brushes blend the copied pixels into their new surroundings. One can even alter the opacity of the brush to make the clone only partial. Use the same shortcuts you would use with the Brush Tool to change brush attributes: e.g., [or] for size.

1. Change the view of your image to 100% - select View > Actual Pixels. Zooming into 100% makes it easier to see dust spots and defects you might otherwise miss. Select the Navigator Palette and move the view so it occupies the upper left of your image. Use the Navigator to move carefully over the entire image as you look for defects.

2. First, find a blemish in the image and note an adjacent area of the image without the spot but with a similar texture, color, and density. You'll clone from the "clean" area onto the spot.

3. Select a brush slightly larger than the defect (if it is small like a dust speck). Otherwise, a brush of between 20 and 100 pixels in size will do nicely.

4. Place the pointer over the "clean" area of the image. It appears as a circle the same size as the selected brush. Hold down the <option>/ <Alt> key to display a small target, then click on the clean area. **Important:** Once you designate the "clean" area as your Clone Source, release the <option>/ <Alt> key.

5. Move the cursor over the spot to be removed.

6. Paint over the spot. You will see two cursors while you paint: the center of your source marked with a + cursor, and the circle of your brush. There is a spatial relationship between them that will be maintained until you define a new source point. So if you define a source above and to the left of where you paint, when you paint elsewhere the source will be above and to the left of the cursor in its new location. The trick is to keep an eye on each cursor to be sure that as you paint, your source doesn't drift toward areas inappropriate to cover your blemishes.

7. Repeat for each defect.

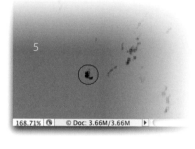

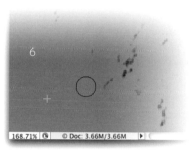

We strongly suggest that for larger defects, and for areas with many defects, that you change your source point frequently to avoid noticeable repeats of pattern.

The Healing Brush

The Healing Brush Tool is very similar in some ways to the Clone Stamp in that you specify a source point by <option>/ <Alt> clicking, then paint away defects. But there is a huge difference, too.

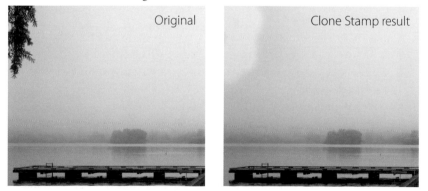

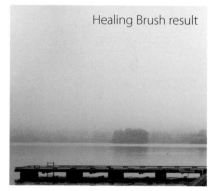

When you paint over the defect, you must paint it all away in one brush stroke. And when you release the mouse, Photoshop does magic: it uses the texture of the source pixels, but then uses the color and density surrounding the flaw. So even if your source pixels are very different in color and density from the flawed area, but have a similar texture, the resulting repair will be seamless.

Because of this, the source doesn't follow the cursor around as you repair the image. Essentially, you define a texture to use, then fix areas with

the same texture (sky texture for defects in a sky, or stone texture for defects in stone, etc.).

In short, you have the control of the Clone Stamp, plus nearly the freedom offered by the Spot Healing Brush (below). Nonetheless, use the Clone Stamp when you need a literal copy of pixels. Use the Healing Brush when a literal copy is either the wrong color or density or both.

The Spot Healing Brush

The Spot Healing Brush is an alternate version of the Healing Brush. It works by merely clicking on a dust spot or defect in the image.

Click on the defect, and Photoshop eliminates it—usually. It picks its own source point. If it chooses inappropriately, use the Healing Brush or Clone Stamp.

The Spot Healing Brush has several options. Keep the detail Mode set to Normal and the default Type set to Proximity Match.

The Spot Healing Brush works best with a *moderately* hard-edged brush—a very soft edged brush doesn't completely fix a defect, and a very hard-edged brush can leave a noticeable edge around the defect. Choose the tool, then **<control>+click/ <Right-click>** anywhere on the image to change the brush's hardness.

With Advanced, we adjust the noise reduction on each color channel, then we go back to "Overall" to make final tweaks. Above, we can see in the upper left the original noise in the image, then in the lower right of the preview window is the reduced noise version.

Sometimes the Spot Healing Brush fails and creates an obnoxious smudge. This is especially common if the dust spot is right at the edge of an image. If this happens, press **<⌘>+Z/<Ctrl>+Z**, and just try the brush again. This often fixes the problem. But if you can't get a good result with the Spot Healing Brush, use the Clone Stamp tool or Healing Brush as a back up.

Reduce Noise

Digital camera images all contain some amount of digital noise. The noise is just random density variations resulting in a random pattern of spots over the image. Although digital cameras have reduced noise dramatically, it's a good idea to run the noise reduction filter on most images anyway.

Select Filter > Noise > Reduce Noise to access the Reduce Noise dialog.

Turn off the Preview option in this dialog and look for digital noise. Digital camera noise is most noticeable in the smooth-toned areas of an image.

Turn the Preview option back on. For most images the Photoshop default settings for the Reduce Noise dialog are good. Increasing the strength may further reduce noise, but often it begins to soften the image. Don't increase the Sharpen Details option beyond 25%—you can sharpen the image later in the workflow.

The Reduce Noise filter works well for reducing typical noise in digital camera images. For images with significant Levels of noise, more advanced techniques are required. Often, we end up masking the noise in very noisy images with some other effect such as film grain.

Save the Clean Image

After you have completed the image clean-up stage, use File > Save. If the file had been a RAW image, you will be presented with the Save As dialog, as Photoshop edits cannot be saved into RAW files. JPEGs cannot hold Layers, and so Photoshop will give a Save As dialog for them, too.

Remember to change the label in Bridge, so you know that the file has been cleaned, and whether it needs more work, namely, local adjustments.

Stage 5 Perform Local Adjustments

In the preceding sections, all the adjustments were applied globally—affecting all image pixels. Yet, almost always you'll still want to apply some adjustments locally—affecting the pixels in only one part of the image or "selection." But you can get lost in the techniques of making selections. You need to step back and start with a look at the overall process of localized adjustments. Therefore, this section starts with an ordered list of tasks on that process, followed by techniques for creating selections, notes on selections, and ending with the application of localized adjustments with layers and editing the mask.

A Task List for Localizing Adjustments

This task list is important; it shifts emphasis from specific techniques for making a selection to the overall process of localizing adjustments. The basic strategy is to determine the desired localized adjustment, create a good basic selection of the image area, create a new Adjustment Layer, make the adjustment, and fine-tune the mask.

Determine a Name for the Localized Adjustment

First clearly articulate what you're trying to do—this may sound trivial, but it's often the most important step. A well-articulated name identifies the steps for the localized adjustment. Some name examples for localized adjustments are:

▸ Darken the foreground

▸ Make the sky bluer

▸ Add contrast to the person

▸ Reduce the blue in the shadows

All of these examples include a localized part of the image (foreground, sky, person, shadows) and a specific adjustment (darken, make bluer, add contrast, reduce blue). Now you know what to select and the adjustment to perform on the selection. It's so much easier this way. You will also use the name for this localized adjustment when you create the Adjustment Layer later in this task list.

Make a Basic Selection

Once you've identified the image area to adjust, make a basic selection of this area. There are several good selection tools to use: the Magic Wand, the Color Range selector, the Elliptical Marquee, and the Lassos. Use the best tool to make a basic selection, but the selection doesn't have to be perfect. Add to or subtract from the selection using the **Shift** or **option** / **Alt** key, respectively, or invert it using the Select > Inverse command.

If none of the selection tools seem to work for you, try creating a simple selection using the Quick Mask. If the selection edge will be too sharp for the adjustment to follow, you might use the Select > Feather command, or wait to blur the Layer Mask you'll make from the selection. More on specific techniques for selections later in this section.

Create an Adjustment Layer

Create a new Adjustment Layer by selecting Layer > New Adjustment Layer > [any adjustment]. Photoshop automatically creates a mask based on the selection you created. The mask makes the adjustment apply only in the area of the previous selection. Use the same name you determined for this localized adjustment to identify this new Adjustment Layer.

Some adjustments you might want to make (such as the Shadow/ Highlight adjustment) are not available as Adjustment Layers. To perform these adjustments, first create a Smart Object (see the section on Smart Objects in the Essentials chapter). Remember, again, to use the name you determined for this localized adjustment. Also, when you create the mask

for the Smart Object, Photoshop makes it active. Don't forget to make the image part of this layer active by clicking on the image in the Layers palette. (Otherwise you'll be adjusting the mask!) You'll be using Smart Objects for a number of tasks in the Advanced Options chapter.

Make the Adjustment

Make your adjustment within the specific adjustment dialog. Since the mask was created based on the selection you created, the adjustments are localized to the area you selected. Work with the adjustment until it provides the correct image. Don't worry if the area of the adjustment is not exactly correct at this point. It'll be good enough to visualize the adjustment. Once the adjustment is correct, click on OK to accept the adjustment.

If you created a Smart Object, select the appropriate adjustment from the Image > Adjustment menu or the Filter menu and perform the adjustment.

Fine Tune the Mask

Now fine-tune the mask. There are several tools for editing the mask. If the layer is an Adjustment Layer, the mask is automatically selected for any edits. If the layer is a Merged Image Layer, you need to select the mask by clicking on it. The most common options for editing a mask are to paint on it using the paintbrush and to feather it by blurring with the Blur filter.

Repeat as Necessary for Other Adjustments

Experiment with this task list. Take an image and perform some simple localized adjustments. Try "add contrast to the center of the image" and "darken the bottom half of the image." Use the simplest selection tools to start—the elliptical and rectangular marquee tools work for these examples. Get used to this particular task list. It's the easiest way to work with selections and masks and works for the vast majority of localized adjustments.

Selection Tools & Methods

Given the task list for localized adjustments, you need to familiarize yourself with selection techniques. Selections should be quick and easy; most should take less than 60 seconds to create. Users often try way too hard to create a very precise selection. With the basic selection tools this can be very frustrating. There are definitely times when a very precise selection is needed, but most often a fairly simple selection is a great start.

Here are some of our favorite selection techniques. They're not listed in any particular order of preference. Try them all.

Quick Selection Tool

The Quick Selection Tool is new to Photoshop CS3 and will please many who have tried to tame the Magic Wand (which is still present, but many will use this tool instead). This tool selects pixels intelligently, and gets more intelligent as you build a selection. If you are trying to select an object in a photo, like the grass in the example below, you simply drag the cursor much like you would paint. Photoshop reads the pixels over which you "paint", growing a selection to include pixels similar to the ones over which you dragged!

If Photoshop includes too many pixels, hold down the <option>/<Alt> key while dragging over the unwanted pixels, and Photoshop will remove those, and pixels like them, from the selection. With this tool, you can build a complex selection very quickly.

As with painting tools, you can change the size and hardness of the "brush" you use to make selections.

Often, however, Quick Selections have imperfect edges. As we often make masks from these, we can wait until they're masks and refine them. But CS3 also introduces new ways to refine selections. See the "Refine Edge" section on page 88.

Elliptical Marquee Tool

The Elliptical Marquee tool is often maligned because of its simplicity. It's often easiest to make a very quick selection with a few clicks of this tool, feather this selection, and use this selection to make a quick localized adjustment. A quick selection is often sufficient. Pick the elliptical selection tool from the Tool Palette. If Rectangular Marquee is displayed, click and hold the Rectangular Marquee tool to display the Elliptical Marquee tool underneath. (You can also select the current marquee tool by pressing the **M** key,

and switching between the Rectangular and Elliptical Marquee tools by pressing <Shift>+M).

Make a few passes with the Elliptical Marquee over the image part you want to select while holding down the shift key to build up an irregular shaped selection quickly.

If you select too much of the image with the Elliptical Marquee undo the most recent selection easily by hitting <⌘>+Z/<Ctrl>+Z. Or subtract a piece from the current selection by holding down the <option>/<Alt> key while making a selection over the part you want to remove from the selection. This is an easy way to take a quick bite out of an existing selection.

When making a selection using the Elliptical Marquee tool, you often will want to feather the selection with a fairly large value to soften the edge of the selection. This is especially true in nature photography where perfect ellipses are rare. Make the edges soft enough and the irregular edges of the elliptical selection won't be visible in the final image. Remember, it's also possible to soften a selection further when you edit the mask at the end.

Polygonal Lasso Tool

The Polygonal Lasso tool is also an easy tool for making quick, rough selections of irregular shaped objects. You can then feather these selections to soften the roughness. We prefer the Polygonal Lasso tool over the traditional Lasso tool as it feels a bit easier on the wrist. The Lasso tool simply requires you to draw a selection on the screen in a free-hand manner, but the Polygonal Lasso allows you to make a series of clicks —more for greater precision, fewer for a less precise, more facetted selection. Choose the Polygonal Lasso tool from the Tool Palette. If the Lasso tool is displayed, click and hold the Lasso tool to display the Polygonal Lasso tool underneath. (You can also select the current lasso tool by pressing the "L" key, and switch between the three lasso tools by hitting <Shift>+L.)

Use the Polygonal Lasso tool by clicking along the edge of the area you want to select. If you come to the edge of the image, click outside of the image to select right along the edge pixels. To complete the selection, make selection points until you return to the first selection point and click back on that point. Or you can double click to automatically create a point, connecting it to the first point closing the selection. Again, remember, let this be a rough selection tool. Don't try too hard to make a perfect selection. And remember you'll often feather the selection you created with the Polygonal Lasso tool.

Color Range—Highlights, Midtones, Shadows

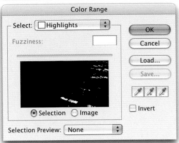

Color Range lets you select various tones (or colors) in your image. Selecting the Highlights selects the highlight pixels and also makes a gradient of selection for pixels with a density between highlights and midtones. That is, there will be pixels that are only partially selected, and will get only some of the adjustment you are about to make. It's like feathering, but is based on a pixel's similarity to the ones you target. To make a quick density selection, use the Select > Color Range… command to open the dialog. The Select menu at the top of that dialog box is used to access the options for Highlights, Midtones, or Shadows, as well as preset colors. It displays the pixels that will be selected in white, the ones that won't be selected show as black.

Photoshop selects a predetermined range of tones for each of the selections for Highlights, Midtones, or Shadows. These often work well for making a quick selection, but sometimes you may want to select only the darkest shadows or a specific range of midtones. To access these tones, make a quick temporary Adjustment Layer to force Photoshop to select the tones you want Photoshop to select. For example, you might create a temporary Levels Adjustment Layer that narrows the range of midtones. It's then easy to use Color Range to quickly select the midtones you want, then throw away the temporary Adjustment Layer.

Color Range—Sampled Colors

Color Range selects a range of pixels by clicking on the image and Photoshop selects similar pixels. Open the Color Range dialog by using the Select > Color Range menu command. Create a selection based on a sampled color by clicking on a color in the image window.

The window in the Color Range dialog displays a black and white version of the selection it creates. You can also display a Quick Mask over your image that shows the selection by changing Selection Preview to Quick Mask (as in the example).

Color Range has one significant advantage over other tools—it completely selects pixels that are very similar to the pixel you click on. Plus it partially selects pixels that are less similar to the pixel you click on, thus providing a built-in feathering option based on the sampled colors. The Fuzziness slider lets you adjust how broad a range of pixels will be selected or partially selected—increasing the fuzziness results in a larger selection. You will also use the Add to Sample and Subtract from Sample droppers to increase or decrease the range being selected.

If Color Range selects too many pixels, try reducing the fuzziness to reduce the number of selected pixels. If Color Range selects too few pixels (very common), don't immediately increase the fuzziness. Rather, sample additional pixels by using the Add to Sample dropper or by holding the <Shift> key and selecting more pixels.

You can restrict the area Color Range "sees" by making a selection before you activate Color Range. For example, if you want to select just one of several green objects in an image, you can make a quick selection using a simple tool like the Polygonal Lasso. When you open Color Range, the selection is restricted to pixels inside of the first selection.

Magnetic Lasso Tool

The Magnetic Lasso tool is a 'cool' tool that works wonders on images with very well defined edges but is amazingly frustrating on images with less than ideal edges. The Magnetic Lasso creates a selection along an edge with well-defined contrasts of color or density, so it works best where the edge contrasts are noticeably different in the image. Choose the Magnetic Lasso from the Tool Palette, click at the edge you want selected to start the selection, and drag along the edge to create the selection.

There is a good chance that the Magnetic Lasso will meander from the edge you're tracing and move the selection somewhere else. Don't panic! Just move the pointer back to the edge you want selected and force Magnetic Lasso back to this edge by clicking on it again. Don't worry about the piece of the selection that is 'off' the edge; you can clean this up later when you edit the mask.

Editing Selections

Selections can be built by combining multiple selection tools: in fact, it's often easiest to do so. With any of the Tool Palette selection tools, hold down the <Shift> key while making a new selection to add this new selection to the existing one. Remember to *build* a selection rather than expect one tool to make a great selection in one quick step.

Take a chunk out of a selection by holding down the <option>/ <Alt> key while making a new selection to subtract this new selection from the existing one. Use different tools to build up a selection from multiple pieces.

Refine Edge

Photoshop CS3 offers an elegant way to refine your selection even before you add your Adjustment Layer and finesse its mask. You may have noticed that we have suggested in several places that you should "Feather" your selection so it has a more natural edge. There are times when you'll notice that the edge of your selection is very rough.

To better visualize your selection, and to refine its edge at the same time, use the Select > Refine Edge… command (also in the Options Bar for any selection tool).

When you open the dialog, you'll see five sliders and as many preview mode buttons at the bottom. But the Photoshop engineers were nice enough to include help as you use this tool: as you hover your cursor over each slider or button, an explanatory note appears at the very bottom of that window.

Here's a synopsis:

Radius determines how far from the selection edge the refinement will take place. If your selection already has fuzzy edges, for really fine detail (as will selections involving hair), you'll need a larger Radius setting.

Contrast makes fuzzy selection edges look sharper. Use the Mask Selection View mode (the last button, in black and white) to see what we mean. Increase the Feather amount, introducing soft, fuzzy edges to the selection, then increase the Contrast to see the effect.

Smooth smooths rough, "crinkly" edged selections.

Feather as mentioned above, gives a blurry edge to the selection so it blends into its surroundings.

Contract/Expand is especially good with fuzzy selections when they're a little too big or small.

Let experimentation guide you. You'll soon find that for selections of objects that are differently colored from the rest of the image, you'll often want a larger Radius and Contrast before you use the Contract/Expand. Where there's little difference, you'll Smooth and Feather before using Contract/Expand. Larger file sizes, therefore more pixel-rich images, will also need higher values than smaller images.

Feathering a selection makes some of the pixels along the edge of the selection "partially" selected. Partially selected pixels result in a mask with some intermediate (gray) value, neither completely masked (black) nor completely visible (white). Pixels that have a gray mask only have a portion of an adjustment applied. This provides for a range of pixels along the edge of the selection to display a smooth transition from the complete adjustment to no adjustment.

Inverting the Selection

It's often easier to select pixels that you don't want selected than to select those you do want selected. Just make a selection of everything that you don't want, and then invert the selection by using the Select > Inverse command. In this example, it's easy to select the grass with the Quick Selection Tool and then invert the selection to make a selection of the walkway.

Using Quick Mask Mode

Imperfect Selections Many of the tools make decent selections, but these might still have imperfections. It's common for the Quick Selection Tool or Color Range to make a good selection, but leave small unselected areas within the field of color selected. Clean up many of these imperfections quickly and easily by using a paintbrush! Enter Quick Mask mode from the bottom of the Tool Palette and paint on the Quick Mask to clean up the selection (or, again, wait and clean up the mask created from the selection).

Painting Quick Mask mode is an easy way to edit a selection by just painting using the Brush tool. Quick mask mode makes it possible to edit a selection as if it were an image using any of the image editing tools in Photoshop. We'll start with the Brush Tool in this example and then use the gradient tool in the next example.

Turn on the Quick Mask mode by its shortcut: pressing the **Q** key. Turn it off by pressing the **Q** key again. You can also click on the Quick Mask mode buttons in the Tool Palette. Photoshop shows you're in Quick Mask mode by displaying 'Quick Mask' in the image title bar.

Before you start painting, open the Quick Mask Options dialog by double clicking on the Quick Mask mode button in the Tool Palette. The options dialog allows you to set the color for displaying the quick mask. A bright red color works for most images. We want to change the color to something that will contrast with the foreground. Double click on the color square to bring up the color picker and pick a different color. Here we used a bright red. Click on OK to close the Quick Mask Options dialog.

You can now use the paint brush to paint onto the Quick Mask. Just select the Brush tool, set the paint colors to the default colors of Black and White (simply press **D**), then paint. Painting with white "grows" the Quick Mask, painting black "chokes" it. Press the **X** key to switch the foreground color from black to white. Use the square bracket keys ([or]) to make the brush larger or smaller. The mask shows up over the image as a semitransparent overlay. Once you have painted the selection you want, press the **Q** key again to switch out of Quick Mask mode and display your selection as a marquee.

Be careful in Quick Mask mode. Quick Mask mode merely changes the selection into an image that overlays the main image. Most of the standard Photoshop tools still work in Quick Mask mode, including the selection tools, but this can cause some confusion about the current 'state' of the selection in Photoshop. It's usually best to switch to Quick Mask mode, paint the selection, and then switch right out of Quick Mask mode again.

Gradients A gradient selection lets you make an adjustment transition smoothly across part of the image. In this example, we want to make a selection that allows us to lighten the bottom third of the image (the foreground). The gradient makes a smooth transition for this selection. For the gradient selection, just paint a gradient onto the quick mask.

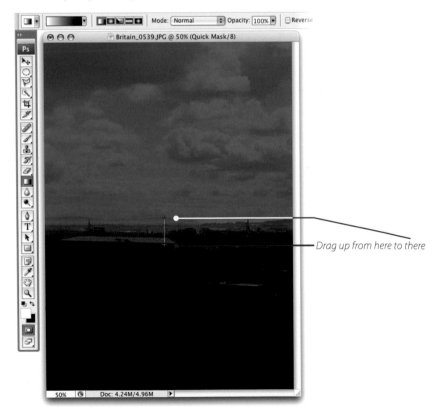

Drag up from here to there

Switch to Quick Mask mode (press **Q**). Open Quick Mask options dialog to ensure the color shows the selected areas and a useful color is selected.

Select Gradient tool on the Tool Palette; press the **G** key. The default options for the Gradient tool are usually the best options. These paint a gradient using the foreground and background colors, create a linear gradient in the direction you paint, and apply paint to the gradient over the top of the quick mask. To paint the gradient, just draw a line in the direction you want the gradient—not along the edge of the gradient. Don't worry, just draw a line. There's a good chance the gradient won't be at all what you expected. Often you'll paint the gradient in the wrong direction or paint a mask where you want no mask. If you get the wrong gradient, just draw the gradient again. Maybe switch the direction of your line. Experiment with the gradient until you get the quick mask over the part of the image you want selected. This creates a selection over part of the image with a nice smooth transition to the unselected part. Switch out of Quick Mask mode to see the gradient selection.

Some Notes on Selections

These are the selection methods we use most often. The best way to learn them is to experiment with them. Don't get stuck with one favorite tool. It might be great for some selections, and very difficult for others.

Performing the Adjustments

Once you have the selection and have refined it, immediately create the Adjustment Layer or Smart Filter Object for your target adjustment. We often opine that selections have little purpose other than to be converted into masks.

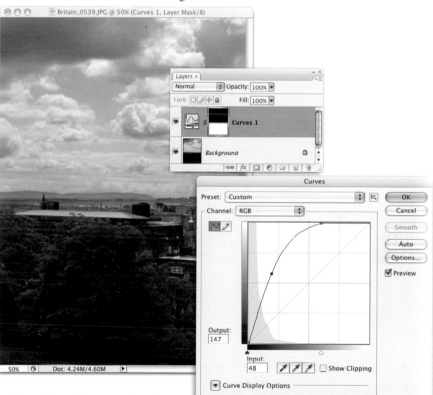

Create an Adjustment Layer and perform the specific adjustment you determined at the beginning of this process. Photoshop automatically converts the selection into a mask for this Adjustment Layer.

If you need to convert a layer to a Smart Object (because the adjustment, such as Shadow/Highlight or Lens Correction, is not available as an Adjustment Layer), <control>+click/ Right-click on the layer's name in the Layers palette and choose Convert to Smart Object.

Now you can apply the Filter or Adjustment as a Smart Filter.

The result should be an Adjustment Layer or Smart Object Layer that contains the appropriate adjustment, and a mask that localizes this adjustment to a part of the image.

Editing the Mask

The final task for localizing adjustments is editing the mask. Often the mask is just fine for the adjustment you want, in which case you can just skip this step, but the mask might be further improved by some basic edits.

We have five basic edits for fine tuning a mask: painting, blurring, sharpening, expanding, and contracting.

Painting on the Mask Make some simple changes to a mask just by painting on it. For Adjustment Layers, the layer mask is automatically selected for painting. For the Image Layer you first need to select the mask for painting. Just click on the mask in the Layers palette to select it. (Otherwise you might paint on your Image Layer.) Photoshop shows that the Layer Mask is selected by displaying Layer Mask in the image title bar.

Select the Brush tool from the Tool Palette, set the foreground and background colors to the default values (white and black), and start painting. Painting black adds to the mask (hides the adjustment) and painting white removes the mask (reveals the adjustment). Change the size of the brush using the square bracket keys ([or]). Paint more softly by changing the opacity of the paintbrush to paint gray values on the mask. More details on painting in the section on the Brush Tool.

Blurring the Mask Blurring the mask is identical to feathering the selection. Often, the selection may not have been feathered sufficiently, or you may have painted the mask using a hard-edged brush. You'll be surprised how many carefully prepared images are improved by blurring the mask.

To blur a mask, simply select Filter > Blur > Gaussian Blur and adjust the radius of the blur. The filter previews the result of this edit.

Sharpening the Mask A good reason to use the **Brightness/Contrast** Adjustment tool! Increasing the contrast of the mask acts to sharpen the edge of the mask. Adjusting the brightness expands or contracts the mask slightly. If you feathered a selection too much, this can sharpen up the edges some.

Use Image > Adjust > Brightness/Contrast and crank up the contrast. Adjust the brightness value to fine tune the edge of the mask.

Expanding or Contracting the Mask This is similar to expanding or contracting the selection. Make the overall mask slightly larger or smaller, and thereby change the area of effect for an Adjustment Layer. Use Filter > Other > Maximize to expand a mask. Use Filter > Other > Minimize to contract a mask. You may need to try both options to see which works best. This is also good for removing the halo around the edge of a mask.

Printing

Printing is a fairly straightforward process. We will present two main choices for how you want to accomplish this process: a Basic method that relies on your printer's driver software to deliver (hopefully) adequate color and detail. This method is what is expected of casual photographers, and thus is easier. It can also yield very good results for many images, or...

A method that uses profiles that describe your printer's characteristics. This method offers stunning consistency and optimal results from a printer. It also can allow you to experiment with many more papers than your printer manufacturer supplies. Choose a method depending upon the print quality you want and the amount of effort you're willing to expend to achieve it.

Basic or Advanced?

1. Current desktop printers and online printing services all produce good results when used as designed. Most users are pretty happy with the basic results of a typical inkjet printer. If you're one of them, print using the steps outlined in the "Basic Printing" section (page 112).

2. Advanced photo printers provide options for printing with profiles. Some users will want to take advantage of the full color range of their photo printers and more precisely print their image colors. The "Advanced Printing" section outlines the steps for printing using profiles (pages 116–120).

The real challenge in printing is to accurately match your printer colors to the image colors. A print image may not accurately match the color of the image as displayed on your monitor, but it may by following the three key steps of "Color Management":

1. Profiling your monitor color

2. Setting up an image "Color Space"

3. Configuring your printer driver for each print

Everyone needs to follow these steps for color management in order for your monitor and printer images to match.

What is Color Management?

To understand color management is to realize that your digital darkroom actually contains at least three different image versions—the virtual image inside the computer, the monitor image on the computer screen, and the print image on the paper.

The virtual image is how the computer (or Photoshop) sees your image. This is the precise digital version of your image, and for color management we'll assume the most exact image version. Monitor and printer images are not exact; innate faults within monitors and printers render the image imperfectly. We can fix this though, by preparing monitor and printer profiles. A profile is a list of target colors that are assigned value corrections, so colors map precisely from the virtual image to the monitor or printer image.

Summary: Your digital darkroom contains at least three different images— the virtual image, the monitor image, and the printer image. The goal of color management is to render the monitor image and the printer image the same as the virtual image by using profiles.

Let's take a closer look at the monitor image. The monitor image is the computer's attempt to display the virtual image on the computer screen,

but, unless given some help, it fails to do it exactly. For example, assume that the virtual image contains a specific shade of red, let's say, "Red#87." Photoshop knows the exact value of Red#87, but the monitor fails to display that exact value. It may add 3 points of blue. A common mistake many users make is to try to eliminate this blue in the virtual image, only to change Red#87 to a completely different color. The correct way to solve this problem is by preparing a monitor profile. Red#87 can be defined within the profile as 3 points more yellow to correct the blue so it displays accurately on the screen. Acknowledging the error value of a specific color on a particular device allows correction for that error inside the computer before rendering the color.

Summary: A profile is a list of target colors with value corrections to allow precise color rendition by a particular device. By using a profile, we can present a particular target color and correct it so it is accurately rendered. Monitors and printers must be profiled and color corrected independently.

You need to create a profile specifically for your monitor. See the Introduction for Monitor Profiling (page 8).

Printer profiles are more complex. A good printer profile addresses a specific printer, ink set, paper type, and software settings. There is a variety of sources of good printer profiles, though. Your printer driver likely includes a good set of profiles to work with the inks and papers designed for it.

Summary: Monitors and printers are profiled and color corrected independently. If we setup both the monitor and the printer to match the virtual image inside the computer, then the printer and monitor should match each other as well.

Devices have another limitation. The real world has a vast array of colors: saturated, brilliant, subtle, muted, dull, and gray. No device can reproduce all of these colors.

The gamut of a device is the range of colors it can render. Colors outside this gamut simply cannot be rendered by that device. Were you to try, the device would render a similar color it could display.

Because of the differences between monitor gamuts and printer gamuts, you cannot assure the monitor image matches the printer image. Colors that appear on the monitor may simply be unprintable. To resolve the mismatch in printer and monitor gamuts, restrict your virtual image colors on your monitor to match those within the printer gamut. If your virtual image only contains printable colors, the monitor and the printer prints can both render them accurately. Restrict the colors by selecting an appropriate "working" color space for your virtual image.

Note: Restrict virtual image colors to printable colors by selecting an appropriate working color space. These colors can be better displayed by your monitor and printed on your printer.

Working Color Spaces

A Working Color Space defines the extent of color used by Photoshop when editing images. The boundary of a working color space indicates the brightest, darkest, and most saturated colors that are possible within that space. We try to match that boundary to that of the color space profiles of the devices to which we output. Photoshop provides methods for dealing with any remaining discrepancies.

The most common working color spaces (used for image editing) are: sRGB, AdobeRGB, and ProPhotoRGB. Each holds a particular range of color. Select an appropriate color space for your print image work.

sRGB

sRGB is the standard default color space for the Internet. Images created supporting sRGB should look similar on any monitor across the Internet, as this is the standard to which many are produced. Although a ubiquitous color model for the Internet has not yet been achieved, progress has been made, and the computer industry has adopted sRGB well, making it the standard for many programs and devices, including printers. Its main limitation is that it holds the smallest gamut of all three color spaces—a sort of lowest common denominator.

Use sRGB to create web images—it's the Internet standard. Use sRGB if you wish to forever forget about color spaces. It is the easiest color space to use. We do not recommend it for professional work.

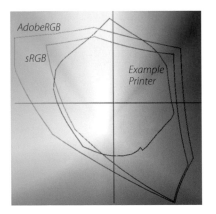

AdobeRGB

AdobeRGB is the most popular color space for digital photographers. AdobeRGB has a larger Gamut than sRGB. It includes most of the colors of a typical photo printer and is made to encompass all the colors of printing presses.

Use AdobeRGB to ensure access to the largest range of colors your printer can print. (This is especially important if you want to take full advantage of the latest inkjet photo printers.) You'll likely print with profiles. See Advanced Printing (pages 116–120) if you use AdobeRGB. You will still use sRGB for web images and those printers that don't support AdobeRGB.

ProPhotoRGB

ProPhotoRGB has recently become a much more popular color space for professional photographers for at least parts of their workflow. Larger than AdobeRGB's Gamut, it includes all colors likely available in printers for many years to come. But, with such a large color space, it's very easy to edit colors that are unprintable. And finally, ProPhotoRGB includes colors that

cannot be rendered on any monitor. However, it is useful on the input end of an advanced workflow: it will encompass all the colors from your camera, for instance.

We don't recommend ProPhotoRGB for editing images, even though it allows access to all colors any printer can print. In fact, it offers access to many colors that *no* printer can print. Nonetheless, it is the right choice for Adobe Camera RAW's Workflow Options and for Adobe Photoshop Lightroom, as these need to take in all of your camera's colors. They then can deliver to Photoshop a more reasonable gamut, perhaps Adobe RGB, using the settings below, .

Color Space Settings

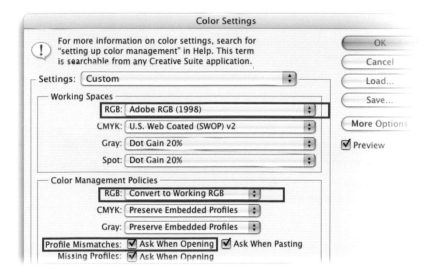

Use the Color Settings dialog to configure your color space by selecting Edit > Color Settings. (See also the Color Settings section of the Introduction.)

Begin by changing the Settings: Option to the Prepress option appropriate for your region of the world (North America Prepress 2, Europe Prepress 2, Japan Prepress 2).

For now, leave CMYK, Gray, and Spot as defaulted. Any print shop with whom you do business will guide you here.

Under Color Management Policies, set the default RGB: Policy to "Convert to Working RGB." As a result, an image opened that was created with a color space other than your default causes an "Embedded Profile Mismatch" dialog to open, warning that the image color space is not the same as the working color space. It gives you the option to use, convert, or discard the embedded profile. Typically, you would convert images into your default color space, and this setting ensures that conversion is the default choice.

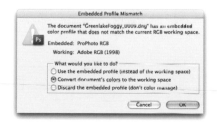

Convert to sRGB

If your default color space is AdobeRGB, you must convert your images to sRGB for uses where sRGB is assumed; e.g. preparing images for web pages, placing images in standard office applications, or sending images to most printers. Otherwise color results can be unpredictable and typically drab, as illustrated.

To convert an image to sRGB, select Edit > Convert to Profile. Just set the Destination space to "sRGB…" and set the Intent to 'Perceptual' as shown. Click OK to convert. Likely, your image will appear unchanged.

sRGB assumed but AdobeRGB provided *Converted to sRGB*

Components of a Good Print

Paper

Paper is one of the most important components of a good-looking print yet is often the most overlooked. Even inexpensive printers can produce excellent prints with the correct premium paper. The Epson 980 printer is several years old, yet still produces great prints when we use Epson Heavyweight Matte photo papers. The printer and the paper are manufactured to work specifically and especially well with each other. Check your printer manual for papers designed specifically for your printer. Choose the best paper to get the best print. For Basic Printing, use the printer manufacturer's premium photo papers. Advanced Printing using printer profiles allows for a vast array of papers from various manufacturers. However, you should still stick to using your printer manufacturer's inks.

Printer Driver Settings

The printer driver includes settings for specifically supported papers, print quality, and color correction. It is important all are set properly. Check your printer manual for specific instructions. The number one cause of bad prints is incorrect printer driver settings. More on this in the section on Basic Printing (pages 112-114).

Note: the driver settings for Basic Printing and Printing with Profiles will differ dramatically. With the former, we depend on the driver to manage all color conversions and corrections. In the latter, Photoshop governs those, and so we must not have the driver do any of it.

Color Space

Basic Printing Good color can only happen if your images are in the correct color space when printed. Many Epson printers, for example, now support data from either sRGB (using its "Epson Standard" settings) or AdobeRGB (with settings that match). If your printer doesn't support AdobeRGB, you should print your images from sRGB

Printing with Profiles The methodology used to print with printer profiles allows conversion from any working color space to any printer color space profile. Nonetheless, we still recommend AdobeRGB.

Viewing Lights

Printers are generally designed to create images that look accurate when viewed under daylight. But most people view their prints indoors under tungsten lights which are much more yellow and dimmer than sunlight. Viewing under tungsten lights results in images that appear to have little shadow detail and a noticeable yellow cast. It's best to get a good viewing light. Professionals use expensive D50 (5000K is another designation) or D65 viewing lamps available from quality lighting stores. Many office supply stores carry more moderately priced desktop daylight fluorescent lights. Other photographers use desktop halogen lights—the 20W–35W models produce a good bright light. Even though halogen light is still noticeably more yellow than daylight, it is often considered a better match for viewing prints indoors. Get a good bright light for viewing your prints. Not all of us can do what a friend of Steve's does: he goes outside to view his prints—but he lives in Southern California where he enjoys extended periods of "daylight balanced" outdoor lighting, as well as warm breezes.

Printer

Many people believe only expensive, dedicated photo printers produce excellent images. But, many desktop printers print very well. The biggest advantage of dedicated photo printers is prints that will last many years; manufacturers claim over 100 years. This isn't trivial if you want your photos to last. The best photographers look to the newer photo printers with inks designed to print extremely rich colors and gorgeous black & whites.

But don't run out and buy a new, expensive photo printer right away. First learn the process for good image editing and printing on your current printer. If you're in the market to buy one, at least buy an inexpensive, modern desktop printer. As you learn, you'll better determine your own needs and will be able to make a more informed choice when you buy a professional level printer.

Proof Prints

You can make a quick proof print to see where the image really stands. Make it about 5" x 7" (18cm x 12.5cm) to print quickly on a desktop printer, yet be large enough to evaluate. Print it onto an A4 or letter-sized sheet of paper; the unused white space provides a good frame for the proof print.

Printing a Quick Proof Version of your Image

To quickly print a 5" x 7" (18cm x 12.5cm) version of your image, change the print size in the Print dialog in Photoshop. For final prints, do not resize your image in this dialog, since it's not as precise as using the Image Size dialog. But it is adequate for a quick proof print.

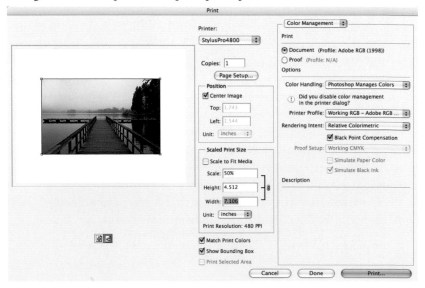

1. Do not resize your print for the proof.

2. Select File > Print. In the Print dialog, change the long dimension (Height or Width) under Scaled Print Size to create a 5" x 7" or 18cm x 12.5cm print; changing one will automatically change the other.

3. The preview will display the layout of your image on the page. To select letter or A4 size paper or rotate paper orientation, you may need to select the Page Setup option. The Preview should display the 5" x 7" version of your image nested inside an A4 or letter-sized layout.

4. Finish by printing normally.

5. The next time you open the Print dialog, ensure that Scaled Print Size is set back to 100%.

Printing a Selection from your Print

If your image is much larger than A4 or letter-sized, you may wish to make a proof print of a 5" x7" (18cm x 12.5cm) selection out of your image. This allows you to preview a piece of the image as it will print in the final image.

1. Make sure your image has no current selections; Select > Deselect. Choose the Rectangular Marquee tool from the tool palette. In the Options Bar, change the Style on the to Fixed Size. The Width and Height options now become available. Make these 5" and 7" (or 18cm and 12.5cm).

2. Place the selection on the image—just click on the image and a rectangular selection will appear with the correct dimensions; you can move this selection around by dragging it to get the exact placement that you want. If the rectangular selection is the wrong orientation (i.e. vertical when you want horizontal), click on the Switch arrows between the Width and Height options on the Options Bar.

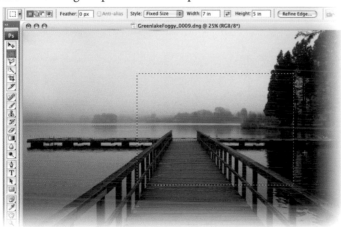

3. Select File > Print. In the Print Dialog select the Print Selected Area option under Scaled Print Size. Photoshop will now print only your selection (which is exactly 5″x7″ or 18cm x 12.5cm). Note that the preview does not display the selection as it will appear on the final print.

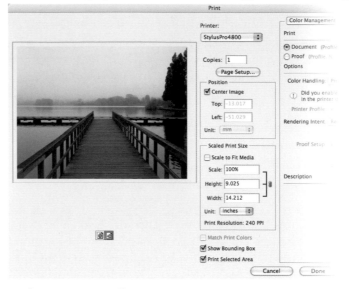

4. Print the image normally.

Preparing Images for Final Print

Up to this point, the work that you have done to your image isn't particularly dependent on the final target for the image: the final size or print medium. But now you will perform edits on your image that are. We often don't know how our images will be printed when we start working on them, or we want to be able to print an image in a few different ways; so we make sure that these printer specific steps are performed after we have completed all of our basic edits, and have saved and labelled the edited image. In fact, we often create a separate, duplicate image made specifically for a given print medium and size.

This may seem like a lot of work to just get your image ready to print, but with some practice, you will be able to perform all of the steps required in about a minute.

Outline of the Print Prep Stage

▸ **Save the Edited Image**—You have been working on your image for a couple of hours now, and before you rush into printing the image, save it. The printing process involves several steps that alter your image in ways that are specific to a particular size or paper type. Save the file as a Photoshop file to keep all of the edits and layers.

▸ **Create a Flattened Duplicate Image**—Once you have saved your master file, the duplicate will not need to have all those layers; and it is generally best to sharpen on a flattened image file.

▸ **Determine the Print Parameters**—You need to determine the printer, paper, and print size that you want to use for this image.

▸ **Crop the Image (if appropriate)**—Often the final print needs to match a particular aspect ratio (i.e., 8"x10" or 5"x7"). If you need to match a specific height and width, then you will likely need to crop the image to fit.

▸ **Resize the Image**—Resize/resample the image to the target print size (i.e., 8"x 10") *and* the appropriate printer resolution.

▸ **Sharpen the Image**—Digital images generally improve with a modest amount of sharpening, especially after resampling.

▸ **Print**—Make sure you have the printer driver set to the optimal settings for your particular paper.

▸ **Save the Print File**—If you like the results, save the print file; this file is specific to a particular print size, printer, and paper; if you're not satisfied, go back to the master file you saved in the first step and continue editing.

Now, let's look at each of these steps in detail.

Save the Edited Image

Likely, you will already have a saved file for your edited image. After completing all of your other edits and are confident that it reflects your vision, save this image so that you have a protected version of it that includes all your edits and layers (File > Save). In Bridge (or Lightroom), label the image as your Master (we use the purple label for this).

Duplicate your master image—maybe this is a bit cautious, but we recommend making a duplicate of your edited image so you can perform all of your print prep steps with far less concern or confusion. Select Image > Duplicate…. in the Duplicate Dialog, change the name to '[My Image]_Print' (or an even more specific name that includes the printer and size, like "Tower of London E2200 8x10_Print"). Select 'Duplicate Merged Layers Only' to flatten the image and skip the next step.

Save this duplicate in the same folder as your original. Before you forget, you should probably use Bridge to label it as an "Alternate" (blue) and "Stack" it with the original, so you can always identify one from the other.

Determine the Print Parameters

For a high quality print, you will need to resize the image for a specific printer and size. You get to choose these (you are the artist here). Just select the printer and the size that you want to print. Remember that your image must be able to fit onto the paper—an 8"x12" image won't fit onto an 8½"x11" piece of paper.

You will need to crop your image if you want the image to fill a specific sized piece of paper, or you will be placing the image into a document for printing; you may need to print to a specific shape and size.

Crop your Image

Often your image is not the right shape to fit your final print. Typically, images from digital cameras mimic the long format of 35mm film, a format that has the proportions of 4"x6". If you want to fit this into a more traditional print proportion, like 5"x7" or 8"x10", you will need to crop off some of the long end.

1. Select the crop tool from the Tool Palette.

2. In the Options Bar for the Crop Tool, input the Width and Height for the target print; this will ensure that you crop to these specific proportions. Make sure the Resolution is blank; you will set the resolution when you resample the image.

| 口 ▾ | Width: 12 cm | ⇄ | Height: 18 cm | Resolution: | | pixels/inch ▾ | Front Image | Clear |

3. Drag the Crop Tool across your image to roughly define the area of the crop; the Crop Tool restricts the crop to the proportions entered in the Options Bar; you can make the crop any size your want. If the crop tool restricts you to a vertical crop, and you want to make a horizontal one (or visa-a-versa); hit <Esc> to cancel the crop, and hit the switching arrows between the width and height to exchange these, and drag the crop tool across your image again. Drag from within the crop area to reposition the crop as necessary.

 Once your have drawn and positioned the crop to fit your final image, hit the <Enter> key to accept the crop.

Resize the Image

Note: You should not have resampled your image at any point yet—there should be as many pixels in the uncropped area as there were when the image was born. Computers are very good at resampling and scaling images, but there are some potential problems with resampling, so generally, you should only resample your image once—when you are getting ready to output.

The resolution of your image doesn't really matter to Photoshop; Photoshop views the image merely as a large array of pixels without any specific 'size'. As you edit, your image may have a wide range of possible resolutions—many digital camera images have a resolution of 72ppi, and sizes around 20"x24"; scanned 35mm film usually has a resolution around 4000ppi, and a size of about 1"x 1½". You'll set the appropriate size and resolution right before you print.

To resize and/or resample, select Image > Image Size to open the Image Size dialog.

Make sure that the option for Constrain Proportions is set to ensure that we don't stretch or squish our image. Also, make sure the option for Resample Image is set.

Input the target Width or Height; since these will change in proportion, changing one will also change the other.

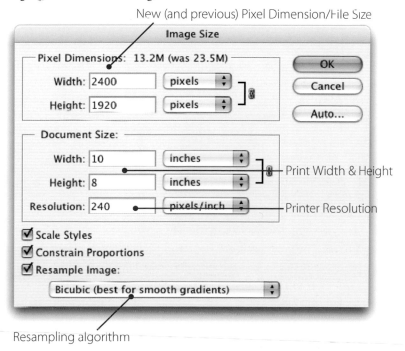

New (and previous) Pixel Dimension/File Size

Print Width & Height

Printer Resolution

Resampling algorithm

Input the target resolution for your printer. Almost all print devices print at a resolution of 300ppi; if you don't know your printer's resolution, set it to 300ppi. For Epson printers, use a resolution of 240ppi or, for images

with very sharp details printed onto glossy papers or film, Epson printers can also use a resolution of 360ppi.

Some printers used by online services to print onto traditional photographic papers (like Lightjet, Chromira, or Frontier printers) have unusual resolutions like 304.6ppi. But these printers generally do a very good job of resizing your image to this exact resolution. For these printers, set the resolution to 300ppi.

Finally, you need to set the appropriate Resample Algorithm. Up at the top of the dialog are the new (and old) pixel dimensions for this image; if the new dimension is larger than the old one (you are adding pixels to your image), then set the Resample Algorithm to Bicubic Smoother; if the new dimension is smaller than the older one, set the Resample Algorithm to Bicubic Sharper.

There are lots of add-on tools for Photoshop that perform sophisticated resampling algorithms; these tools often provide some benefit for resizing images to large sizes while maintaining sharp detail. This was a major issue for earlier versions of Photoshop, but the options available beginning with Photoshop CS2 are quite good for most images.

Sharpening

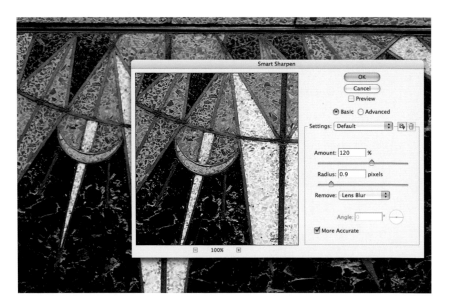

Photoshop CS2 introduced an excellent new tool for sharpening images—the Smart Sharpen filter. This tool is both easier to use and sharpens better than the traditional sharpening tools. Always sharpen after you have resampled your image.

1. Your print image should have only one layer; but it can be a Smart Object. Plus, make sure that your image view is set to 'Actual Pixels', so

you can preview the image well.

2. Select Filter > Sharpen > Smart Sharpen.

3. Within the Smart Sharpen dialog, set the Amount to 100%, the radius to between 1 and 1.5, and the Remove option to 'Lens Blur'. Turn on More Accurate—this slows down the filter considerably, but the time that you allow this filter to run is well worth it.

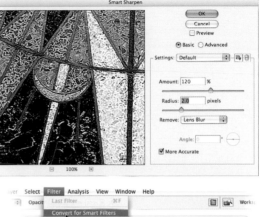

Over-sharpening…too easy to do.

4. Now adjust the Amount carefully: don't let the image look over-processed. If you find the Amount getting toward 300%, it may be that the image is simply too "soft." Learn to like it that way, or use another image.
That's it!

You may wish to experiment with the Amount to obtain the best sharpening, but be cautious, as too much can create harsh black & white lines ("haloes") around any sharp details in your image.

If you want to be able to revisit your sharpening decisions, add a Step "0" above:

0. Convert the **Background** or your only Layer to a Smart Object: **<control>**+click/ **Right-click** on the the layer's name in the Layers palette and choose Convert to Smart Object.

Then you'll be able to change the sharpening settings later, even weeks later.

Localized Sharpening

Localized sharpening is one of the easiest and most effective of the power sharpening techniques. Leaving some of the image unsharpened will make the sharpened areas more noticeable. It's also an ideal way to avoid making areas that are almost too noisy even more so.

1. Convert the **Background** or your only Layer to a Smart Object: **<control>**+click/ **Right-click** on the the layer's name in the Layers palette and choose Convert to Smart Object.

2. Select Filter > Sharpen > Smart Sharpen to create a Smart Filter.

3. Run the Smart Sharpen filter as suggested in the previous section on sharpening.

4. Note that the Smart Filter has a mask. Select the Brush tool, set the default colors and switch these so that the foreground color is black, and paint over the image where you want to hide the sharpening. This allows the sharpening to focus on the important parts of your image.

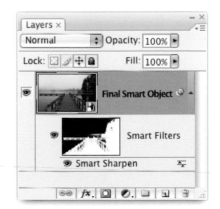

Edge Sharpening If your image has lots of grain or other texture, you may need to perform edge sharpening in order to sharpen well without also sharpening the grain. Grain is common in images shot on some color or B&W negative films, especially high speed films.

Print

Finally, the print stage. You will likely be printing your images onto a desktop printer, from an online image printing service, or through a print service bureau. You can chose to print using the basic printer driver settings as outlined in the next section on "Basic Printing." Or you can print using profiles as outlined in the section on "Advanced Printing."

After you print your image, make sure that you evaluate it under good lighting, ideally some sort of daylight-balanced light or a good, bright halogen light. The colors and density will be much easier to see under a good light.

Add an Annotation

Annotations are a great way to add details about the printing process to an image and keep all these details together with the print file. Select the Note tool from the Tool Palette and click on the image.

Type in all the details about how you created a good print from this file, including printer, paper, printer settings, profiles, and other printing details. Annotations can be saved as part of a Photoshop PSD, PDF, or TIFF file.

Save the Print File

Once you have a print file that you like, save it under a name that will help you to identify the image and printing process later; include the print size and print technique in the file name; "My Image Print E2200_8x8" for an Epson 2200 print at 8″x8″. If you have added layers in the print prep process, go ahead and flatten the image again. Save the Print file as a TIFF file.

Most desktop printers and many on-line print services will add some additional contrast to your image in the printer driver. This was designed to make the prints just a bit snappier—which is tremendously frustrating: we want the driver to print our image exactly as we send it to the printer. This can be corrected before sharpening.

Basic Printing

Today, most printers produce excellent color prints as long as you work with the manufacturer's papers and inks, and you properly configure the printer driver. Now that you've done all the print prep, we're ready to print.

1. Convert the image to sRGB *if needed.*

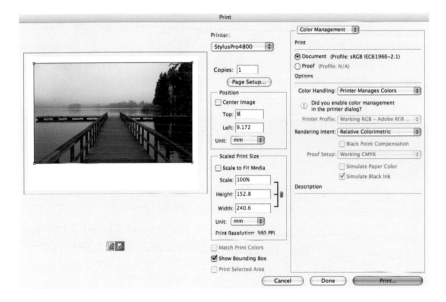

2. Select File > Print… to access the Print dialog. The first time you access this dialog, the default settings are set properly for basic printing. But, look at the Color Management settings (menu in top-right) to understand what they do.

 In the Print area, the option for Document should be selected. This also displays the profile or color space for the image to be printed.

 The Color Handling option is set to Printer Manages Colors. This allows the printer driver to handle the color for this image; Photoshop merely passes the image to the printer driver unchanged.

 The Rendering Intent defines how the image colors are converted from one profile into another. Use the Perceptual intent for basic printing and the Relative Colorimetric intent for advanced printing.

 In the Position area, the Center Image option is checked. In the Scaled Print Size area, the Scale option is set to 100%.

 The preview window reflects at this point how your image would print onto the paper you've selected.

3. Click on the **Page Setup** button to open the Page Setup dialog. This dialog is different on a Mac and on Windows.

On a Mac, select the Printer, Paper Size, and orientation for your print. First select the printer you want, then select the appropriate paper size and orientation.

On Windows, you must first select the Printer button to access the Printer Select dialog, then you can select a printer other than the default printer. In the Page Setup dialog, select appropriate paper size and orientation. Press OK in the Page Setup dialog to return to the Print dialog.

4. Now, the print preview reflects your image centered on the paper size you selected. If your image appears much larger or smaller than the paper size, you probably didn't follow the print prep steps properly to resize your image. Cancel out of the Print dialog and resize the image.

5. Once the preview looks good, and the Color Management settings are correct, click the Print button. Once again, the dialog is different between Mac and Windows.

Mac Print Dialog

In the Mac Print dialog, select the Print Settings option to access the settings for your printer driver. These settings differ for each type of printer, but almost all printer drivers have options for Paper (or Media) Type, Mode, and Quality. Set Paper Type to match the paper you're using. (You'll only have choices of the manufacturer's papers; here Epson's "Matte Paper—Heavyweight.") Set Mode to Automatic and set Quality to the highest setting available. Check your printer's manual for details on these printer settings.

Next, change Print Settings to the Color Management option. (Some printer drivers refer to this setting as ColorSync, while some have no color management options at all.) For most printers, the default Color Management option is set to Color Controls or Automatic; this works best for most printers. Your printer may also have an option for ColorSync; this may allow your printer to print images in color spaces other than sRGB. Check the printer manual for details on ColorSync.

Finally, click on Print to print the image.

Windows Print Dialog

In the Windows Print dialog, select the appropriate printer from the printer list, and click on Properties to access that printer's print properties dialog.

The Properties dialog is different for each type or printer, but almost all printer drivers have options for media type, print mode, and/or print quality. Set the Paper Type option dropdown to match the paper type you want. (You'll only have choices of the manufacturer's papers; here Epson's "Matte Paper—Heavyweight.") Set the Quality option to the highest quality setting available. If available, set the print mode to Automatic, Photo, or Quality.

Look for the Color Management options for your printer; these may be available on the Advanced page for the printer driver. The default Color Management option is set at Color Controls or Automatic for many printers, which usually works best. Your printer may also have an option for ICM; this may allow your printer to print images in color spaces other than sRGB. Check the printer manual for details on ICM.

Finally, click on Print to print the image.

Note: In the Printer driver dialog, select the paper or media to exactly match the paper you are using, set the driver to print the highest quality, and set the printer's Color Management to Color Controls or Automatic. You might also use ColorSync or ICM for color management.

Online Printing Services

Online printing services allow you to upload your images via the Internet and have high quality prints made onto traditional photographic media. Online printing services have some great advantages: they produce images with the look and feel of traditional photos, they're generally cheaper than similar inkjet prints, they don't require a complex printer dialog, and they typically offer sizes from 4″x6″ (15cm x 10cm) up to poster size (20″x 30″). The only major disadvantage of online printing services is the printing is somewhere other than your desktop, so it takes time to get the final prints.

Photoshop CS3 supports online printing directly via Adobe Photoshop Services handled in North America and Europe by Kodak EasyShare Gallery. Similar services are available in other parts of the world.

Kodak EasyShare is an excellent example of a consumer online service. Prints from Kodak EasyShare can also be excellent if you conform to their requirements. To print with Kodak EasyShare, an image must be saved as a JPEG file in the sRGB color space. To print using an online printing service, use the following steps.

1. To duplicate your image select Image > Duplicate Image… Give the duplicate image a simple name—"my image webprint," for example. If your image has layers, select the option Duplicate Merged Layers Only.

2. Make sure your image is in the sRGB color space.

3. Make sure your image is set to 8 Bits per channel to make a JPEG file. Select Image > Mode > 8 Bits /Channel.

4. Save your image as a JPEG file, select File > Save As…, set Format to JPEG and click OK. In the JPEG properties dialog, set quality to 9—"Maximum."

5. Send a single file to print online by selecting File > Print Online in Photoshop. But more often, you want to save a set of images and print them all together. Once you have a set of images ready, open Adobe Bridge by selecting File > Browse…

In Adobe Bridge, select the images you want to print online, and then select Tools > Photoshop Services > Photo Prints… This opens the Kodak EasyShare Gallery and loads your images. (The first time you access Photoshop Services you need to register with them, i.e., supply some basic information and create a login ID and password.) Within Kodak EasyShare, merely select the prints for each image and check out. If you made sure your images were in the correct format, excellent images will arrive in a few days.

Advanced Printing

The main focus of advanced printing is printing with printer profiles designed specifically for your printer and paper. The main advantage of printing with profiles is a more precise match between the edited image, the monitor, and the printer. This allows careful editing of print colors on the computer before you print and the ability to use most or all of the color range available from your printer. In order to print with profiles, you will need to obtain the appropriate profiles for your printer.

Manufacturer's Profiles The easiest source of profiles is from the appropriate paper manufacturer (including the printer manufacturer for the papers that they sell for that printer). Printer profiles are widely available for many photo printers on the websites of a number of paper manufacturers. Many make excellent profiles for their papers on a number of printers popular with professional print makers. Epson, Ilford, Kodak, Legion Paper, Red River Paper, Pictorico, and others provide printer profiles for their papers via the Internet. And often the paper box provides a website for profiles. You need to obtain profiles for your specific printer model *and* paper type. Usually, profiles are only available for the printer manufacturer's inks, but if the printer can use multiple types of ink (like the Epson 2200 or R2400 printers), be careful about which inks you use. For example, if your printer uses either matte or "photo" black ink, you need to use a profile for the black that is in your printer. Additionally, find specific instructions that may be included for each profile on how to configure the printer driver. If the driver settings are not configured on your computer in the same way as they were when the printer profile was created, the profile probably won't print properly. The specific settings to look for are media type (one chooses a paper supported by the printer), resolution, and quality setting. Other items may be specified.

Custom Profiles You can also have custom profiles made for you by a professional profile service. These have some advantages but cost money. A quick Google for "custom printer profiles" found several services for around $40. These companies provide a test target and instructions on how to best print this target. You print the target, snail mail the physical target to the profile service, and they email you the specific profile. It is necessary to purchase a profile for each paper type you'll be using. One service that makes this process a bit easier, including the installation of the profiles (see below), is provided by a company called Chromix (chromix.com).

Some photographers choose to make their own custom profiles. However, this requires both expensive hardware and software, and a solid understanding of color management practices.

Installing Profiles Once you download the profiles, you need to install them. Some of the manufacturer's profiles include an installer that installs the profile for you, but most require that you install them yourself.

AdobeRGB1998.icc

On Mac OSX, copy the profiles to the appropriate directory. If you have administrator privileges for your computer (most users running their own desktop computers have such privileges), use the <drive>/Library/ColorSync/ Profiles folder. Just move the profile files to this location. If you don't have administrator privileges, use the <drive>/Users/<username>/Library/ ColorSync/Profiles folder. You'll have private access to profiles in this folder. Once installed, you'll be able to use these profiles from within Photoshop.

With Windows XP, install the profile by right-clicking on the profile and selecting Install Profile from the context menu. This action copies the profile to the appropriate directory.

Profile Names Profiles can be named almost anything, but there's a general consensus that a good profile name includes a reference to the printer model, paper, and ink (if appropriate). A typical Epson profile is named "EP2200 EnhancedMatte 2880MK.icc"—the printer is Epson 2200, the paper Enhanced Matte, the ink Matte Black (MK), the printer resolution 2880dpi.

Set up the Proof

One advantage of printing with profiles is the ability to Soft Proof the image before printing. Soft proofing allows Photoshop to mimic the look of the final print on the monitor.

1. To setup soft proof, select View > Proof Setup > Custom…

2. For Device to Simulate select the printer profile for the printer/paper combination you'll use to print.

3. Set Rendering Intent to "Relative Colorimetric."

4. Turn on Black Point Compensation. This matches the black point in your image to the darkest black of the printer.

5. Use the Simulate Paper Color option to better mimic the look of the print in the proof. Often, selecting this option makes the image appear washed out. Don't select this option for bright white photo papers, but definitely use it for papers that are noticeably off-white.

6. Save a proof setup you use often by clicking the Save button. Give it a useful name incorporating the printer and paper names, like "EPR2400 Prem Luster." This name then appears at the bottom of the View > Proof Setup menu for easy access in the future.

7. Photoshop now displays a soft proof of how your image will print using this profile. There might be some minor color shifts in the print to correct at this point. Display a new view without the soft proof by selecting Window > Arrange > New Window… for before and after views. The title

for each view displays if a profile was applied to it.

Printing with Profiles

Once you've adjusted the image to taste, printing with profiles is *similar to* the basic printing steps, but there are some important differences.

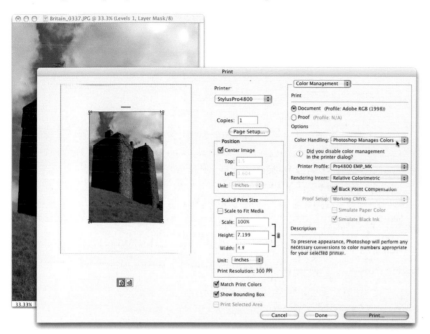

1. Select File > Print… In the Print Dialog, select Page Setup to access the page setup dialog, then select the appropriate paper size and orientation.

2. Set **Color Handling** to Photoshop Manages Color. Notice the little note that appears immediately under that choice which asks: "Did you disable color management in the printer dialog?" You will shortly! Choose the **Printer Profile** for your printer/paper/ink combination (likely the one you just "proofed"). This section is also where you set the **Rendering Intent** (method used by Photoshop to convert to your printer's color profile). Some downloadable (and custom) profiles indicate an Intent. However, you may wish to experiment.

 Choose either **Perceptual** or **Relative Colorimetric**, then hover your cursor above that choice. You'll see a description of that Intent in the space below. The short version is this: Relative Colorimetric will give a better match to your edited images' colors, but may lose gradations in *very* saturated areas (e.g., intense blue skies); Perceptual won't clip your saturated colors, but it tends to make colors throughout the image more bland and shadows less deep.

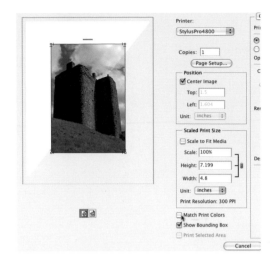

3. Set your sizing and positioning options in the center of the dialog. Notice the "Match Colors" checkbox. This gives you a soft-proof here in the Print dialog. In this illustration, we split the view diagonally so you can see a kind of before/after. Note how the preview will show paper color if that has been built into the profile!

Bleed: *When you intend to trim to the final crop, you have to assume that perfection cannot be acheived. So we let the image "bleed" past the crop a small amount.*

4. In the menu in the upper-right, you can choose Output. The dialog displays options for Printing Marks and other options such as Bleed. In the example here, we set bleed to ¼" and we enabled crop marks which are set into the image by a distance equal to the bleed.

5. Click Print to access the Print dialogs. Once again the dialog is different between Mac and Windows. This is where you disable color management. Since Photohop will have done the conversion the moment you hit the Print button, you will not want the printer driver software to do it again!

Images for the Web & Devices

4

Today, more images are placed onto the web than printed. The web has become a primary medium for communication, and images are as important on the web as they are for any print media. This chapter covers some considerations for web images, and provides some tasks useful for creating images for the web. It does not describe the entire process for creating websites, nor for creating complex web elements like rollovers and buttons, as these topics would certainly require much more space than these few pages.

It is important for anyone involved in image creating and editing to know a few essential tasks for targeting images for the web. Some of these tasks can be done in a simple way, such as creating an image to send via email, but following a few basic steps can help make the images look significantly better. Some tasks, like creating thumbnail images, are often handled by automated tools that can make a mess of a good image. And some of the tasks are commonly handled by web designers using image editing tools that have features that are useful to web pros, but lack the image editing power of Photoshop.

Even if you do not initially target your images for the web, review these tasks, since it is certain that at some point your better images will need to be posted to the Internet—and you will want control over how they get there.

Lastly, the digital world is fairly ignorant about color. Adobe is one of the few companies that provide real color management solutions. Very few computer applications provide any color management or implement color management well. If you intend to use your images for traditional office or consumer publishing applications, you should follow the tasks listed in this chapter.

Tasks for Web Images

The following issues should all be considered when creating an image for use on the web (or for use with most typical office applications):

▸ Precisely downsample to the required dimensions (usually to the pixel) using the Bicubic Sharper resampling method

▸ Converted to the sRGB color space

▸ Saved as JPEG

Precise Resampling

Most programs used to create web pages are optimized to render images quickly rather than accurately. If you provide an image to a web designer that must be resampled, or worse, if you place an image on a web page that is resized by the browser, awful results can occur. Resize your images to exactly the size it will be used on the web.

Bicubic Sharper Interpolation

Photoshop provides options for interpolating/resampling. The Bicubic Sharper option is especially good for web images: as most images are *down-sampled* for use on the web and Bicubic Sharper applies a gentle amount of sharpening and is recommended for downsampled images.

Bicubic Resampling Bicubic Sharper Resampling

Choose Image > Image Size. Check the box to Resample Image then immediately choose Bicubic Sharper from the menu at the bottom of the dialog box. It's easy to forget to do this as this is usually not the default method. If you create web images regularly, you may consider making this method the default (via Photoshop's General Preferences).

Specify the required Pixel Dimensions at the top of the Image Size dialog—these are determined during a site's design.

Convert to sRGB

The Web assumes images are in the sRGB color space. If your RGB working space is Adobe RGB or another color space, then you will need to convert all of your images to sRGB before saving them for the web. This is essential, since your Adobe RGB images will appear flat and desaturated when they are displayed on the web.

Adobe RGB in a browser sRGB in a browser

To convert an image to sRGB, select Edit > Convert to Profile. Set the Destination space to "sRGB…" and set the Intent to 'Perceptual' as shown. Click OK to convert. Likely, your image will appear unchanged.

If your image is using 16 bits/channel, you should convert it to 8 bits by choosing Image > Mode > 8 Bits/Channel.

Save As JPEG

Choose File > Save As then choose JPEG as the file format. In the dialog box that results, you can preview your image as you choose a Quality setting. For a moment, choose 0 to see the kinds of artifacts that JPEG compression might introduce if allowed. Increase the Quality, toggling the Preview periodically to gauge the fidelity of the resulting JPEG.

Sometimes a web designer may specify a maximum file size, which you can monitor in this dialog as well. Most often, we aim for the lowest Quality setting that renders an acceptable version of our image. To squeeze out a slightly lower file size, you can try to use the Baseline Optimized or Progressive Format Options, but these are less compatible with some older browsers and email programs.

Web files need to be small and still render a high quality image. The JPEG file format provides an excellent compromise between size and quality. Use JPEG files for your web images, and be willing to use the moderate quality settings that allow your files to be very small.

Save for Web & Devices

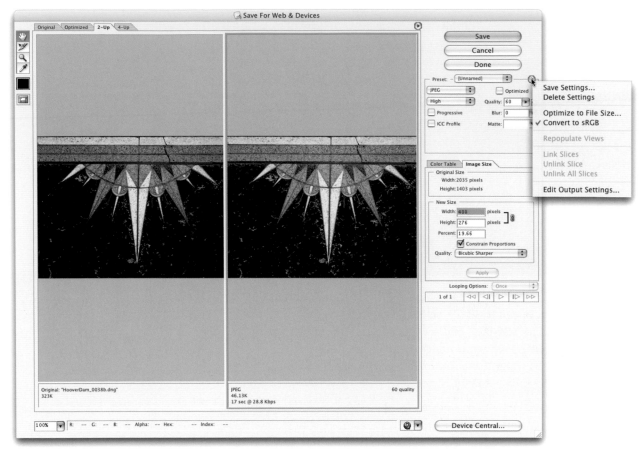

An alternative to the process in the previous section is the **Save for Web** dialog. In principle, you would open your full size Adobe RGB image, then use File > Save for Web & Devices.

Note that there is a "fly-out" menu where you can choose to automatically Convert to sRGB. Use it! You will also choose JPEG as the format, and set a Quality setting, although the scale runs from 0 to 100 rather than 0 to 12, as in the Save As JPEG dialog. Finally, there is an Image Size tab in the lower right which allows you to specify the desired pixel dimensions and resampling method.

Note: As of this writing, it does not seem that resampling uses any method other than Bicubic, regardless of the choice made. Therefore, you may wish to resample first, then use Save for Web & Devices.

Also, strangely, when using the Convert to sRGB setting, the preview doesn't seem to accurately reflect this choice, but the resulting JPEG does. But, do try to use both of these settings as Adobe may have fixed this issue by the time you read this. We hope so!

Device Central

You may notice the button in the very bottom-right of the Save for Web dialog: Device Central. Using that launches the new (in CS3) application from Adobe that emulates the behavior and characteristics of many mobile devices.

You can choose what sort of image (Background, Screensaver, etc.) you're preparing for the device you're testing. Specify scaling/fitting and positioning.

Creating an Email File

Email files are generally created to send a file so that it can be viewed on a computer screen. These images should be small enough so that they can be viewed on a typical computer, but still large enough to show sufficient detail. Also, most email systems have a limit on the size of attachments of about 1 to 2 megabytes; this limits the size and number of files that can be sent.

Save the image by selecting File > Save for Web & Devices. In the Save for Web dialog set the file format to JPEG, turn off Progressive, and turn on ICC Profile which you'll convert to sRGB from the Optimize fly-out menu. The File Information will display the file format and file size, so you will be able to monitor the size as you adjust the Quality and Image Size. If you're emailing only one file, the settings can be ambitiously high. If you're saving several for a single email, make sure the image sizes don't total more than your recipients' attachment limit (or yours!).

Thumbnails

The steps for saving web images can also be used for creating Thumbnail images for the web. It is very important to set the default resize algorithm to 'Bicubic Sharper' since it makes a significant difference for such small images.

Web Photo Gallery

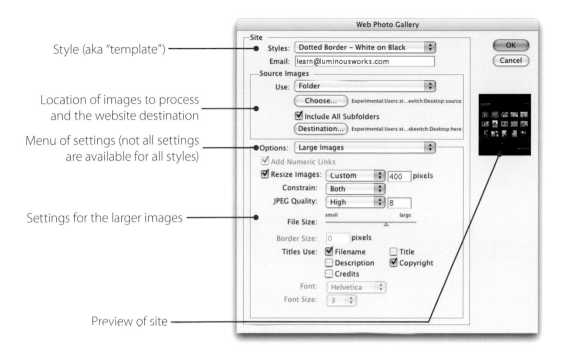

Style (aka "template")

Location of images to process and the website destination

Menu of settings (not all settings are available for all styles)

Settings for the larger images

Preview of site

Photoshop's Web Photo Gallery automation creates an entire web site quickly, complete with thumbnails and larger images. The thumbnails can be links to the larger images allowing a viewer to navigate an entire photo shoot easily. Some of the templates supplied even provide a chance for a viewer to add feedback on whichever images they choose, then email the comments along with a reference to the images to which those comments refer.

To use this feature, use File > Automate > Web Photo Gallery. At the top of the resulting dialog, choose the template ("Style") and enter the email address you want viewers to use to contact you.

When the process has been run, you will have a folder that contains all the necessary elements for a functional website or part of one. It is then up to you or your web designer to get this folder uploaded to your web server, and provide links to it from other pages on your site.

For example, if the folder is called "bahamas", the URL for the gallery could be http://www.yoursitename.com/bahamas. The folder would have to be uploaded to the right directory on your server (in this example, the same one as your home page).

So what's the down side? The images are resampled with only Bicubic resampling and thus look soft. Also, the images should already be in sRGB or they will look flat and desaturated as well. Thus, this feature is a compromise of quality in favor of tremendous speed and convenience.

Advanced Options

5

This chapter provides a location for all the commonly used advanced techniques that should be included in a book on image editing in Photoshop. But these techniques require some advanced knowledge that is best left until after you have a solid understanding of the basics of Photoshop.

A key for many of the tasks included in this chapter is the process of blending layers. The next section provides a description on how layers are blended and combined. Examples of blending layers are included in several tasks in this chapter.

The Toning section provides important techniques for adjusting image tone using tools beyond basic Levels and Curves. These include more precise techniques for using Levels and Curves, dodging and burning, and shadows and highlights. These techniques can replace similar basic adjustments provided in the Workflow chapter.

The Color section primarily provides additional options for adjusting the color balance of an image. A simple technique for using the Auto Color tool, and techniques for precisely correcting known colors like grays or skin tones are provided.

The section on Black and White images provides techniques for converting images from color into black and white, and a simple technique for toning black and white images.

Finally, the section on Photographic interpretive effects provides a few tasks that apply different looks to the image. These include adding film grain, split-toning or applying variable focus.

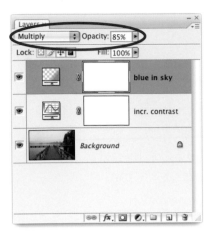

Blending Layers

This is a discussion on creating a more sophisticated blending of layers. Some of the advanced tasks in this book include steps that use these techniques for blending layers; this section should help you understand how layer blending works.

Typically, an Image Layer completely obscures the pixels in the layer(s) below it. However, a layer can also be visually blended with those below it. There are two basic options for blending layers—Opacity and Blending Modes. Both are important for blending layers. The default opacity for a layer is 100%. The default Blending Mode for a layer is Normal—the pixels of the layer with these defaults merely hide the pixels in the layer(s) below it. For many cases, these values work well, but let's consider changing them.

Note: You cannot change the Blending Mode or Opacity of the Background layer.

Opacity

The opacity of a layer is easy to understand. Lowering the opacity makes the image semi-transparent. Opacity is the opposite of transparency—a 100% opaque layer can't be seen through at all; at 50% opacity, the layer is 50% transparent, and the layer blends 50/50 with the pixels below; at 0% opacity, the layer is 100% transparent, and you can see right through the layer. Just select the top-most layer in your image and change the opacity of the layer to experiment with it.

Lessening the Effect of Adjustment Layers Photoshop is a tool that demands some subtlety for editing images. Even after many years, we still often make adjustments that are of the right kind but are too strong. Opacity is a great way to "turn down" an Adjustment Layer. If you decide during the editing process that a particular Adjustment Layer is a bit too strong, you can reduce it by merely reducing the opacity of that layer—an Adjustment Layer set to 50% opacity is essentially the same as applying half the adjustment.

Smart Objects & Smart Filters Lowering the opacity also works for Smart Objects or the filters applied to them—in fact, it is great for Smart Objects, since it makes it easy to adjust the effect of a Smart Filter without having to create a new layer with the filter applied to it, then lowering its opacity.

Example: Soft Focus Effect

There are some effects that used to be created by duplicating a layer, or merging several layers, then applying a filter to that duplicate or merged duplicate. If one wanted a ghostly glow in an image, one might duplicate the layer, apply a Gaussian Blur to the duplicate, then lower the opacity to have the

blurred image coexisting with the sharp one. Now, we convert the layer (or layers) into a Smart Object, then apply a filter to that. Since the filter is applied nondestructively as a Smart Filter, it can be masked, or its Blending can be controlled (see illustration).

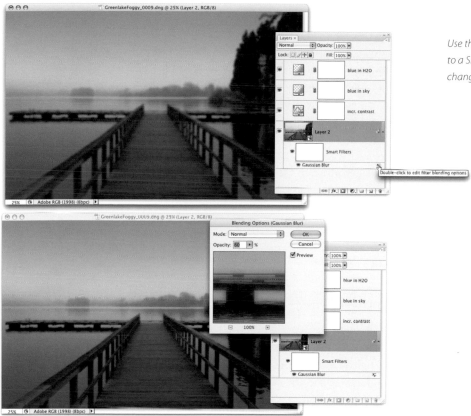

Use the Blending Options for a filter applied to a Smart Object to lower its opacity or change the filter's Blending Mode.

To convert one or more layers into a Smart Object to apply a Smart Filter, follow the steps below.

▸ Select the layers in the Layers palette

▸ **\<control\>**+click/ **\<Right-click\>** on the layer(s), choose Convert to Smart Object.

▸ Choose the filter you wish to apply from the Filter menu

▸ To adjust the filter's opacity or other blending options, double click on the slider icon (⚍) to the right of the filter's name in the Layers Palette (see above).

Normal

Multiply

Screen

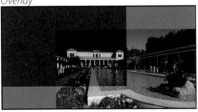

Overlay

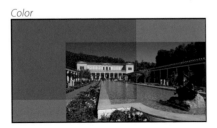

Color

Luminosity

Blending Modes

The Blending Mode for a layer sets how the pixels in that layer blend with the pixels in layers below it to create a new result. The default "Normal" Blending Mode is simply no blending.

The various Blending Modes can be divided into four basic categories: Darken, Lighten, Contrast, and Color modes.

The Darken modes make the resulting image darker by either yielding the darkest pixels of the blending layers (via the comparative modes Darken and Darker color) or by using the colors of each layer to reinforce each other. Multiply is probably the most definitive of the group. Imagine stacking two photographic slides one upon the other, then looking at the two on a light box: this is the same visual result as Multiply.

The Lighten modes make the resulting image lighter by either comparing the blended layers and yielding the lighter pixels (Lighten and Lighter Color) or by using the lighter pixels of the layer to which the mode is applied to brighten the layer below (Screen). Let's continue the slide analogy: instead of "sandwiching" the slides, let's imagine projecting two slides onto the same screen. Where each is lighter, it lets more light reach the screen, seeming to bleach away the other image. This is the result of Screen mode.

The Contrast modes make the result darker where the layer to which the mode is applied is darker than middle gray, and lighter where that layer is lighter than middle gray. The key here is Hard Light: where the layer to which its applied is lighter than middle gray it "Screens"; where it's darker than middle gray, it "Multiplies." What about where the layer is exactly middle gray? Then it's completely invisible! But, by emphasizing light and dark, overall contrast seems to increase. Overlay is probably more commonly used than Hard Light, however, as it leaves more of the underlying colors and textures present and "feels" more subtle.

The Color modes cause the layer to which they're applied to change only one aspect of the underlying layer(s): the Hue, Saturation, Color (Hue+Saturation), or Luminosity (density) of the image. The two that get the most use are the last two, Color and Luminosity, as they are the complementary ingredients of an image. That is, if you remove the color from an image, all you'll be left with is the Luminosity or grayscale part, or what most of us think of as the detail in an image. Somewhat more abstract, is Color. If you look through colored glass, it changes the colors you see but not the luminosity as much. Similarly, if you paint with colors on a layer to

| Normal |
| Dissolve |
| |
| Darken |
| Multiply |
| Color Burn |
| Linear Burn |
| Darker Color |
| |
| Lighten |
| Screen |
| Color Dodge |
| Linear Dodge (Add) |
| Lighter Color |
| |
| Overlay |
| Soft Light |
| Hard Light |
| Vivid Light |
| Linear Light |
| Pin Light |
| Hard Mix |
| |
| Difference |
| Exclusion |
| |
| Hue |
| Saturation |
| Color |
| Luminosity |

which Color mode has been applied, then you can simulate "hand-tinting" of the image below, changing its color but not it's tonal details.

Blending Adjustments

The Luminosity mode is especially useful with Adjustment Layers if you want an adjustment to change only the luminosity (or density) of the image and not its color. It is common for Adjustment Layers that apply significant density changes to also result in some moderate color changes. A Curves Adjustment Layer that adds a moderate amount of contrast can also result in a slight change in color—changing the Blending Mode of this Curves Adjustment Layer forces the layer to change the luminosity and not the color.

The color Blending Modes can be used for most common Adjustment Layers that adjust brightness, contrast, color, or saturation. In general, a brightness or contrast layer should only change luminosity (so the Blending Mode should be set to Luminosity); a color or saturation layer should change only color or saturation.

Original

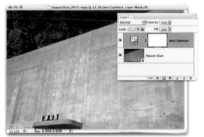
Contrast added Normal

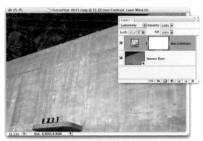
Contrast added Luminosity

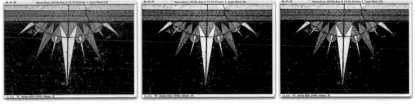
Original *Contrast added Normal* *Contrast added Luminosity*

Combining Images

Remove Random Content in Frames

Has the following ever happened to you? You're trying to photograph a scene, but vehicles, animals, or people keep passing in and out of it. Photoshop CS3 has a feature that will examine multiple images and average them. The result is that those parts of the scene that remain static and consistent remain, but those that are in only one frame disappear. The more images you make of a scene, the better this feature works.

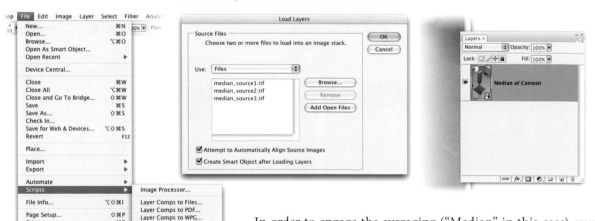

In order to engage the averaging ("Median" in this case), you have to load the images as both a Photoshop Stack and as a Smart Object.

1. Choose the command File > Scripts > Load Files into Stack…

2. From the dialog box that appears, you can "Browse" to your files or, if they're already open, add them to the list of files to stack.

3. Check both boxes at the bottom of the dialog: Photoshop will attempt—and likely succeed—to line up the images even if you had not used a tripod when shooting! Also, the images will not only be stacked as layers, but once loaded, they will automatically be converted into a Smart Object.

4. Finally, choose Layer > Smart Objects > Stack Mode > Median.

After some processing (it can take a few minutes), the images will be averaged, grain/noise will be reduced, and random elements should vanish. Very cool!

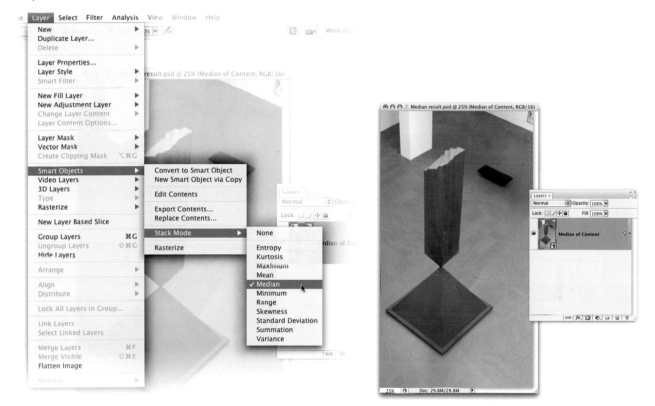

Keep in mind that despite our showing how this works with people as the random elements, this also works wonderfully to combat the noise that plagues digital images, especially in long or night exposures.

HDR: High Dynamic Range Images

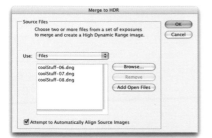

If you have a subject that has extremes of light and dark that cannot be captured in one exposure despite the powerful highlight and shadow recovery of Adobe Camera RAW, you can instead bracket several exposures, 1 to 2 F-stops apart.

The process that follows creates a Photoshop HDR (High Dynamic Range) image, which uses 32 bits per channel to describe an immense range of tonal detail.

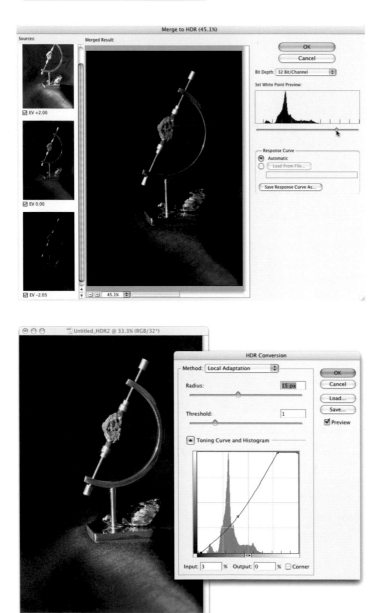

1. Once your bracketed images are downloaded to your computer, use the command File > Automate > Merge to HDR… to choose them for the creation of the HDR. Press OK.

2. Adjust the White Point Preview to make the HDR look *approximately* how you'd like it look in the end. But, at this point it doesn't matter so much: all the data is present even if you don't see details in the highlights or shadows—what you're adjusting is a preview only. Click **OK**.

3. At the bottom of the image window, you can adjust the Exposure slider to see a darker or lighter version of the image. Again, this is just letting you see some of the total data. To get an amalgam of all exposures, and at a "bit-depth" that is both printable and sharable (less than 32, likely only 8 bits/channel), we have to use Image > Mode > 8 Bits/Channel…

4. In the HDR Conversion dialog that follows, note the menu at the top, from which you should choose Local Adaptation.

5. Adjust the curve to give a pleasing rendition. It's easy to create something that is too flat, so you will likely bring in the white and black points to increase contrast somewhat, and pull the center down a little too. Each image will vary. The Radius describes the size of a "brightness area" (regions of image that need to be accounted for). Exeriment with this value and the Threshold. In the end, your image will have more tonal detail than any one of your bracketed exposures!

Composite Two or More Images

There are times when the image you want is the marriage of two or more images in your library. Here, we show you the basics of combining images to make one coherent composition.

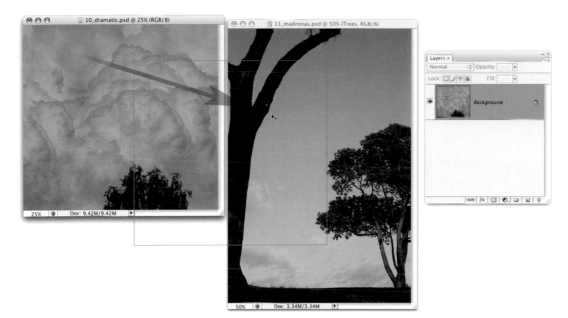

1. With both images open, use your Move Tool to drag one image into the other's window. Don't be timid: be sure the cursor makes the journey all the way to the destination image. **Tip:** Hold down your ⟨Shift⟩ key as you release the mouse to get the image you're dragging centered on the other.

2. Name your layers! You'll thank yourself later as they proliferate and you won't have to puzzle over what "Layer 47" contains.

3. If necessary, reorder the layers. In our example, the Trees layer will now be obscuring the clouds layer. Our objective will now be to mask the pixels of the Trees layer that we don't wish to see: the blue sky. The final image will be of trees in front of a more dramatic, threatening sky.

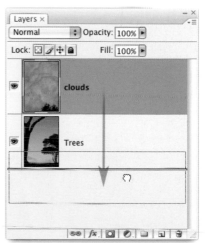

In this case, the image we brought over to the Trees image needs to be below. Simply grab the layer you want to move with your cursor and drag into the position it needs to be in.

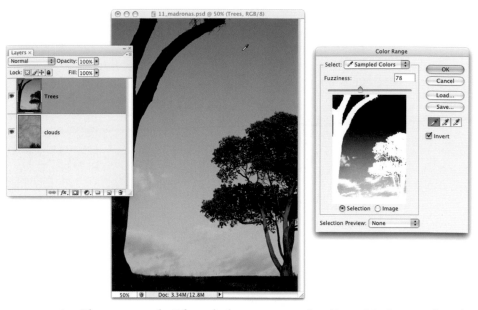

4. Plan your mask. Often, the best way to make a **Layer Mask** is to select the pixels that should remain *visible*, then click the **Add Layer Mask** button at the bottom of the Layers palette. The Quick Selection Tool or Color Range are frequently the ideal tools, especially for complex selections. If necessary, you can refine a selection by using Select > Refine Edge…

5. Here, we're using Color Range (Select > Color Range). First, using the **Eyedropper** tool within the Color Range dialog, click on the color you want to select. In our case, we want the trees selected, but the blue sky is easier! So we clicked the **Invert checkbox** so that we can use the dropper on the blue and cloud-colored pixels, but *everything else* (the trees and grass) will be selected when we're done.

6. After your first click on an area with the color to be selected (or not selected in our case—a blue sky pixel), switch to the **Add to Sample** dropper. Then you can quickly add more colors to the range by clicking on them or dragging across them.

 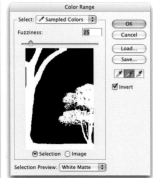

7. Adjust the **Fuzziness** slider to extend or narrow the range of colors getting selected. Monitor your progress by zooming in on areas of concern and using the **Selection Preview** choices at the bottom of the Color Range dialog box. In this example, we're using **White Matte** to hide the pixels in the color range. That way we can see what pixels will be selected when we're done (remember, we turned on **Invert**).

8. When the selection looks good (or good enough to refine with Select > Refine Edge…), click OK.

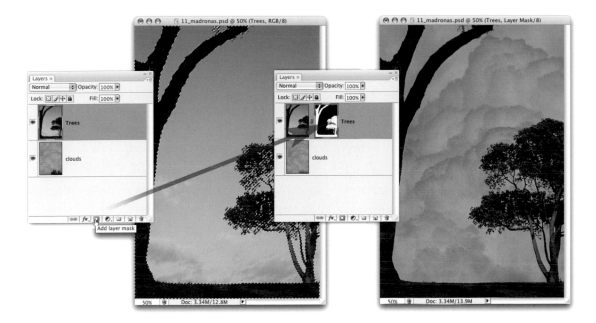

9. Be sure that the layer that needs masking is highlighted, then click on the **Add Layer Mask** button. In our example, the blue sky disappeared on this layer revealing the clouds below. You'll see the second thumbnail of the Layer Mask, white where pixels are visible, black where they aren't. If it's inverted from that, and the mask is still targeted (has a border around it), then you can use Image > Adjustments > Invert and it will reverse itself.

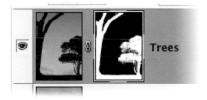

10. Lastly, you'll likely notice that the color, contrast, or tone of the introduced image doesn't quite match its new home. Therefore, it's very common to need an Adjustment Layer or two to harmonize the images. In this case, we created a Curves layer that lightens and "warms" the clouds (adding red and subtracting blue).

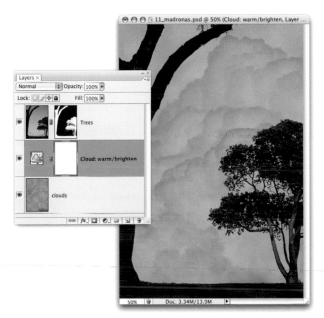

Advanced Adjustments—Tonal

The tonal value of a pixel is merely its brightness; given this simplicity, the adjustments to tonal value are generally very easy to perform. But, this simplicity often hides the importance of these basic adjustments; good tonal adjustments often result in very dramatic changes to an image.

Additionally, the tone of an individual pixel is usually less important than the relative value to other pixels, or the tonal contrast of the image. Contrast can apply to the overall image (the global contrast), and can apply just to nearby pixels (local contrast)—both are key to good image editing.

Note: Contrast is a complex idea in photography. Contrast is the juxtaposition of differences within an image. Photographers often limit contrast to differences in tone, but it is essential to understand the broader definition of contrast to place it as a foundation of image design. Contrast can involve tone, form, texture, color, saturation, focus, sharpness, or even subject matter—all of which can help define the parts of an image. You should keep in mind the various forms of contrast (tone, color, etc.) in your images.

In this section, we will introduce various techniques that we use to edit the tone of an image—these all really involve editing the tonal contrast (global and local) of the image.

The black & white point adjustment is one of the simplest adjustments that you can make to your images, but it is often the most important. This is one of the most effective techniques for improving tonal contrast to your image.

Precise Black & White Point Adjustment

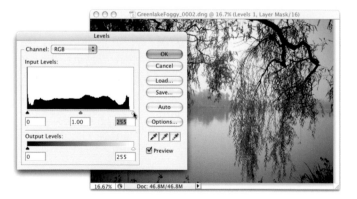

Most images should have full contrast, from a rich, maximum black to bright white. However, there should also be some detail in these black and white tones. The density of maximum black should be precisely set so the shadows still retain some density variation. This balance is difficult to achieve just by eye. Levels is excellent for adjusting the image pixels to these values precisely.

1. Create a new Levels Adjustment Layer by selecting Layer > New Adjustment Layer > Levels… Name this layer "B & W Points."

2. Examine the histogram for your image; ideally the histogram will cover the full range of tones from black to white.

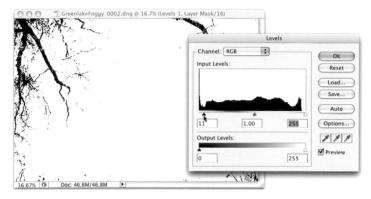

3. Slide the black input slider towards the right; the dark pixels in the image will turn slightly darker. Move the slider over just until the first pixels become pure black. To do this precisely, hold down the <option>/ <Alt> key while moving the black slider; the view of the image will go white, with a few points of black. The pixels shown as black will be turned pure black ("clipped" to black) by this adjustment. You should adjust the black input slider until as few pixels are set to black as you desire.

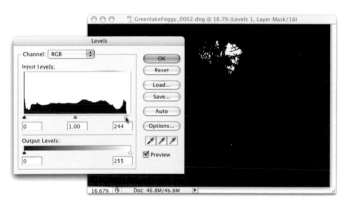

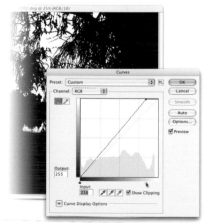

4. Next, slide the white input slider towards the left to set the white pixels, pressing the <option>/ <Alt> key while moving the white slider will show those pixels that will be clipped to white. Typically, the white point should be set so that just a few pixels will display as pure white; you may even wish to pull back the white point from making any pixels pure white. Solid white parts of the image often appear artificial and may lack any smooth details that you might expect in your highlights.

Your image should now have maximum contrast from black to white.

These "Clipping Previews" work in Curves in Photoshop CS3. Just click the Show Clipping checkbox, then as you adjust the Curves' endpoints or use the levels-like sliders, you'll see a clipping preview.

When working on color images, holding the ⟨option⟩/ ⟨Alt⟩ key will show pixels that are getting clipped in each channel by showing the color of the first channel to be clipped. So, if you slide the white point slider far enough to make the lightest pixels on the red channel only clip to white, then the preview will show these as red. If both the Red and Green channels are clipping, you'll see yellow (yellow = red + green), and so on.

Some Tips on Black and White Point Adjustments

The classic rule for setting the black & white points suggests that an image should have full contrast; from pure black to pure white with some shadow and highlight detail. But the truth is more complicated; there really are more options for controlling the full contrast of an image.

▶ For images with smooth highlights (such as portraits), you may wish to maintain a separation between the highlights and pure white. Pushing the whites of a portrait to pure white, even on just one channel, may appear ghastly.

▶ When printing black & white images, set the black point to ensure some areas of pure black. Areas of near black with detail often appear to be merely dark gray. Adjust your black input value so that a larger area of the image is printed purely black.

Dodging and Burning

This is a technique for mimicking the process of two traditional darkroom techniques—Dodging and Burning. Dodging results in lightening part of the image; burning results in darkening part of the image. Dodging and Burning also affect local contrast; dodging a light area of an image will reduce the local contrast; burning a light area of an image will increase it. The converse applies for dark areas. This technique uses two Adjustment Layers *that hold no adjustment!* One of these has its Blending Mode set to Multiply (to darken or "burn"), the other to Screen (to lighten or "dodge"). Earlier in this chapter, we discussed the Blending Modes, and how using them (especially Luminosity) is useful with adjustments. Now, even without an adjustment *per se*, blended Adjustment Layers are useful!

For this topic, we're taking advantage of an interesting feature of Photoshop: if you make an adjustment layer, even with no adjustment made, then set its Blending Mode to, e.g. Multiply, you get the same visual result as you would if you duplicated your original layer and changed its Blending Mode. The difference? With the Adjustment Layer, there is *no* increase to file size. There are other techniques that use Image Layers for burning and dodging, but they too incur a file size hit. Our method, once it gets developed, will also impact file size, but just a little.

Let's look at the technique with a typical example.

Burning:

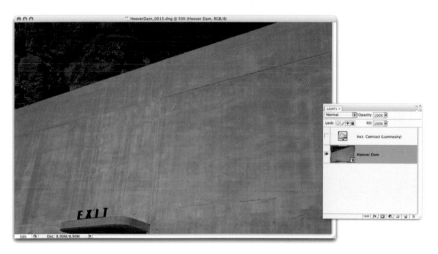

The original: OK composition, but bland and flat tonally.

1. The original: first we do our Global adjustments.

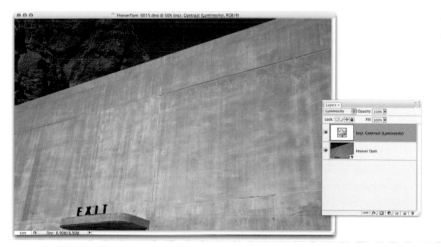

As was done earlier in the chapter, we added a contrast enhancement (set to Luminosity)

2. We added an overall contrast enhancement. Still, we desire more drama and focus on the Exit sign.

*We created a new Curves Adjustment Layer
(the type doesn't matter, but we chose Curves
in case we actually decided to make an
adjustment later).
We named the layer "Burn (Multiply)" and chose
the Multiply Blending Mode.*

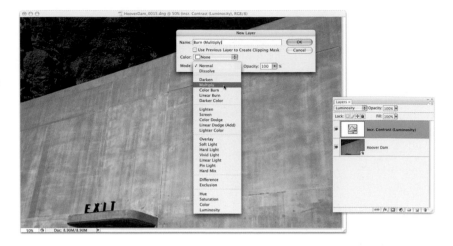

3. We use Layer > New Adjustment Layer > Curves (frankly, any will do). In the New Layer dialog, we give the name "Burn (Multiply)" and choose Multiply from the list of Blending Modes. We click OK.

*The result is the same as having the image
Multiplying itself.*

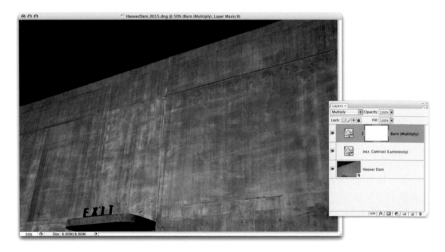

4. The Adjustment Layer is making the image darker everywhere because its mask is white everywhere. The darkening effect is identical to the effect of duplicating the original layer and setting that duplicate to Multiply.

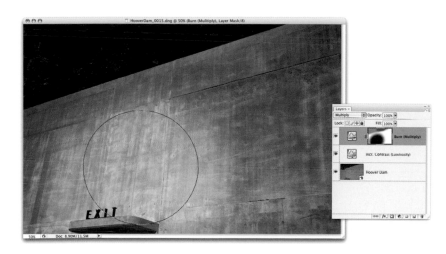

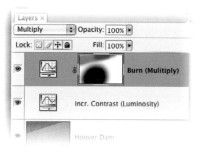

Although we wanted to burn much of the top and sides, we didn't want to burn the area around the EXIT sign. So we used our Brush Tool, set the color to black, and masked away the burning effect.

5. We paint on the mask with black to hide the "Burn." If we want to slowly diminish the effect, we could set the Brush's opacity to a low value and paint over an area repeatedly until the effect is tamed to an acceptable level.

 Instead of painting black on a white mask, we could have used Image > Adjustments > Invert to make the mask black then painted with white to burn in where we wanted to.

Dodging

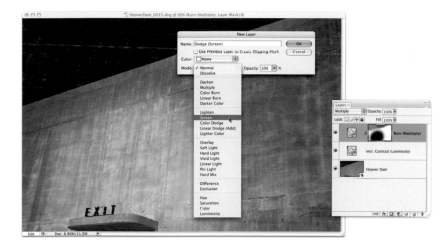

We created a new Curves Adjustment Layer. We named the layer "Dodge (Screen)" and chose the Screen Blending Mode.

1. We use Layer > New Adjustment Layer > Curves (again, any one is fine). In the New Layer dialog, we give the name "Dodge (Screen)" and choose Screen from the list of Blending Modes. We click OK.

We inverted the Adjustment Layer's mask via ⌘+I/ Ctrl+I *then painted with white at 50% opacity to dodge (lighten) the area around the exit sign and slightly at the right edge of the image.*

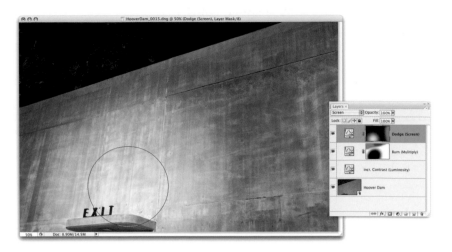

2. This time we inverted the mask before painting as described above. You could also use the shortcut ⌘+I/ Ctrl+I to invert the mask. When painting, we used a very soft brush preset.

Because the Dodge layer (and the Burn layer too) are Adjustment Layers, we can use them to readjust the effect of our burning and dodging.

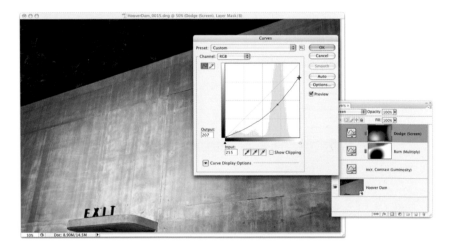

3. The dodge effect was good, and painted in all the right places, but it was a little too strong. So we took advantage of the fact that the layer was a Cuves Adjustment Layer: we double clicked on the Curve thumbnail, then pulled down the white and midtones. Because the layer is set to Screen, this adjustment cannot make the image any darker than it was before the Dodge layer was created—pixels set to screen can only lighten, never darken. So even if we had brought the curve all the way down, we would have only negated the dodge layer.

Curves Adjustment using Locking Points

We often want to make small adjustments to an isolated range of tones in an image (usually to increase the contrast between these tones), but without changing the adjacent tones. This can be done easily by 'locking' the adjacent tones first, before making the Curves adjustment.

Create a new Curves Adjustment Layer.

With the Curves dialog open, click and drag the mouse around on the various parts of the image—a tone point will move on the curve in the dialog to display the various tones for these parts of the image.

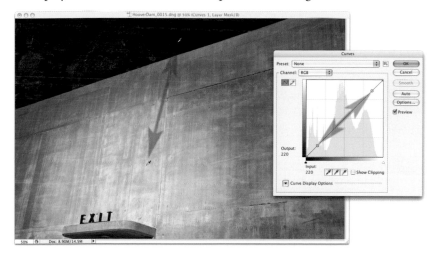

In this example, we want to add some contrast to the lighter area, while preserving all of the other tones in the image. Most of the tones in this area are quarter-tones. You want to be sure that as you sample, you're not misled by some stray dark or light pixel. So `<control>`+click/`<Right-click>` somewhere in the image and you'll be presented with a list of sizes that Photoshop will sample and average, ranging from a single pixel (Point Sample) to an area of over 10,000 pixels (101x101 Average). Choose a size that is consistent with the pixel dimensions of your image (larger for a 12 megapixel camera than for a 6 megapixel camera) and the details in your image (e.g., larger for weaves to average the fibers, smaller for smooth surfaces).

For tones in the image that you do not wish to change, `<⌘>`/ `<Ctrl>` click on these tones to create 'lock' points on the curve; These points will remain unchanged. Repeat to cover all the tones that you wish to protect. These lock points on the curve will assure that these values will be unchanged by this curve adjustment. In this example, we'd put the lock points in the patch of sky and mountain, as well as the sides of the image.

Finally, don't forget to add points for the tones you do wish to adjust!

Now, let's use the keyboard to go from one point to another and even to adjust them: use `<control>`+`<tab>`/ `<Ctrl>`+`<tab>` to go from one point to another. (Notice that the selected point is dark and that you can see the

"input" and "output" values for that point.) Once you've selected a point that needs tweaking, use your keyboard's arrow keys to move that point up and down to lighten and darken those tones.

Hit OK to close the Curves dialog.

You may now wish to localize the affect of this curve to only a certain area of the image. Do this by painting on the mask for the Curves Adjustment Layer.

Shadow/Highlight Adjustment

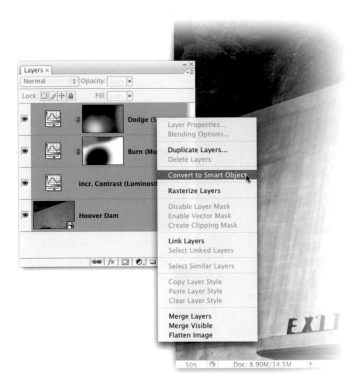

After making the full range of tonal adjustments to an image, the result has good overall tone, but the shadows and/or highlights may have become compressed, resulting in flat shadows or highlights with little detail. The **Shadow/Highlight** adjustment is an effective and fairly easy tool that allows you to restore some of the detail within the shadows or highlights without making significant changes to the overall tone that you have carefully adjusted. Shadows/Highlight is able to determine the areas of the image that contain shadows or highlights and edit the local contrast within these areas. The only limitation of Shadow/Highlight is that it is not available as an Adjustment Layer; so you will need to make a Smart Object on which to perform the Shadow/Highlight adjustment.

First, create a new Smart Object on which to perform the adjustment. To do so, select all the layers that form the image that needs to be adjusted. Then **‹control›**+click/ **‹Right-click›** on one of them. Choose Convert to Smart Object from the context menu. The Smart Object will get the name of the former top layer; you may wish to rename it. To get to your original layers again, you just have to double click on the Smart Object's thumbnail and follow the directions that appear.

Open the Shadow/ Highlight tool by selecting Image > Adjustments > Shadow/Highlight….

This is about the only adjustment that is treated like a filter; later, you'll be able to revisit it and mask its effects.

Amount: *How much to lighten shadows or darken highlights (while leaving deepest black and brightest white intact). The scale is arbitrary from 0% to 100%*

Tonal Width: *How far into the midtones do you wish to go from your shadows or highlights? You set that here.*

Radius: *The size of elements in the image that you're trying to adjust. You don't know? Guess! In the words of Adobe's inimitable Russell Brown, "Adjust the Radius slider until the image looks better — then stop." Good advice!*

Color Correction: *Increases saturation, as nearly blown highlights and nearly blocked shadows have little.*

Midtone Contrast: *Corrects for the slight overall flattening that Shadows/Highlights imposes.*

First, check the box to "Show More Options." Don't be alarmed by the excessive adjustment—feel free to tone down the aggressive defaults. Make the smallest adjustments that help the image. If your shadow or highlight areas cover a large part of the image, like clouds or the shadows of buildings may, then you will use a large Radius value. Otherwise adjust it with an eye on important details in the image. Tonal width should have a starting point of about 20%; experiment from there.

See the text with the accompanying graphic for an explanation of the terms used in this dialog.

After you've made the adjustment and clicked OK, you'll see that the Smart Object has an entry for Smart Filters—this adjustment is really a filter and thus can be treated like one. As a smart filter, it can be masked, readjusted, and have its Blending Options adjusted.

Color Corrections

Color matters! Very small changes in color can create strong overall changes in your image. This is especially true for subtle colors, colors that are near to neutral gray, and colors that complement each other within the image.

There are lots of techniques for correcting color precisely within your images, yet often the final judge for the quality of the image is simply your own eye.

Note: For any color corrections, you need to depend on your monitor to display your images accurately; make sure you have your monitor calibrated and profiled.

Look at images that have good color. We still often use the colors of other images to help us make adjustments. You can go to the website for any stock agency and search for images that are well-corrected; Adobe Stock Photos is built right into Adobe Bridge, which makes it easy to copy accurate images into Photoshop for comparison. Remember, good color is not necessarily accurate color; good color serves your design goals. But, be careful, modern photographic design includes some fairly unusual color casts; usually, stock images either have accurate color or very unusual colors.

A great image to use to gauge both your eye and your monitor is the Getty Images test image. It features many colors both subtle and vibrant, and a well-made grayscale across the top. It also features three models of different skin tones. As of this writing, you can download this image via a link on this page:

http://creative.gettyimages.com/source/services/ColorResources.aspx

In fact, this image is a very useful way to judge whether you are correcting an image so that skin tones are preserved. The best advice for adjusting skin tones is to have a well calibrated monitor, a comparison image where the skin tones have been accurately adjusted, and the ability to judge if the skin tones "look natural."

Using Photoshop's Auto Color

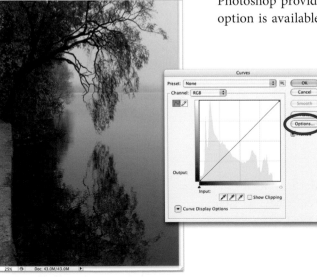

Photoshop provides a tool for automatic color correction; the Auto Color option is available in the Image > Adjustments menu, but here is a more powerful way to use this tool.

1. Create a new Curves Adjustment Layer; Layers > New Adjustment Layer > Curves, name this the 'Auto Color' layer. The Curves dialog contains a button for Auto color correction, and a button for auto color correction Options; select the **Options** button.

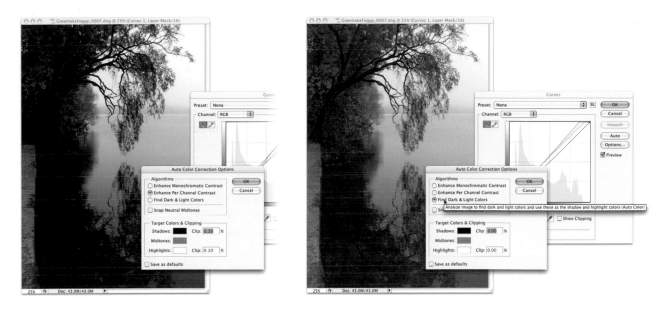

2. The default Auto Correction options are not the most effective options, but these options can be adjusted. Try both "Find Dark & Light Colors" and "Per Channel Contrast" to see which does a better overall job of color balance.

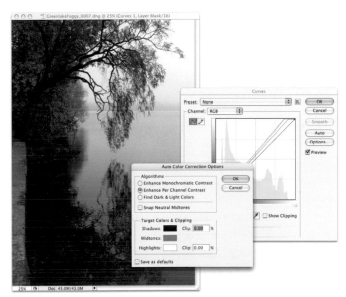

3. Next, set the Target Clipping values to "0.00%" for both the Shadows and Highlights; it is not necessary to clip any pixels in the color balance step, this is best done when adjusting highlights and shadows. Increase these values with the arrow keys if necessary.

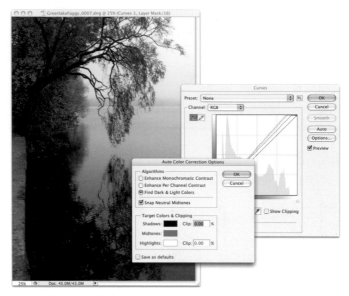

4. Try "Snap Neutral Midtones." Often, this auto color correction improves the color, but still does not properly color balance the image. One step to improve this is to set the Target Color for the Midtones. By default, Photoshop tries to lock the middle tones to an exact Gray value, but sometimes these middle tones should actually be a slightly different color near gray.

5. Click on the gray box for the Midtones Target Color; this brings up the Photoshop Color Picker.

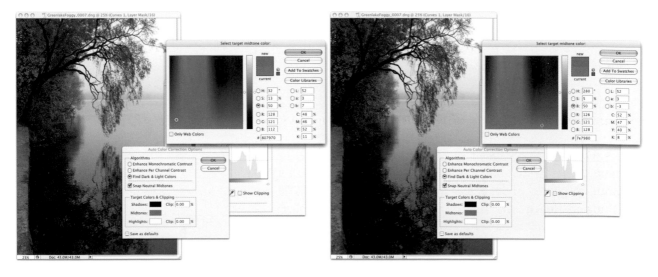

6. Change the target mid-tone color to a color that provides for a better overall color balance. Set the 'B' (brightness) to 50 to make the Color Picker display a field of midtone colors.

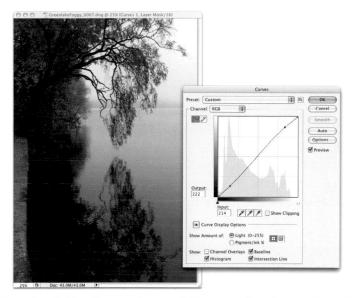

7. The color field will now show a full range of midtones. Try selecting some colors that you feel the image needs; just click around the lower half of the color picker, and the image will show a preview of your image. Once you have picked a color that makes your image look good, press OK to accept your color from the Color Picker, and click OK to accept the Auto Correction options. You may now make whatever standard Curves adjustments may still be needed.

The image should now have a fairly good color balance; this process works well for a majority of images, but there are still many images that will require manual color correction.

Color Correction by the Numbers

Even with a well calibrated monitor, it is more precise to color correct using numerical values rather than visually. This is especially useful when you have something in the image that should be gray or neutral: a color is neutral if the R, G, and B values are all equal. If you have an image that contains something that should be neutral, use this technique. Ideally, you might have something bright that should be neutral (like a cloud, or a white dress) and something mid-toned that should be neutral (like concrete or other stone). If there's a shadow area that should be neutral as well, you can use it also.

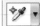 Sample Size: 5 by 5 Average Clear

1. Use the color sampler tool to measure the precise values of individual colors in the image. With it, you mark up to 4 areas to be monitored from the Info palette, where the color values will be displayed.

2. In the Options Bar for the Color Sampler, change the sample size to "5 by 5 Average" or larger if the area where you will place the sampler is noisy or grainy.

3. Reveal the Info palette, Window > Info or use the ⟨F8⟩ key.

4. As you move the color sampler tool over the pixels of your image, the numerical RGB values of the pixels are displayed at the top of the info palette.

5. Examine the image for good highlight, midtone, and shadow areas. These should be areas that you want to be neutral. If your image does not have one of these, then you need another way of knowing the target RGB values you are aiming for. Neutrals are easy: R=G=B.

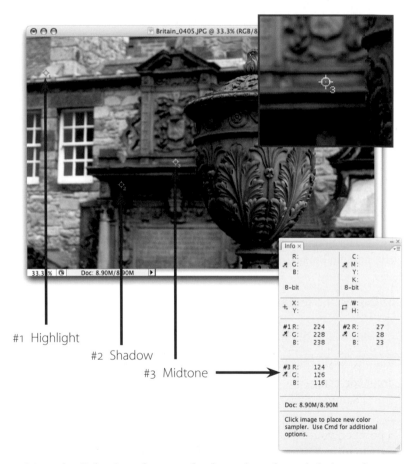

#1 Highlight

#2 Shadow

#3 Midtone

6. Move the Color Sampler over the desired pixels and click on the image. A numbered point will be placed on your image and a reference to it will appear in the Info palette. **Tip:** The numbers won't be equal yet (that's why we're correcting the image!), but for the midtone, for example, you should look for RGB values that approximately average to 128 (midtone). In this example, the values chosen are a little lower, but will be fine.

7. Create a Curves Adjustment Layer: Layers > New Adjustment Layer > Curves. You may, of course, make adjustments by moving the curve with your cursor, but it can be much faster and more efficient to use keyboard shortcuts, so we'll mention those as we go.

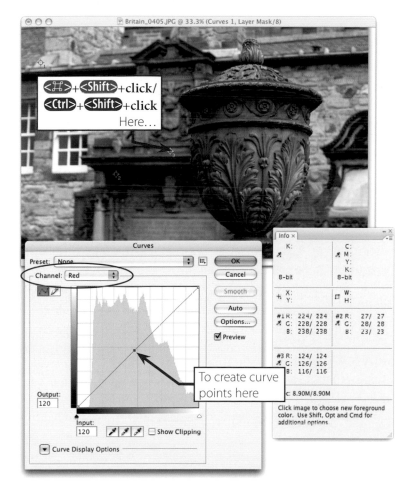

8. If you forgot to create your Color Sampler points until the Curves adjustment is open, that's ok. You can hold down your ⟨Shift⟩ key while any color correction dialog is open, then click on the image. This will create a Color Sampler. Do you recall the Lock Points tip in the previous section of this chapter? Holding down the ⟨⌘⟩/ ⟨Ctrl⟩ key and clicking creates a point on your RGB channel curve. But, here's the best one, though it's easy to miss: ⟨⌘⟩+⟨Shift⟩+click/ ⟨Ctrl⟩+⟨Shift⟩+click to create a point on *each* color channel. You will have to go to each channel in Curves to see them. If you do this on your midtone target in the image, you'll find a point roughly in the middle of the Red, Green, and Blue channels' curves. **Warning**: you won't see any point on the RGB channel.

9. To quickly navigate from channel to channel, use the shortcuts listed in the Channel menu.

Channel Navigation:

Red: ⟨⌘⟩+1/ ⟨Ctrl⟩+1

Green: ⟨⌘⟩+2/ ⟨Ctrl⟩+2

Blue: ⟨⌘⟩+3/ ⟨Ctrl⟩+3

RGB: ⟨⌘⟩+~/ ⟨Ctrl⟩+~

10. To navigate among Curve points, use `<control>`+`<tab>`/ `<Ctrl>`+`<tab>`

11. With the midtone curve point in the Red channel selected in the Curves dialog, use your `<tab>` key to alternately highlight the **Input** and **Output** fields (at the lower left in the dialog).

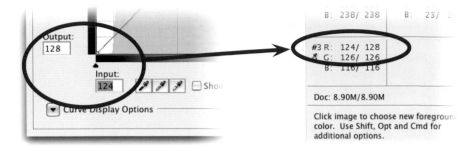

12. For Output, type in "128", hit `<tab>` to get to the Input field, then type the Red value you see for the midtone Color Sampler. (We use 124 in the example). Now, 124 units of red will output instead as 128.

13. Repeat this for each channel. It's easier than you might think: if you have the midtone point selected on the Red channel, the midtone point will automatically be selected on the other channels as you go from one to the next.

14. Finally, the white and black points. Navigate back to the Red channel's curve and select the white point (the uppermost right). Unfortunately, if you try to enter values for the light and dark Color Sampler areas, your colors will likely get very crazy. It's usually not prudent to move points that are close to the ends. But it *is* OK to move the endpoints themselves: left or down for the white point, right or up for the black point.

Move white point left or down (black point right or up) until desired value is achieved in the Info palette. Here, the target value is 228. By moving the white point (normally 255) to the left, the color sampler that is being modified is raised as well, though more gently.

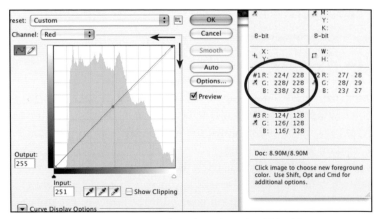

15. One decent method to neutralize the white (and black) points is to make the highest and lowest value equal to the middle value. In this example, the uncorrected highlight values are 224R, 228G, and 238B, so 228 would seem a good target for each channel's highlight point.

16. Repeat the analogous process with the black points.

Summary

With Curves open, you create curve points on each channel, then go from channel to channel adjusting the midtone values directly and numerically. Then you can adjust the black and white endponts while watching your color sampler references in the Info palette and getting the RGB values close to equal and therefore neutral. In this image, the greenish cast is now removed.

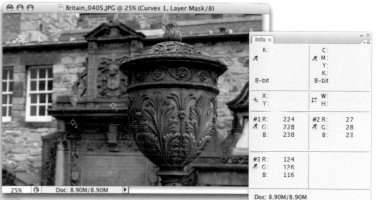

Copying Color Corrections

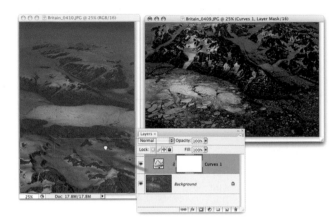

There are many times when you might wish to apply the same color correction to a number of different images. This generally happens when you have a number of images that were shot under very similar conditions, so that the same color balance will work well for all these images.

It is possible to just copy a color correction Adjustment Layer (or any layer) onto another layer merely by dragging from the source image and dropping the layer onto the destination image. You can also copy a layer from one image to another by selecting that layer in the source image and using the Layer > Duplicate Layer command; in the Duplicate Layer dialog, change the Destination Document to the destination image.

Just copying a color correction layer from one image to another works for color corrections that use an Adjustment Layer, which is active everywhere (the mask is white). But often, the color correction may have required a number of different adjustments including masks or adjustments that have been applied to stamped Image Layers; these won't copy well to a new image.

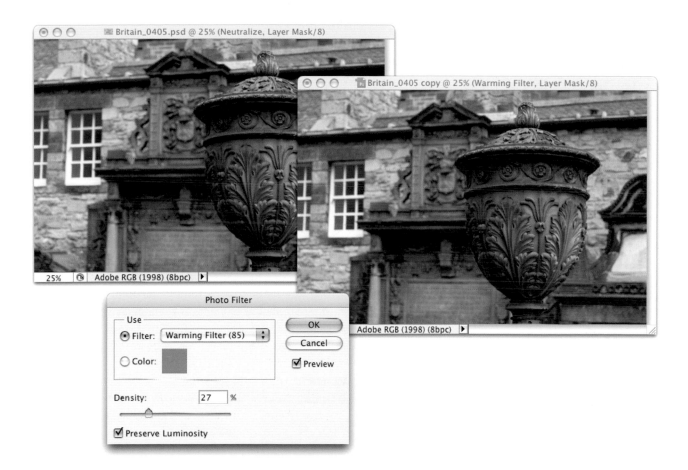

Photo Filters

Often, accurate or neutral color is not enough—or not what pleases. Photoshop provides a nice, simple tool for mimicking color filters. A Photo Filter will add some snap to images that have merely adequate color.

1. Create a new Photo Filter Adjustment Layer; Layer > New Adjustment Layers > Photo Filter.

2. In the Photo Filter dialog, choose a Filter from the menu or, if none of those achieve the desired result, you can click on the color chip and use the Color Picker to specify precisely what color your filter should be. The best filter is often the 'Warming Filter (85)'; it creates a nice warming effect without being obvious. Adjust the Density (intensity) to increase or decrease the effect.

3. Note the Preserve Luminosity checkbox. This is equivalent to a photographer's adjusting exposure after having put a filter in front of the lens.

4. Hit OK to close—done! The warming filter adds just a touch of extra color to your image.

Reducing Localized Color Casts

Digital cameras and color film can both reproduce skin tones with too much red or magenta. Sometimes shadows exhibit too much blue. And those of us who photograph people often find ourselves whitening and polishing teeth in Photoshop, too.

Each of these issues can be dealt with fairly easily with a roughly targeted Hue/Saturation adjustment.

1. Make a rough selection of the area that has the color cast (select the red-faced person's face, the coffee-stained teeth, or the bluish shadows, excluding red, yellow, or blue things that shouldn't be adjusted).

2. Create a Hue/Saturation Adjustment Layer: Layer > New Adjustment Layers > Hue/Saturation.

3. In the menu at the top, pick the color that needs help. If, for example, you are trying to make a magenta cast in skin merely reddish, choose "Magentas." In the example here, we selected yellow.

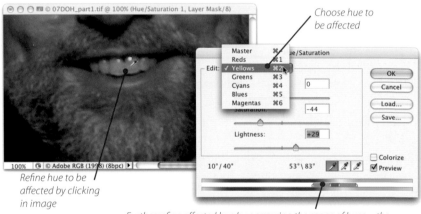

Choose hue to be affected

Refine hue to be affected by clicking in image

Further refine affected hue by narrowing the range of hues—the darker gray is under the hues most adjusted. Dragging the lighter gray patches broadens or narrows the "ramp" of hues

4. Refine the range of color affected by clicking in the image on the color you're trying to change and by moving/narrowing the adjustment slider (between the spectra at the bottom of the dialog).

5. For this example and the others mentioned, lowering the saturation is one adjustment that helps reduce the cast (less yellow teeth, not so great a blush in the magenta face, etc.). In the example illustrated, we also lightened a small amount.

6. If necessary, paint white or black on the Adjustment Layer's mask to spread or limit, respectively, the effect of your adjustment.

Black & White Images

Black & white photography continues to evolve and create its own artistic path. Yet, many image editors or designers only consider black & white images when their printing budget requires black & white. Black & white images are already non-photorealistic images and are therefore somewhat abstract. Printing images in black & white provides great creative opportunities. Black & white images can usually be edited and manipulated in ways that would ruin color images; the abstract nature of black & white photography automatically reduces the need for a traditional 'photorealistic' image.

In the digital realm, images are rarely shot in black & white, but rather they are shot in color and converted to black & white. This gives you more flexibility in how individual colors are translated into various black & white tones. If you use a digital camera, shoot all your images in color. If you are comfortable shooting b&w film, definitely continue to do so! "If it ain't broke, don't fix it," is the old saying. But, many opportunities are available in Photoshop to customize a conversion from color to black and white.

Start with a color image that has good density by performing the basic white and black point, brightness, and contrast adjustments on the color image (it is easier to convert a color image to b&w if it starts with good density).

If you query 100 Photoshop experts as to what is the "best" way to convert from color to black and white, you'll receive about 50 answers. Here, we'll provide a few that have served us well. We will assume you've tried a direct Image > Mode > Grayscale method and found it lacking.

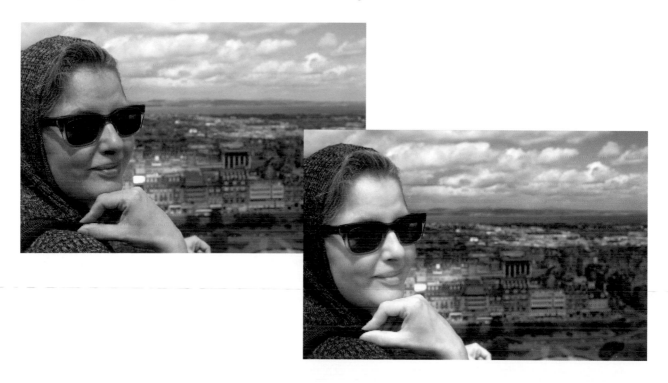

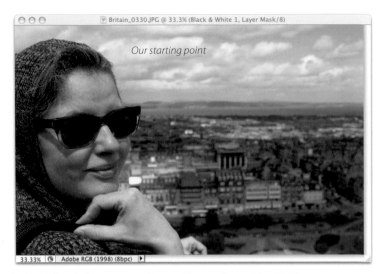

Our starting point

Black & White Adjustment Layer (introduced in CS3)

1. Create a Black & White Adjustment Layer: Layer > New Adjustment Layers > Black & White.

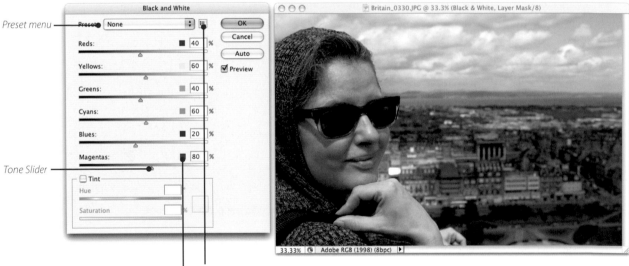

Preset menu

Tone Slider

Original color whose tone is being affected.

To save Presets

Tip: <option>+click/ <Alt>+click *to reset slider*

2. There are many presets that can be chosen at the top of the dialog. If you choose none, you'll get a generic conversion. If you press the Auto button, Photoshop tries to give a good balance of tones based on the colors in the image. For this image, that isn't such a great choice, though it serves well much of the time.

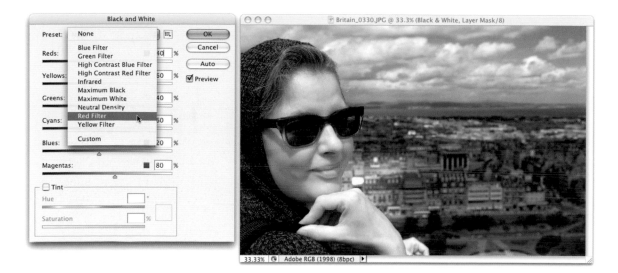

3. For pictures of people over a wide variety of skin tones, the Red Filter preset is a great starting point.

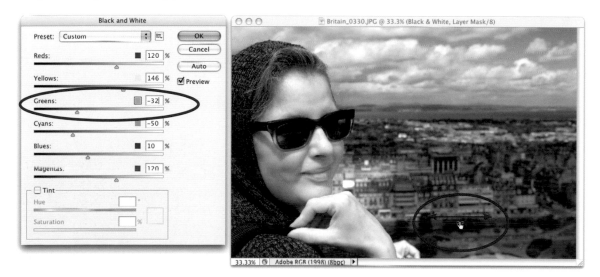

4. Now, do you remember what color each part of the image is? You don't have to: click with your cursor over the image, and the correct slider's number field highlights! But it gets better: don't simply click, but drag in the image, and the color under the point where you started to drag will get lighter and darker. You can even see the slider moving as you drag in the image.

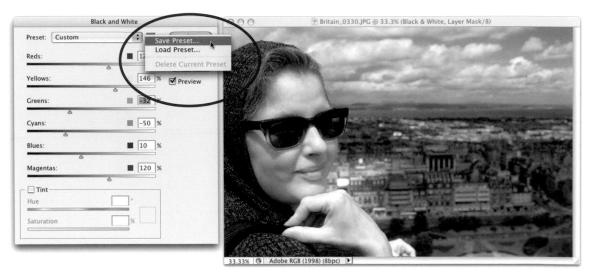

To make a Grayscale mode duplicate, choose Image > Duplicate. In the dialog, give a name that indicates that this is (or will be) Grayscale, and check the **Duplicate Merged Layers Only** *box. Then convert this to Grayscale.*

5. If you like what you've done and would like to apply the results to other images, save your settings as a Preset. At this point you could click OK to commit the adjustment. If the image truly needs to be in Grayscale mode, we usually recommend making a duplicate.

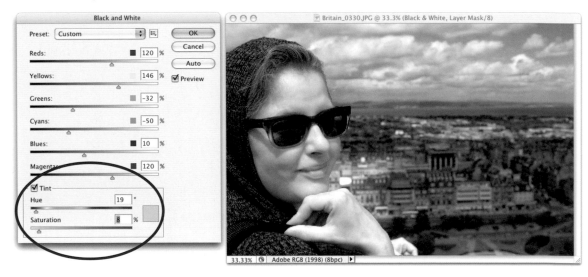

6. To apply a color tone to the image, click the Tint checkbox. Then choose a Hue with which to tone the image and a Saturation level for that Hue.

Photographic Effects

Film Grain

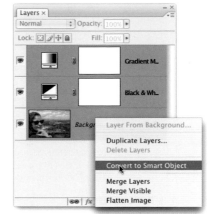

Film Grain in photographic film is due to the clumps of silver or dye in the emulsion. It has its own important aesthetic in photography. You may wish to add simulated film grain to add abstraction to your images, create a more classic or even dreamy appearance, and even to mask softness or digital noise in your image. This technique will also demonstrate how to apply Photoshop filters that are not immediately available in 16 Bits/Channel mode.

1. Select all the layers that "construct" your image then **\<control\>+click/ \<Right-click\>** on the name of one of those layers. Choose Convert to Smart Object.

2. If the image is in 8 Bits/Channel Mode skip to step 3. If not, use Image > Mode > 8 Bits/Channel. What's great is that the Smart Object's contents retain their greater bit depth, but now you can apply filters to it that you couldn't in 16 bits/channel!

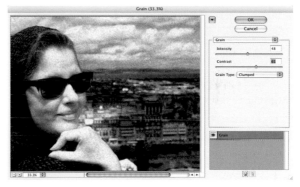

3. There are many Filter choices at this point, but a good place to start is with Filter > Texture> Grain. It will present you with a lot of Grain Types: experiment! In this image, we chose Clumped, despite its colorful nature— we'll deal with that shortly.

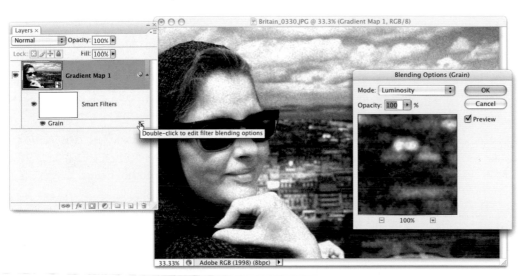

4. When the filter is applied (it will be a Smart Filter), edit its Blending Options by clicking on the icon to the right of the filter's name. Choose Luminosity as the Mode so the grain *color* will disappear.

Lens Blur

You may have an image with a good subject, but a distracting background. Use focus (or lack of focus) to separate the subject from the background and make the image stronger. The Lens Blur filter is an excellent, if time-consuming, tool for defocusing part of the image.

1. Create a duplicate Layer on which to perform the Lens blur. If you only have a background layer, duplicate it by selecting Layer > Duplicate Layer… Name this the 'Lens Blur Layer'. Sadly, Lens Blur is too complex a filter to be applied to a Smart Object.

2. Make a selection around the subject. Use whichever tool best suits the image. The Polygonal lasso was used first to make the initial selection around Carla in this image, and then Quick Mask mode to paint the edge more carefully. Pixels that are partially selected will be blurred less by the Lens Blur filter.

3. Once you have a good selection, save the selection by selecting Select > Save Selection… and provide a name for the selection that refers to the blur. After saving the selection, remove it from the image; select Select > Deselect.

4. Select the Lens Blur filter; Filter > Blur > Lens Blur…Open the Source option under Depth Map and select the selection that you saved for the blur. This defines where on the image the blur should occur. Drag the Radius option to the right to set the amount of blur to apply to the image. More blur is often better, but a stronger blur will also make flaws in a less than perfect selection more obvious. If the subject becomes blurred (rather than the background), just reach into the image and click on the part that should be sharp. .

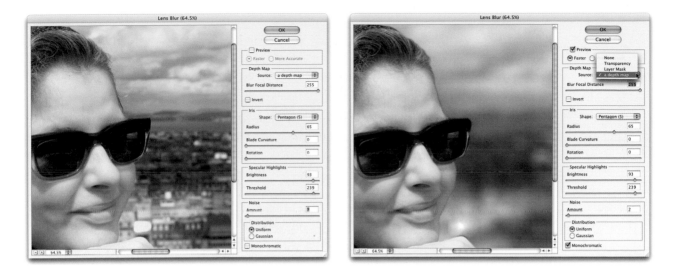

There are many different options available for fine tuning the lens blur to provide additional options which mimic the effects of real photographic lenses.

1. When specular highlights are present, a real photographic lens will shape those into the shape of its aperture. The Lens Blur filter can simulate that in the Iris section. Here we used a pentagonal aperture simulation. You can see this subtly demonstrated near Carla's chin.

2. To control how strong those specular highlights are, and what brightness in the image triggers their presence, you can adjust the Brightness and Threshold sliders respectively.

3. Finally, since blurring removes grain, noise, and other artifacts that a real lens wouldn't, this filter has provision for introducing noise that is proportional to the amount of blur. So if a part of the image isn't blurred, it gets no noise.

"Split-Toning" Black & White Images

As long as your image is in RGB mode (if it's in Grayscale, use Image > Mode > RGB), you can tone it to your liking. Split-toning is an effect that uses more than one color to tone the image.

We'll do this by applying colors that "map" to the image's shadows and highlights and transition between these extremes. To do this, we'll use a Gradient Map Adjustment Layer.

1. Create a Gradient Map Adjustment Layer. Layer > New Adjustment Layers > Gradient Map. Be sure this new layer is at the top of the stack.

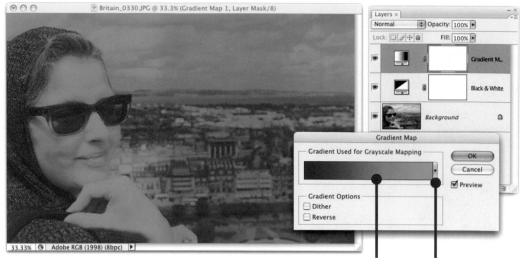

Click to edit the Gradient Click to pick a Gradient Preset

2. Don't be alarmed! It's very likely that the colors applied are *not* the ones you want. If **there**'s a Gradient Preset that does have colors you like, choose it **from the** small menu to the right of the gradient preview. Otherwise, click **on the** preview itself to edit the gradient.

3. When you click on the gradient preview, you get the Gradient Editor dialog. This dialog would get a chapter of its own if the world were just. But here's the heart of the matter: The Color Stops along the bottom of the gradient can be double-clicked to change the color they give to the gradient. For the Gradient Map Adjustment, the color at left "maps" or replaces black in the image, and the color at right replaces white. So, if you want an "old fashioned" image, you may choose a cool toned shadow area transitioning to a cream (mimicking old paper).

4. When you double-click on the Color Stops, **you get** the Color Picker. Here, we chose a dark blue to map to black, **and a** cream to map to white.

5. You can even add more colors to map to intermediate tones. Here, we chose a 50% brightness brown to map to the original's midtones. Note the Location field for the position of the selected Color Stop.

Adobe Photoshop Lightroom

Lightroom is Adobe's attempt to put much of the workflow discussed in the previous chapters into one program. This one window takes you through its "Modules" that facilitate sorting and organizing, developing, spotting, printing, website output, and even slideshows.

However, many of Photoshop's compositing and other power editing tools keep it well within the workflow.

In this chapter, we'll look at how you may use Lightroom to do many of the things discussed earlier. Whether Lightroom is a workflow substitute or an aid is something you'll have to decide. Keep in mind that we expect you to be familiar with the Photoshop/Bridge/Adobe Camera RAW workflow before tackling this chapter, as Lightroom provides not just an alternative, but an extension to that workflow.

The Lightroom Interface

Navigation

When you open Lightroom for the first time, it offers a tour of sorts. Take it! If you have already skipped this, you can find it with the command Help > The Five Rules. This highlights the major parts of the interface: The **Module Picker**, where you take images through the workflow; the **Panels**, similar to Photoshop's palettes, where you achieve your editing tasks; the **Filmstrip**, where you can always access your images along the bottom of the screen; 6 important keyboard shortcuts; and a suggestion that you "Enjoy" the program.

Shortcuts	Function
\<tab\>	Hides & shows side panels
\<Shift\>+\<tab\>	Hides & shows all panels
\<F\>	Cycles Full Screen Mode (to maximize space)
\<L\>	Dims the interface except for selected image (partially, black-out, and normal)
\<~\>	Toggle between Loupe view and normal view
\<⌘\>+[*forward slash*]/ \<Ctrl\>+[*forward slash*]	Brings you Module-specific help

The first thing most Photoshop users notice about Lightroom is that it consists of one huge window, where the palettes of Photoshop have been replaced by panels that can slide in and out of the sides of the screen. And although there are menus, we use them very little, and thus spend much of our time in one of the full screen modes, even the one that removes the menu bar!

Much of the workflow that we've discussed in this book can be accomplished with Lightroom, however, there are notable exceptions: any edit that involves selections, multiple images (compositing), or masked adjustments.

Menu bar
Identity Plate (editable!)
Module Picker
Histogram
Metadata, adjustment, and layout panels, depending on the Module.
Folder, Collection or Preset panels, depending on the Module
Grid or Image view
Filmstrip

While looking at the interface, try the shortcuts on the previous page. When the panels are hidden (by using the **⟨tab⟩** key), you'll see the triangles on the edges are pointing inward. If you hover your cursor over the left or right edge, the panel will automatically move in so you can use it. Once the cursor is away again, the panel retracts.

Click on the name of the Module you want to examine:

1. **Library** is for organizing, applying and checking metadata, and perhaps a little bit of image adjustment or "Development."

2. **Develop** is where you do your global adjustments and light retouching with a tool similar to the Healing Brush or Clone Stamp. You can save and apply Develop Presets, or work with the History states in your images' editing lifetime (yes, a history palette that doesn't clear upon closing the document).

3. **Slideshow** is the module where you can design and present a slideshow with music or without, and with or without your "Identity Plate" as a sort of watermark. You can export your slideshow as a PDF.

4. **Print**, as the name implies, is the module for outputting to your printer. You may print many images on a contact sheet, several copies of one image per sheet, adjust margins, and apply last minute "printer" sharpening. What's really great is that you can queue up many images to print.

5. **Web** is the module where you can set up and use site templates for creating online portfolios. These may be fairly straightforward HTML or they may use Flash for more interesting effects. Everything from text to color may be customized, and you get to preview in a web browser for a real sense of the user experience. Lightroom can even upload to your web server once you've configured its settings.

Preferences

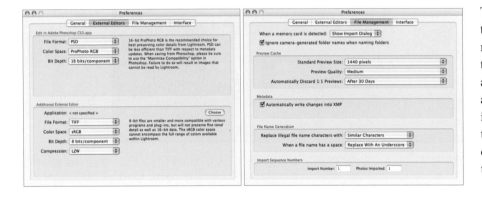

There are "only" four pages to the preferences in Lightroom— not bad for an Adobe application. The first and last pages are fine in their default states, and are fairly self-explanatory if you should wish to adjust them. The middle two, however, could use a little explanation and adjustment.

The preferences for **External Editors**, *Edit in Adobe Photoshop CS3*, should probably be set as illustrated here. This is especially true if you have configured your color settings as suggested in the Introduction (this would also make Lightroom consistent with our suggestions for using Adobe Camera RAW). Later, to open a Lightroom image in Photoshop, select it in the Library Grid, then either use ⌘+E/ Ctrl+E or control+click/ Right-click on the thumbnail and choose Edit in Adobe Photoshop CS3. Before the document opens in Photoshop, you will see the dialog box illustrated. We recommend, unless you have reason to do otherwise, that you edit a *copy* of your original, but one that exhibits the edits you have already done in Lightroom (your global adjustments and light cleanup for example). You can even "Stack" this copy with the original so that they stay associated with one another!

Use the **File Management** preferences to have Lightroom oversee the downloading of your images from your camera. From the menu "When a memory card is detected:", choose Show Import Dialog. We also recommend that you check the box for ignoring camera-generated folder names.

Now would be a good time to consider image import.

Stage 1 Image Import

Automatic Import

When you set your preferences as we suggest on the previous page, Lightroom will automatically launch and offer to download images when you connect a camera or card to your computer.

Convert to DNG and import to any location

Uncheck images that should not be downloaded

Folder naming by year (with subfolders by date)

Automatic backup of your unadjusted RAW files

Custom and automatic file naming

Automatic RAW settings

Apply metadata template and keywords

Preview and choose images to download

Configure the dialog box to download images to your main image library (or another if you wish). RAW files can automatically be converted to DNG format and named in a usable way. Note also that you can choose to back up your files straight from the camera to a network backup drive, for example. Some prefer to apply some initial global corrections before using Lightroom's Export feature to create backup files. Lightroom ships with export defaults for burning full sized JPEGs to disc, exporting DNGs, and even to send files by email.

If you trigger your camera from your computer, then download the images to a special folder, you can specify that Lightroom "watch" that folder, then automatically import any images that appear in it. Choose the settings that get applied, and the Watched Folder itself, with File > Auto Import > Auto Import Settings.

Keywording and Metadata

Even upon automatic import, you can apply keywords and a metadata pre-set, if you've built one. To do so, find the Metadata panel on the right side of the Lightroom window, and use its Preset menu and choose Save as New Preset… which presents a dialog box:

Fill in any field that you would like on this preset. For your "default" preset (one you will apply when importing images), fill in all fields that should appear on all your images. You can always create more presets later for special cases, and even apply metadata to one image at a time.

Just above the Metadata panel is the Keywording panel. Here is where you can quickly add keywords as they come to mind for selected images. As you add Keywords (or more properly, Keyword Tags), they will appear in the Keyword Tags panel on the left side of the Lightroom window.

In the Keyword Tags panel, you'll see your growing list of keywords. As this list grows, organize it: for example, Neidpath Castle is near the town of Peebles in Scotland, so we put the *Neidpath Castle* keyword tag under *Peebles*, and *Peebles* under *Scotland*. Please note that this is not possible with Adobe Bridge. Sometimes we need to send images to others who may not have Lightroom. If we want those "Parent" keyword tags to be exported

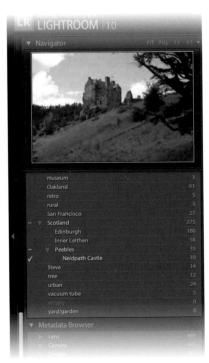

with the images, we should <control>+click/ <Right-click> on the *Neidpath Castle* keyword tag and choose Edit Keyword Tag. In that dialog, we can specify synonyms (in

case we forget the real keyword) and ensure that the "parent" keywords accompany the "child."

Back on the right side of the screen, *Peebles* and *Scotland* appear in the **Implied Keywords** area of the Keywording panel. Between the Implied Keywords and the ones directly applied is a set of 9 keywords. These can be the nine most recent keywords, or any set of nine you would care to create. You can apply them to a selected image by simply clicking on the keyword. To apply one from the keyboard, hold down the <option>/ <Alt> key, note the numbers that appear next to the keyword tags—press one of those numbers on your keyboard to apply the keyword tag. Notice how the numbers correspond nicely to the layout of the number pad on an extended keyboard?

You can apply metadata to JPEGs, TIFFs, DNGs, and PSDs. You can "develop" JPEGs, TIFFs, and DNGs. Nonetheless, we recommend setting your camera to capture in its RAW format, then convert to DNG upon importing into Lightroom.

Libraries—or is it Catalogs?

Lightroom has a default library database that stores references to your images and their metadata. As of version 1.1, the "Library" was renamed "Catalog." However, you may have several libraries: to keep personal and professional images separate perhaps. To create and then to access other libraries, hold down the <option>/ <Alt> key when launching Lightroom. From the dialog box that appears you can choose any library you've made, or you can create a new library database.

Each library can have a different look and feel. And since a Lightroom library keeps only references to your images, and preview images to display, you can work on images to which you may not currently have access. For example, if you have an external hard drive attached to your laptop to store your images, you may sort, develop, apply metadata, and otherwise use Lightroom as if those images were still accessible! Of course, if you tried to print, you may use only "Draft" mode. When you reattach your hard drive, Lightroom updates its database and the files' metadata.

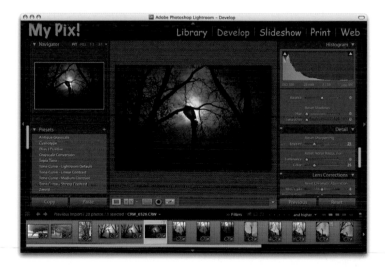

Stage 2 Sort & Organize Images

Library Module: Rating and Filtering

Grid Loupe Compare Survey

If you wish to go through and star-rate the images you have just downloaded, you can use one of several views in the Library Module: Grid View (the lightbox, as it were), Loupe View (where you can zoom in to gauge sharpness, etc.), Compare View (to judge between two images: the "Select" and the "Candidate"), and Survey View (for deciding from among several candidate images). We use Loupe, navigating with the Filmstrip below, while rating.

The tip we offered in the section on rating using Bridge (proceeding through the images using your thumb on the right arrow key, and using your fingers to press a number 1–5 to set a rating) is useful here. After going through and rating the images, if you wish to filter for, say, 3 stars or higher, note the Filters section of the Filmstrip. There, you can click on the third star and choose and higher from the menu next to the stars. You could also choose to see that rating and lower, or just those images that have exactly that rating. You may also filter for one or more labels. Finally, there is a small switch icon with which you can disable or enable your chosen filters.

Filter Switch icon

Library Module: Labelling

In order for Lightroom and Bridge to respect each other's labels, they *must* be named identically. If they are, any workflow landmarks you pass in Lightroom will be notable in Bridge as well. Use Lightroom's menu bar and choose Metadata > Color Label Set > Edit to create your own labels. If later you need to change these, you can by either using the default set, creating a new set, or editing this one. We named ours "Photographer's Handbook."

To apply a label in Lightroom, it's easiest to press the number associated with that label, or, if you don't remember which number corresponds to which label, then you can choose Set Color Label > [*your choice of label*].

In the Library Grid view, you can **\<control\>**+**click**/**\<Right-click\>** on a thumbnail and edit the View Options. This rich dialog lets you choose which data is shown whether the Library Grid cells are compact or expanded. We often choose not to show the file name in favor of seeing the label text in Compact mode. This also helps you to be sure of where an image is in the workflow.

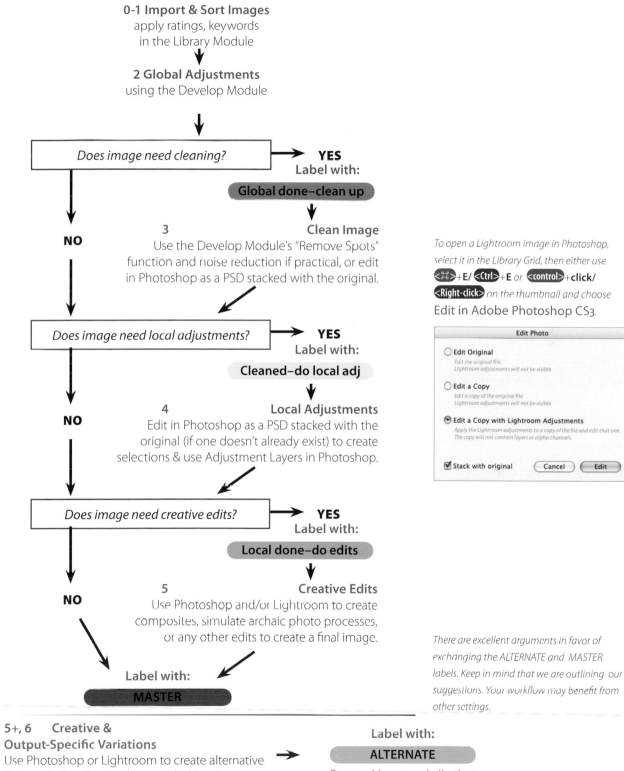

0-1 Import & Sort Images
apply ratings, keywords
in the Library Module

2 Global Adjustments
using the Develop Module

Does image need cleaning? → **YES**
Label with:

Global done–clean up

NO

3 **Clean Image**
Use the Develop Module's "Remove Spots"
function and noise reduction if practical, or edit
in Photoshop as a PSD stacked with the original.

Does image need local adjustments? → **YES**
Label with:

Cleaned–do local adj

NO

4 **Local Adjustments**
Edit in Photoshop as a PSD stacked with the
original (if one doesn't already exist) to create
selections & use Adjustment Layers in Photoshop.

Does image need creative edits? → **YES**
Label with:

Local done–do edits

NO

5 **Creative Edits**
Use Photoshop and/or Lightroom to create
composites, simulate archaic photo processes,
or any other edits to create a final image.

Label with:

MASTER

*To open a Lightroom image in Photoshop,
select it in the Library Grid, then either use*
<⌘>+**E/** <Ctrl>+**E** *or* <control>+**click/**
<Right-click> *on the thumbnail and choose*
Edit in Adobe Photoshop CS3.

Edit Photo

○ **Edit Original**
*Edit the original file.
Lightroom adjustments will not be visible.*

○ **Edit a Copy**
*Edit a copy of the original file.
Lightroom adjustments will not be visible.*

◉ **Edit a Copy with Lightroom Adjustments**
*Apply the Lightroom adjustments to a copy of the file and edit that one.
The copy will not contain layers or alpha channels.*

☑ Stack with original (Cancel) (Edit)

*There are excellent arguments in favor of
exchanging the ALTERNATE and MASTER
labels. Keep in mind that we are outlining our
suggestions. Your workflow may benefit from
other settings.*

5+, 6 Creative &
Output-Specific Variations
Use Photoshop or Lightroom to create alternative
"interpretations", resized/resampled versions
for specific print sizes or web output, etc.

→

Label with:

ALTERNATE

Be sure Master and all other
versions are "stacked."

The white triangle (and the Histogram) indicate that there is clipping in the shadows in the image being developed.

The "switches" to the left of each Panel's header disables/enables that Panel's effects.

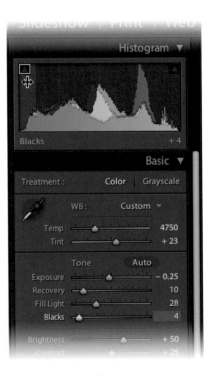

Stage 3 Develop Images

For "developing" your images, Lightroom's Develop Module is an evolution of Adobe Camera RAW. But if that's true, it certainly has a few mutations, too! We'll presume you have familiarity with ACR and its controls, and we'll focus on how Lightroom differs.

In the History Panel (lower left) you'll see a growing list of edits you do in this Module. The difference between this panel and Photoshop's History Palette is that the items here never go away unless you clear them! You can return to any stage in the image's life with a single click. Since all the edits you do in Lightroom are nondestructive, and all the edits are "just" meta-data, it's easy to do this. So relax and enjoy the process.

The next thing to note is that instead of tabs that you can see only one at a time, you have Panels that can all be expanded and scrolled through. However, some find this to be quite a lot of scrolling. So if you **‹control›**+**click**/ **‹Right-click›** on a Panel's header (on the word "Basic" for example), you can choose Solo Mode. The disclosure triangles become dotted, and as you go from one development Panel to another, the previous one will automatically close. Also, on the left edge of all the Develop Panel headers except Basic, there is an on/off switch, like we saw with the Filters. This is a nice, quick way of seeing a before and after just for sharpening, for example, or perhaps toggling a color adjustment on and off.

The buttons at the bottom of the Develop panels, Previous and Reset, apply the settings from the last image developed or clear all settings to their starting points, respectively. You can also Copy and Paste Develop settings with those commands under the Develop menu. When you choose to copy an image's settings, you're presented with a dialog box that lets you decide which settings you want to copy, and which you don't.

Note: Copying the Spot Removal settings is a handy way to remove sensor dust spots in one image, then paste that correction in all the images that also suffer from that problem!

Although the controls under Basic are the same as they are in ACR 4.0, there is more flexibility and feedback in Lightroom. For example, as you adjust, say, the Exposure slider, the part of the histogram that will be most affected highlights subtly. But, even more interesting, when you put your cursor in the Histogram itself, that highlighting also appears, and the slider that would affect that part of it will also highlight. Notice that the cursor itself changes to indicate that you may drag back and forth in the Blacks (as illustrated here), to adjust them! The Histogram is active as well as indicative.

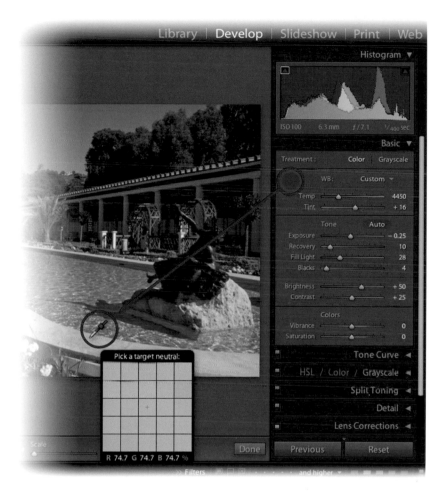

White Balance

The White Balance eyedropper, located in the Basic Panel, acts like a docked cursor. That is, when you click on it, it "becomes" your cursor, and is joined by a *very* magnified pixel grid (a Loupe) so you know exactly which pixel you're using to set the image's White Point. While that tool is active, you can zoom the Loupe using the Scale slider at the bottom of the image (that slider isn't there unless the White Balance tool is active). Once you set your White Balance by clicking, the tool will automatically "Dismiss" itself, returning to its home in the Basic Panel.

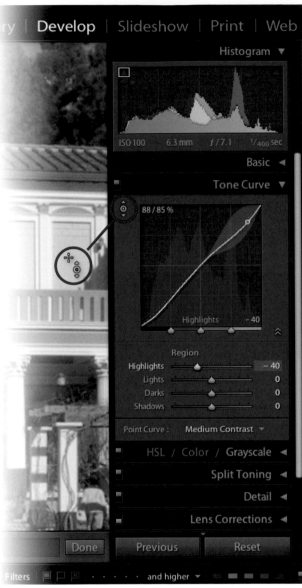

Adjusting Tone

Lightroom's Tone Curve is also a little different than ACR's. Both have parametric controls wherein you drag sliders to affect different parts of the tonal range. However, in Lightroom, as you hover over a slider, the affected part of that range is highlighted on the curve. And it works the other way around, too: as you move your cursor over the curve, the appropriate slider highlights. But it gets better: notice the small target–like icon just to the left of the top edge of the curve window. Like the White Balance tool, this is a cursor waiting for you to click on it. Once you have it, move the cursor over the image: the crosshair is the actual cursor, the target with arrows above and below it are there as a hint. As you move over the image, the curve shows you the tones under the cursor; if you press and drag up and down on the image, you affect (mostly) the tones just under the cursor. So if you press and drag vertically on a very light pixel, your image's highlights will be adjusted, and so on. This will spoil you—you might start trying to do this in Photoshop or ACR and find yourself frustrated.

Adjusting Color

For Adjustment by hue, Lightroom offers two interfaces:

HSL (Hue, Saturation, and Luminance) in which you're given a list of Hues, and you use sliders to shift them, or change their saturation or brightness (luminance).

Color wherein each hue has sliders for adjusting its hue, saturation, or luminance.

HSL has the ability, like the Tone Curve, to load your cursor and change the targeted attribute of the hue under the cursor.

Grayscale Images

Similar to ACR 4.0, you enable Grayscale, then adjust the luminance of up to 8 different hues. The added benefit in Lightroom is the ability to use the cursor to lighten and darken the (pre-grayscale) hues under it. This is handy as you may simply not remember what color something was, and you may just want to make it lighter or darker.

Saving Develop Settings

Once you have adjusted an image, you may wish to save the settings, or some of them, so they can be easily applied to other images. Remember that as you import images you can apply a Develop Preset. So, if you have settings that work very well for conditions under which you shoot often (a studio perhaps), you should save them and apply them automatically when downloading images from those conditions.

Of course, you can apply saved settings Presets anytime by clicking on a Preset's name in the Presets Panel (on the left side) of your screen. To the right of the word "Preset" is a "+" sign: this is what you click to save your settings as a preset.

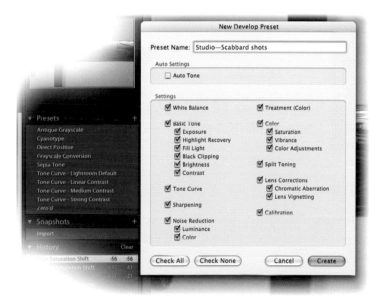

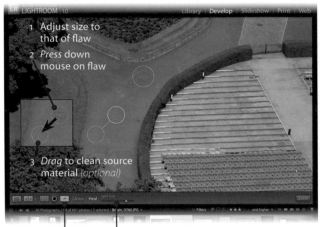

Remove Spots tool *to change size of affected area **or** use scroll wheel on mouse **or** the [or] keys*

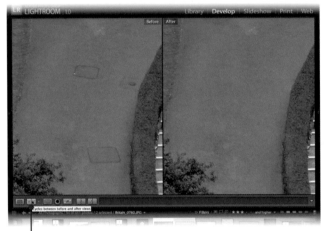

Before/After view

Stage 4 Image Clean-up

Removing Dust and Other Blemishes

For this, we use the Remove Spots tool found in the Develop Module. It is similar in appearance and over-all function to the Retouch Tool in ACR 4.0, but its behavior is, again, just a little bit different and maybe better.

Once you select the tool, the steps are simple:

1. Line up the cursor on the center of the flaw you wish to remove. Adjust its size with your mouse's scroll wheel (or the [and] keys).

2. Press the mouse button down, then, without releasing the mouse…

3. Drag to a clean, logical source area, releasing the mouse when you get there. This step is optional: if you just click on the flaw, Lightroom will try to find a good source area. It often does well, but nearly as often, we wish we had chosen it, so we just do it ourselves.

 Remember you can copy any settings, even Spot Removal, by using Develop > Copy Settings… If you're getting rid of sensor dust, you can paste the Spot Removal on all images with the same dust spots!

Crop & Straighten

Cropping and straightening are definitely improved over what is found in ACR. When you choose the Crop tool, Lightroom snaps a crop to the edges of the images boundaries. When you resize the crop, a 3-by-3 grid forms so you can use the "rule of thirds" if you like while cropping. When your cursor is outside the crop box, you can drag it to rotate the image within the crop. While doing so, you're shown a much finer grid so that it's easier to straighten the image at the same time. But if that isn't enough, you can use the Straighten tool (it looks like a traditional bubble level). With it, you drag across that which you would like to make either vertical or horizontal, Lightroom knows the difference. The crop adjusts to make it so.

Stage 5 Local Adjustments

Lightroom's Integration with Photoshop

If there remain edits that only Photoshop can accommodate, such as those that require selections and compositing of images, then it is prudent to make a copy of the Lightroom original, complete with the edits done so far in Lightroom. So that the copy and original "know" that they belong together, you should make sure they are part of the same Stack. Finally, open the copy and make your Photoshop-specific, local adjustments.

Luckily, all this is achievable in one step! To open a copy of a Lightroom image in Photoshop, select it in the Library Grid, then use either **<⌘>+E/ <Ctrl>+E** or **<control>+click/ <Right-click>** on the thumbnail and choose Edit in Adobe Photoshop CS3. You'll see the dialog box at right. Automatically, you can open a copy that reflects all the work you've done in Lightroom, and have it Stacked with the original!

Finally, when you click **Edit** in that dialog, the image is handed off to Photoshop. You'll be prompted to "Convert document's colors to the working space", Adobe RGB (1998), which you should do. If you don't see the dialog box that suggests this conversion, revisit the Color Settings section in the Introduction of this book (pages 7–9).

Lightroom Edits or Not?

If you are uncertain of whether to accept the Lightroom edits or not, because, perhaps, you think you can do a better job in Photoshop, by all means choose **Edit a Copy** in the Edit Photo dialog. Then you can compare your edits in each application and decide which to use.

Stage 6 Creative Development: Virtual Copies

Some edits are much more than technical: they are experimental and/or aesthetic. And many of these Creative Edits as we call them in this book, can be achieved in Lightroom. Consider some of the Develop Presets that come with the application: Antique Grayscale, Sepia Tone, etc. Often, you'll want to apply these only to copies of your images.

But if the edits you want to make are achievable in Lightroom, then we recommend that you make a **Virtual Copy.**

Just **<control>+click/ <Right-click>** on an image or its thumbnail (in the Library Grid or the Filmstrip) and choose Create Virtual Copy. This Virtual Copy's thumbnail will have a "page-turn" icon in its lower left corner.

Stage 7a Output: Slideshows

Create a Collection

The first step to creating a **Slideshow** is designating the images you want to include and making it easy to choose them again later when you're in the Slideshow Module.

We'll use the temporary storage solution called the **Quick Collection**. You can have only one of these at a time, but if you believe you need to reselect the same images quickly again, you can save a Quick Collection as a more permanent one. You'll find your **Collections** in their own Panel on the left side of the Library Module. For now, however, we'll use the Quick Collection to build our first Slideshow.

In the Library Module or the Filmstrip, select a few images to include in your slideshow. Since this is just an experiment, they don't have to be special. When you hover your cursor over one of the thumbnails, a circle should appear in its upper-right. Clicking it adds that image and all other selected images to the Quick Collection. So, if you want to do a few other things before creating the slideshow, you may. When you return to the Slideshow Module, use the command File > Show Quick Collection or use ⌘+B/Ctrl+B. These commands toggle between the Quick Collection and whatever previous content you were viewing.

In the Filmstrip, you can rearrange the images, changing the order in the slideshow. All that remains for you to do is to choose the appearance and behavior of your Slideshow!

Overview

Template Browser on the left, to store and choose slideshow layouts

Options for fitting the slide's image area, Strokes on the slide images, and for **Cast Shadows**

Layout just while building your slideshow, sets your margin **Guides**

Overlays the most complex, for configuring and positioning your Identity Plate (either text or a graphic, like your logo), the images' Ratings, any Text Overlays you'd like (controlling their fonts, opacities, etc), and, for any of those objects, Shadows. Whew!

Backdrop for a graduated Color Wash background, a Background Image, or, since you can change their opacity, both.

Playback where you can choose a Soundtrack from an iTunes Playlist (Mac OS) or a folder of sorted mp3 files (Windows), specify the Duration of each slide, and the duration of the Fades between them.

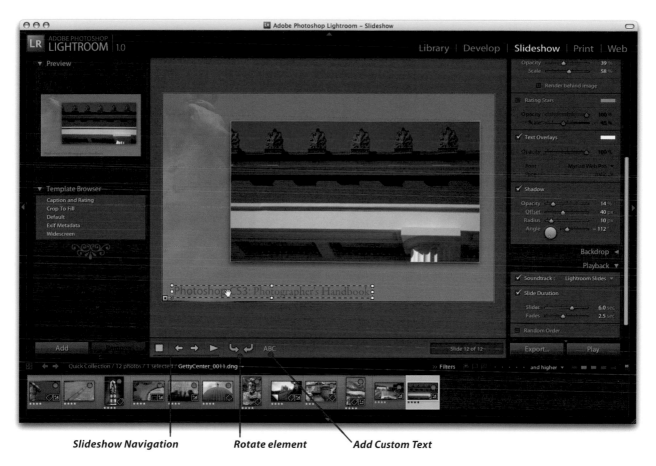

Slideshow Navigation **Rotate element** **Add Custom Text**

Slide Layout

Start with a Template. It's much easier to adjust something already made, unless you have a very clear idea of what your slides should be like.

Most likely, you will not simply work your way down the list of Panels on the right. Rather, you'll find yourself going among them, balancing, for example, the margins in the Layout Panel with room needed for your identity plate, or judging the effectiveness of a background image (in Backdrop) with your particular images. You'll experiment with the slide duration, trying to let each image have a chance to be appreciated, but not to bore your viewers. That is, you'll try some settings, then either use the Preview Slideshow button beneath the main window, or the big Play button on the right. Either way, you'll notice a short delay before the music begins the first time.

To edit your Identity Plate, open the Overlays Panel, then click on the small version (with a dark checkerboard). A menu appears where you can choose Edit. The dialog box that appears is where you can edit the text of your Identity Plate, including font and size, or you can insert a graphic you've built (no more than 60 pixels high). In the first released editions of Lightroom, we found editing the text of the Identity Plate to be a bit unstable: having a couple fonts and sizes was a little too much for it. You may wish to use a graphic rather than doing any fancy text editing.

If you want a generic text overlay, perhaps a title for the slideshow or explanatory text, you click on the "ABC" below the main image window. A field appears for you to enter your custom text, or you may choose meta-data. Once you've committed your text overlay (for custom text, by pressing Enter), a scalable box appears anchored to the lower-left corner of the slide area. You can drag the box and/or its anchor, resize it, anchor it to the frame or part of the image, or use the Custom Text field to change it. Use the Text Overlays section of the Overlays Panel to edit the opacity, color, and font for the selected text overlay.

Exporting Slideshows

When you've dialed in your slideshow, you'll want to show it, of course! You may either show it directly from Lightroom, in which you get all the bells and whistles, or you can export it as an Acrobat PDF. PDFs don't support music, and the transitions won't be so elegant, but neither you nor anyone else will need Lightroom to play the PDF version of your slideshow. All that is needed is the free Adobe Reader software.

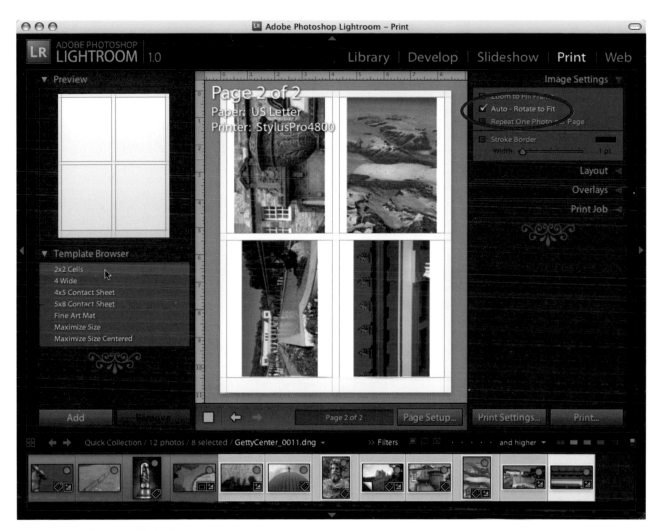

Stage 7b Output: Printing

Many options exist for getting one image out of Lightroom and onto a sheet of paper. But, there are many more options for generating contact sheets; printing several images but only one per page many times. There are space optimizing features, the ability to add strokes of any color around the printed image(s), many page layout options, text and Identity Plate overlay options, and, of course, color management options too.

However, there are concerns in the user community about high quality, high resolution printing, and whether Lightroom is the appropriate application for it. For now, we recommend that if you need to print one image, and print it at its finest, that you do so from Photoshop. But if you need to generate a somewhat customized contact sheet, or any grouping of multiple images on a page, Lightroom is hard to beat for convenience and speed of customization.

Contact Sheets

As you hover your cursor over the several templates in the Template Browser Panel, the Preview Panel will give you an idea of the layout. By name and preview, you should choose a template as a starting point. Then the fun begins.

Be sure you have a few images selected so that the template populates with images, giving a more solid idea of the final output. In the following example, we'll start out with the "2x2 Cells" template. Of course, you may experiment with any layout.

In the illustration, you'll note that we checked the box "Auto-Rotate to Fit" in the **Image Settings** Panel. That way, both portrait and landscape format images will make the best use of the space of their cells. It is in that same Panel that you may apply a border to the images or have the images fill their cells completely. The remaining option, "Repeat One Photo per Page", fills each template page with one of your selected images. So if you needed 4 each of all 12 images, this would be a quick way of getting there.

Setting Resolution and other Settings

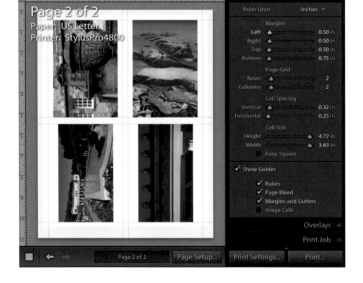

Layout Panel You may have chosen a template to start with, but that doesn't mean you can't make modifications! Here, we adjusted the Margins a bit to make room for the Crop Marks we'll add later. Under "Show Guides," it may be tempting to turn off a few things, but only one is really redundant: the Image Cell lines. The "Page Bleed" grays-out the outer parts of the page on which the printer can't reliably print.

Overlays You may want a little bit of text to help you or your clients identify which images are which. Aside from the Identity Plate, there doesn't *appear* to be much other information you can attach to the image. We added Crop Marks, as promised, and we turned on Photo Info, too. When you look at the menu to decide *which* file info to add, the list is short, but includes Edit. When you choose that, you find a dialog box in which you can construct quite a string of info, including text you type in yourself.

▸ In the field at the top, insert your cursor where you'd like some datum to be inserted.

▸ Then find the kind of data in the list below, clicking "Insert" when you've found it.

▸ Add text to the field where and how you'd like, perhaps adding punctuation or other arbitrary text.

▸ When done, save your customization as a preset so you can use it again later.

©2007 Steve Laskevitch, 1/22/07 12:40:39 PM Pacific Time

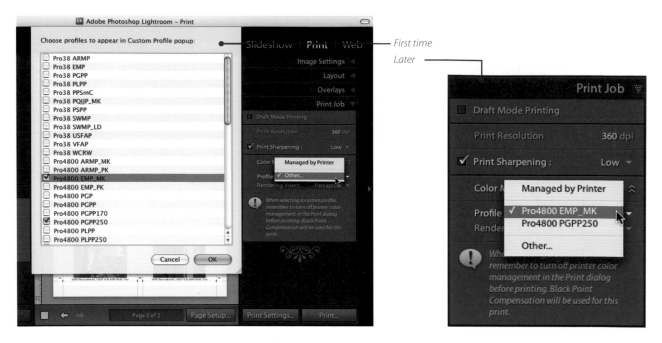

Print Job This Panel is more approachable if you've been printing from Photoshop. What's different? You choose the resolution to which you would like to resample your image (do you hear warning bells? So have others, and this is why we recommend printing detail-critical images from Photoshop). Since resampling may result in diminished sharpness, you can apply some sharpening (Adobe recommends Low for smaller images, Medium for images roughly filling Letter or A4 paper, and High for images filling larger than Tabloid or A3).

Finally, and importantly, Color Management is governed here. We recommend printing with profiles from Lightroom. However, the first time you look at the Profile menu, you won't see a list of profiles at all! You'll see Managed by Printer and Other... Choose Other... and you'll see the list you're looking for. What's nice about this interface is that you can choose which profiles you can see in the Profile menu. Click the checkboxes of the profiles for the papers/printers you use and click "OK."

All that remains is clicking "Print..." at the bottom-right. Since you've chosen to let Lightroom manage color, remember to disable color management/correction in your printer's driver.

Stage 7c Output: Web Module

With the things you've learned in the Slideshow and Print Modules, you can
very quickly choose a web template and customize it to taste. We'll again ask
you to choose a group of images, and from them create a Quick Collection
(select them in the Library Grid, then click on the small circle in the top-left
of the thumbnail).

Now go back to the Web Module—we're ready to begin.

Flash or HTML?

The left side of the Lightroom window is dedicated to the Template Browser
and its Preview. We've picked "Charcoal." It happens to be a more tradi-
tional HTML-based gallery. The other popular choice is Flash, which has
nicer transitions. However, we're comfortable editing HTML code, and
Lightroom's is very elegant and straightforward to customize later (if you
have HTML experience).

Choosing a Layout

Note: The work area (the central window) responds to the choices you make
as you build your web site, and it does so as a browser would. If you make
your window larger, the work areas will re-center your content as a web
browser will. Better still, it navigates like the web will, too! If you click on a
thumbnail, it brings you to the larger version; click on the larger image, then
you're back to the thumbnails.

So we'll start not with the Labels Panel, but one a little lower
down…Appearance.

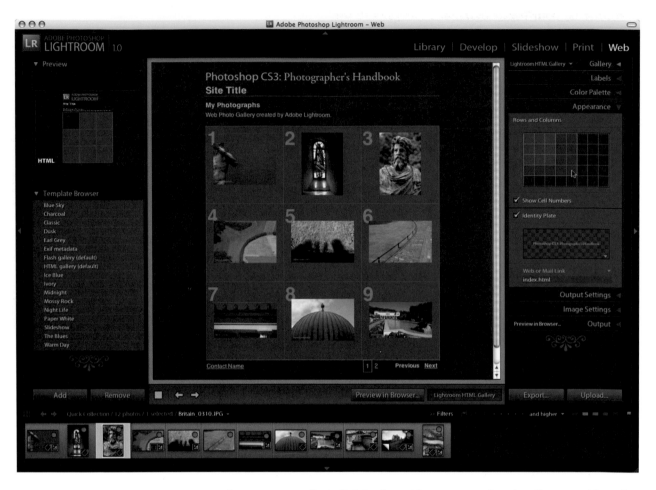

Appearance Just click in the grid to create a thumbnail array with as few as 9 to as many as 40. If you enable your Identity Plate, you can also designate that it become a link when the site is generated. Usually, this is the main page of the site, so the default is "index.html", which is the name of the main page on many sites. Determine whether the thumbnails should have numbers or not.

Customizing your Text, Colors, and Image Settings

Labels You probably want a better name for your site than "Site Title." This is the panel where you enter the text that tells us something about the site we're looking at.

Note: The link you specify under "Web or Mail Link" is the web address to which a person is whisked if they click on the text you entered under Contact Info.

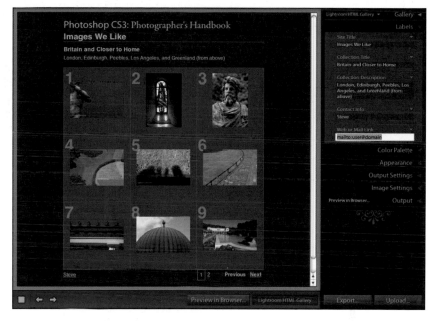

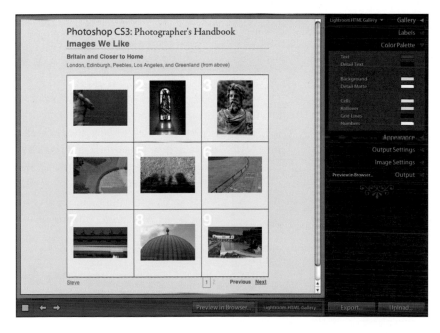

Color Palette As you can see here, we left the Charcoal template behind, going instead for a cream and red theme. Simply click on the current color of the item whose color needs changing, and you'll be presented with a dialog. Choose your new color.

Output Settings This allows you to set the size of the "large" JPEG versions of the images. You can choose widths of 300 to over 2000 pixels. Of course, such size differences greatly affect the look and feel of the page and may restrict who can use the site (bigger images favor owners of bigger monitors). You also must choose the JPEG's **Quality**. Here we've used 70.

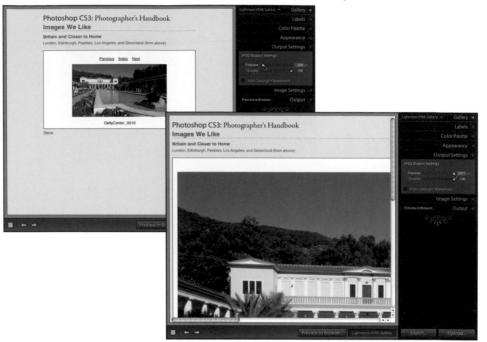

Image Settings You may have text above and below the large versions of your images, whether the Filename or any of the other things we saw in the Print Module's image info. You can also include Custom Text. For example, we let the Filename be the "Title" of the image, and we typed text that we wanted to see (navigation instructions) below each image as a "Caption."

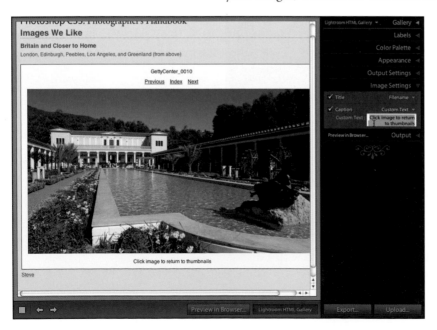

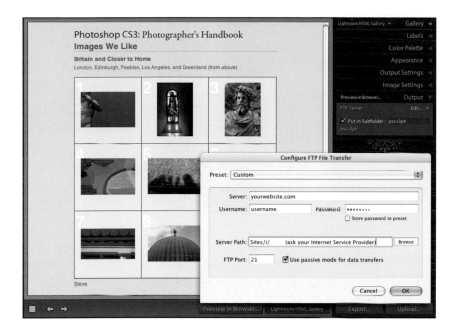

Output This last, small Panel is where you configure upload (FTP) settings. If you already have a website, you may simply add another directory/folder containing the "site" you just built here in Lightroom.

Previewing, Exporting, and Uploading

To see your work in a real web browser before you're ready to commit to uploading it where the world can see, use the "Preview in Browser" button below the work area window.

To upload to a site, use the "Upload" button at the lower-right. It will use the settings from the Output Panel.

Perhaps you just wanted to make a functioning website to burn onto a CD-ROM to permit a client a private look with a pleasant interface. Then you would use the "Export…" button. Give the containing folder a name, then the site gets saved to your specified location.

It's rarely so easy.

Additional Resources for Lightroom

Go to the Lightroom Help menu (we're not kidding!) and choose Help Resources Online… On the right side of the web page that opens is a fantastic list of "Additional Resources"—especially the Forums. Check them out— we do! Many of the questions you'll ask will have been asked by others, and someone may have an answer. Contribute your own, too.

Index